SISTERFRIENDS

SISTERFRIENDS

Portraits of Sisterly Love

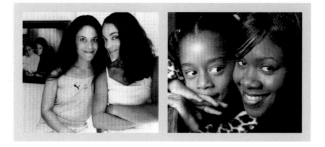

Photographs by Michelle V. Agins

&

Essays by Julia Chance

POCKET BOOKS
New York London Toronto Sydney Singapore

POCKET BOOKS, a division of Simon & Schuster, Inc.
1230 Avenue of the Americas, New York, NY 10020

ISBN: 0-671-03713-7

First Pocket Books hardcover printing November 2001

10 9 8 7 6 5 4 3 2 1

POCKET and colophon are registered trademarks of Simon & Schuster, Inc.

For information regarding special discounts for bulk purchases, please contact Simon & Schuster
Special Sales at 1-800-456-6789 or business@simonand schuster.com

Book design by Lisa Stokes

Printed in Italy

CONTENTS

FOREWORD

M Y SISTER ONCE GAVE ME A BIRTHDAY PLAQUE inscribed, "God made us sisters, hearts made us friends," and that inscription characterizes sisterhood as I have experienced it. And I have experienced sisterhood because my mother had six daughters. I know about those ties that bond—they can feel like velvet strips one day, braided rope the next. But most days our relationships with one another are characterized by impenetrable bonds of charity and fidelity and honesty. And when we're less than that, when we're emotionally stingy or argumentative or gossipy, and even when we're sniping at each other, we're careful to avoid the tender spots, and to not draw blood. In short, we're close. It's a closeness that, as much as I value it, I also take for granted. We're sisters after all, we share parents and history and genetic composition, so shouldn't we be close?

Except that the sets of sisters so stunningly presented by Julia Chance in the following forty-eight essays have come to know that their ties that bond didn't just happen simply because they are related. Each essay reverberates with the implicitly stated notion that these sisters are close not merely because they have the same parents. Some sisters portrayed here do not have a common blood line, nor are they bound just because they grew up sharing hair rollers, or bedrooms, or the backseat of the family car—at least one sister pair was raised in different cities—nor do they avoid controversy—one woman says emphatically that her relationship with her sister is larger and more important than any disagreement they might have. Ultimately, these sisters have at the hearts of their relationships the willingness to cross great expanses—physical, emotional, even spiritual—in order to be and remain connected. In fact, it is the wanting to be close that makes these sisters so.

There's JoAnn Lee and Lynell Kollar, for whom a family arrangement meant that one girl was raised by their grandmother in New Jersey, the other lived with their

parents in Texas. Yet both women describe their relationship as being richer than perhaps sisters brought up in the same bedroom. They use terms like "soul mate" and "unconditional love"; "cohabitation," they say, "has never been a prerequisite for closeness . . . it's more about where your heart is than where you live."

There's actor Kadeem Hardison's mother, Bethann, and her best friend, Marta Vargas. The two met as adults and were instantly fused in a friendship that rivals that of other women bound merely by genetics. They speak of their spiritual, soulful, mental connection, though most of their get-together time is spent on the phone. Yet they'll talk literally all night long if a personal drama is working itself out in either of their lives, as was the case when Marta's mother died.

There's Shirley and Lynn Hopkins, who drew on everything they knew about sisterly bonds to get them through the tragedy of a car accident in which Shirley was left with severe head trauma, comatose, and ultimately in need of prolonged and intensive rehabilitation. It was Lynn who traveled four hours every weekend to help care for her sister, talking her through her coma, being a pillar for her sister as she progressed through her rehabilitation, even taking Shirley's hand in a tender moment at a basketball game when Shirley had forgotten how to walk up steps and couldn't maneuver the bleachers; Lynne guided her, encouraging her every inch of the way.

There's even the charming story of little Yhanni James, who more than anything wants a sister but instead gets a brother, and then finds it difficult to contain her disappointment. Later, when her mother has a third child, a girl, seven-year-old Yhanni is bursting. She's remains elated even as she learns how to process conflicting emotions over the loss of attention from family members, attention that used to be hers exclusively but that has now shifted away from her and toward her baby sister, Thandi.

The women on these pages represent a variety of lifestyles and have experienced sisterhood in its many manifestations, from the heartwarming to the stark. Yet all of their lives have been enriched—in some cases even sustained—because of the ties that bind them to a sister. And in every instance it is the choosing to be close that makes these women so. They sometimes travel long distances to be together. They stretch across potential divides of rivalries or disagreements, of tragedies or nontraditional family arrangements. And it is their willingness to stretch that becomes the ties that bond, the recognition that they are truly sisters not just because of the physiology of genetic makeup, but because of their hearts wanting it to be so.

by Diane McKinney-Whetstone

SISTERFRIENDS

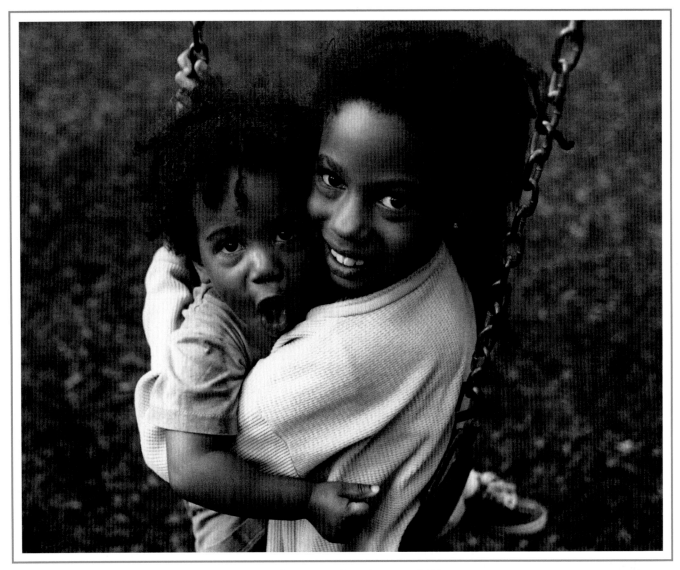

The James Sisters: Thandiwe and Yhanni

JUST THE BEGINNING

WHEREVER YOUNG Yhanni Jamila James goes, little sister Thandiwe Kara is sure to follow. On an early summer afternoon in their hometown of Reston, Virginia, the girls are all squeals and laughter, their coppery dreadlocks bobbing up and down as they run through a neighborhood park and descend on a two-seat swing set. Yhanni plops herself down on the rubbery seat, pushes off, and glides through the air. Thandi approaches her seat with the confidence of a champ but finds it hard to get on. A look of helplessness crosses her face, but before she starts to cry, Yhanni carefully lifts her on to the seat, instructs her to hold on tight, and gently pushes her forward. Thandi shrieks gleefully.

Having a sister is a wish come true for Yhanni. For as long as she can remember she has wanted one, or preferably, two. "I wanted twin sisters so they could be just like me." She was an only child for three years before her mother gave birth to a second child, her brother, Shelby, and she admits she was kind of disappointed that he was not a girl. "We have all the pictures in the photo album and I'm not holding Shelby." Since then she's learned that having a brother could also be a lot of fun, except when it comes to the more girlish pursuits, like playing with dolls. And at times Shelby can be a relentless teaser. But as Yhanni sees it, he's just doing what boys do. "Like it says in the book *Mommy Laid an Egg*, boys are made of puppy dogs' tails, snails, and all the gooey stuff—it's really disgusting—but 'girls are made of sugar and spice and everything nice' and it's better."

When her mother announced that she was pregnant with a third child, Yhanni, then six, again hoped for a sister, and it was not long after that Thandi came into the world. Yhanni was so ecstatic. "I said 'Ohhh!' and then I jumped up

and down." What made the event even more special to her was that Thandi was born at home. "It was exciting because Mommy was having the baby at home and I could actually see her after she was born." And according to Yhanni, their connection was instant. "First she opened her eyes and looked at me," she smiles. "It made me feel real good."

Sometimes the constant attention that her new sister was receiving was difficult for Yhanni to handle. She remembers one time in particular when her grandmother was holding the infant and Yhanni asked if she could hold her for a while. "She looked up at me and said no, and then she looked back down at the baby and started to laugh. It made me feel real sad." Fortunately, through "self-help" she found a way to cope—"I went to my room and started to talk to myself about it"—and her outlook improved.

Thandi is a cherubic handful who tries her best to keep pace with her big sister despite the six-year age gap. Yhanni doesn't mind a bit and lends encouragement every step of the way. "We do our numbers and our ABC's and then we dance together," says Yhanni. They even have some things in common. "She likes to write and she likes to draw, like me." On the issue of toy sharing, Yhanni is all for it, especially since Thandi's doll collection is not as extensive as her own. And since Thandi is big on hide-and-seek, Yhanni plays it with her repeatedly, even though the toddler hasn't quite learned an effective cover strategy—"She usually hides in the closet." Yhanni always finds her.

The real lesson Yhanni has learned is that being a big sister is not all fun and games, and with it comes certain duties and responsibilities. When Thandi was younger, Yhanni would assist with feeding, "but now she can feed herself." And she used to help change her diapers, but "only if I had a nose plug. Now it's worse so I don't do it anymore," she laughs. These days she mostly helps her to get dressed, ideally in outfits that complement her own. "If I wear pants I would want her to wear pants, and when it's a special occasion we'd both wear dresses."

Thandi, in turn, seems to respect her big sister's authority—sometimes more than their mother's, like when she's splashing around in the bathtub and getting water everywhere. "Mommy says stop and she doesn't but when I say stop she does." But Yhanni knows that even Thandi has her moments, when crossing her can make for some pretty painful consequences. "When she's mad don't pick on her because she'll go 'Ahhya! Ahhya!' And kick you. That really hurts so you shouldn't do that." Or even worse, "if you really get on her nerves she will go over to you and bite you."

But Yhanni takes it all in stride because she's got a lot of big plans for Thandi and herself. There are still more dances to teach her, and she wants to be the one to show her how to fly a kite. And years from now, when they are both grown with children of their own, she wants them to go into business together. "I think that we'll be able to make our own store," she states confidently, "and sell baby things and stuffed animals and stuff like that."

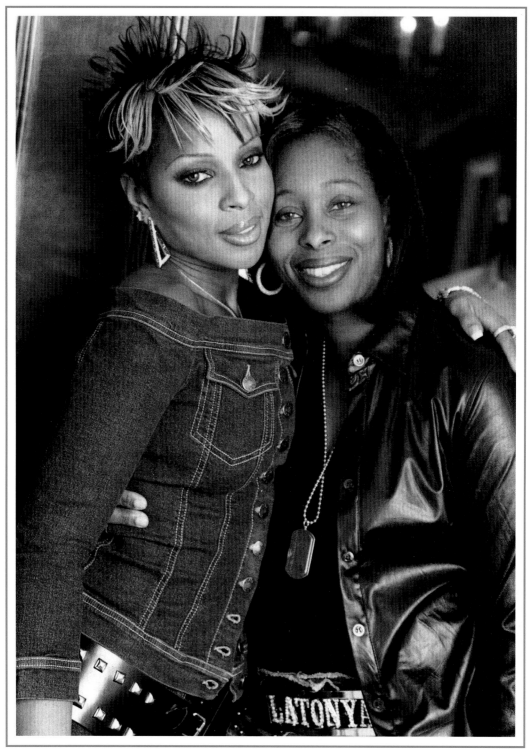

The Blige Sisters: Mary J. and LaTonya

LOVE, NO LIMIT

REMINISCE

ONE DAY I SAW TWO KIDS who I guess were brother and sister. The boy was telling the girl, "Don't walk across the street, wait until Mommy comes," but of course she walked across the street, and the boy went to stop her and she was going crazy. That reminded me of Mary and me when we were younger. I'd say, "Mary, Mommy said don't do that," and she'd say, "I'm doing it." I'd try to stop her and we'd start fighting or whatever. I thought I had to be the boss all the time, and I wanted her to listen to everything I said. See, our parents had separated, so it was only our mother, Mary, and me. That's all we had, you know. I felt like we had to listen to Mommy, and Mary had to listen to me because I was older.

We grew up in Yonkers, New York, in Westchester County. Back then our lives consisted of the basic things, like cleaning up, going to school, and going outside to play. Our mother worked, so I had to watch Mary until she came home. We did regular girl stuff—double Dutch, hopscotch, roller skating, played with our Barbie doll hairstyling head, and our Holly Hobbie oven. We'd have our little arguments over toys, the phone, or clothes. Mary was always bothering my stuff and wanting to use or wear something of mine. I'd see her with it on at school and I'd have to get her. But life was all right. Later, when we were teenagers, my mother had two more children, a boy and a girl.

Mary was always—and I'm not just saying this—a nice little girl. Always outgoing, happy, and singing. I was always saying something "smart" or doing something to people. It used to upset me when people would say that Mary was more pleasant

5

than I was, but it was the truth. It was her nature to be nice, and I was always making sure nobody did anything to her because she was just a nice girl. [Laugh.] I could beat my sister up but nobody else could.

Music has always been in our lives. We sang in the church choir, and our father is a musician. He played the bass and had a band. He sang and he would get us to sing background for him. I just wanted to go outside and play, but Mary was like "La-la-la-la." She always liked singing, but back then she never said "I'm going to be a singer when I grow up." Success really came to her as a gift. Our step-father gave a tape of her singing to someone he knew in the record industry. Before we knew it, Andre Harrell (then head of Uptown Entertainment) and some other guys came over and met with our mother, Mary, and me. It really happened like that.

It was crazy when we heard her first single, "You Remind Me," on the radio because nothing had really changed at first. We lived in the projects still. I said "Mary, they're playing your song on the radio," and she said, "I know." I'd be walking around the neighborhood and my friends would say, "I heard your sister on the radio! She sounds good!" It was nice to have people come up to me and say that about her, but we couldn't really believe it. It wasn't until she won an American Music Award that it dawned on me that things were really happening and I thought, She's going places.

SHARE MY WORLD

In the beginning, it seemed like everything happened so fast for her. I didn't understand it and I guess she really didn't, either. In this business there are a lot of people who come around you for all sorts of reasons—money, pretending to be your friend. Everybody's just grabbing and picking at you, and you think they're looking out for you but everybody's not. That part made me a little sad because I could see how scary all of this could be for her. I wanted to help in some way and be involved. Then one day Mary said, "I need you to work with me. Anybody I take to be my manager, I need you to co-manage with them or just be there watching them." Initially I kept my nine-to-five and worked with Mary part-time. But my husband suggested I quit my job and work solely for Mary, which made sense. I stood to make more money and my sister was my boss. It was fun. It was like, I'm feeling this—going here, going there, singing background vocals for her sometimes on tour and co-writing some of her songs.

Later Mary bought a house that she felt was too big for her to live in alone, so she asked me to move in with her. At first I was reluctant because I had a family—my husband and two sons—and I liked where we lived. But she wanted us all there. "All I need is one room," she said. I figured we are her family and when we're all together she feels good. My husband and I were going to buy a house, but now we don't have to. And she even moved someplace where the schools are excellent. So it actually worked out well for everybody.

THE TOUR

Going out on the road is real hard, but we make each other laugh and I think that's how we survive. I always liked helping her get dressed backstage during the quick changes for the different scenes of a show. It would be hectic. She's yelling, "Take this. Oh hurry up! Zip it up now! Zip it up now!" One time I zipped her the wrong way when she still had the mic in her hand and she went "Ooow!" into the mic [cracks up laughing].

Working with Mary has taught me patience, and thank God for that. If I lost my mind over every little thing, she would go crazy. Once an aunt who was real dear to us passed away when we were on tour. That was hard because we had to go to the funeral on our days off and then come right back to work. We were both sad, but I tried to keep her spirits up because she still had to go out there on stage every night. I miss my husband and boys real bad sometimes, to the point where I used to just start crying. I wouldn't want her to see me cry because I didn't want her to think that I didn't want to help her. Besides, she's helping me, too. When she's feeling bad about something I'll say, "Mary, don't worry about it. It's going to be alright, we'll fix it up."

Sometimes she'll get mad at me for pressing her to do something she may not want to. Or she'll upset me when she gets impatient with people. We go through our stuff, but we still help and do what we have to do for each other. We communicate real good. If something gets Mary upset she'll let you know right then and there. I don't always do that, then I'm stuck thinking about it later. But if you say what you need to in the moment then it's over. You handled it already, and I like that she's upfront.

We've been to Europe thousands of times and it's great but it's always a strain. First of all, you're tired from the plane ride and when you get there everything is different. Everybody's smoking cigarettes and you don't see that many Black

people over there. Mary might have ten interviews a day with reporters. We did MTV in Milan and there were tons of people outside. All we could make out that they were saying was "Mary J. Blige!" It's amazing that even if they don't speak the language, they understand her music and like it. And that's nice for any artist, not just my sister. But Europe is work and going there really helps us to appreciate home.

One of our favorite things to do together is to go to the spa for massages and get our nails and feet done. But usually when we're home, we're so glad to be there that we just stay in and watch old movies, laugh, and talk about people [laugh]. Or we might have a fish fry where I'll make my special hot wings that she likes, and we'll invite friends over—BYOB—and play cards. We go to different parties and events around New York, too.

MY LIFE

I've watched Mary progress to the point of knowing how to handle herself and other people. A lot of her early frustration with the press was because she felt the things she said were taken out of context. She figured why do interviews if they were just going to print what they wanted to, anyway. I've even seen things in magazines that I knew for a fact were lies and they would hurt me, too, but I know this business can be a monster like that. I told her that blowing them off just gave them more to talk about, and she needed to be bigger than that and handle it another way. Now she knows how to talk to them.

I commend anybody who's been through hardship and can talk about it, especially to young people. It doesn't have to be anybody's business if you don't want it to be, but it's nothing to be embarrassed about. I never saw Mary do drugs, but I knew something was wrong. I used to tell her, "Whatever is bothering you, that stuff is not going to help." She'd say, "You just don't understand, LaTonya, because it's not you," and I had to agree with her on that. I could give advice and come up with good things to say, but I didn't know how she really felt. In this business, you can feel alone even when you have someone who loves you around all the time. Doing drugs I guess was one of the ways she tried to distance herself from some of the negative things that were going on. But that experience just made our relationship stronger 'cause I was on her back . . . like a *hound* [laugh]. Finally she realized I was right.

I've always been proud of Mary, but I'm extra-proud of how she's grown

over the past three years. Nobody else can understand that like me. I've seen the ultimate progress. I admire her energy and strength because in this business you need a *lot* of energy and strength. We have a good relationship and she's changed my life a lot and I'm happy.

as told by LaTonya Blige-DaCosta

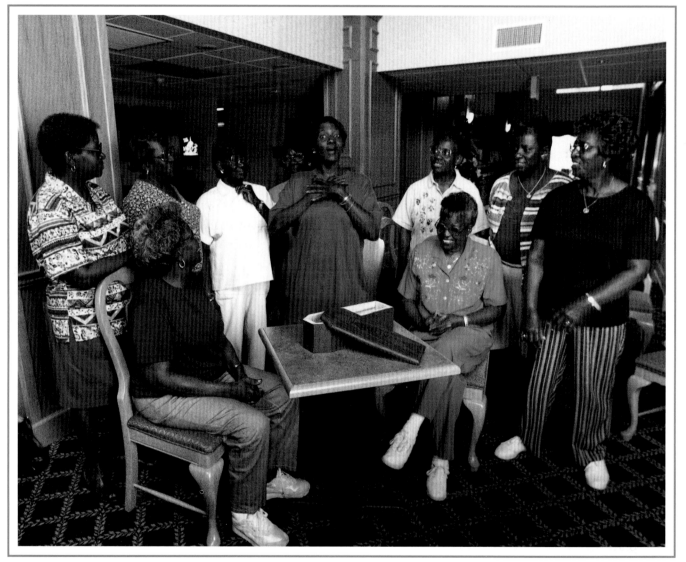

The Spruell Sisters: Gertrude, Mary, Vina, Rubye, Dorothy, Joyce, Hazel, Jean, Hattie, and Magdalene

A SISTERS' RETREAT

A S THE YOUNGEST MEMBER OF A FAMILY of thirteen, Jean Spruell-Boyd found it hard enough to get a word in edgewise, let alone be looked to as the executor of family activities. Considering that several of her sisters are old enough to be her mother, it's easy to see how no amount of self-assertion kept her from being viewed as the baby of the bunch, even now at age forty-seven. "When I was growing up, I did not like my brothers and sisters because they came home and tried to boss me," she admits, now humored by the thought. But she showed them all what she was capable of doing in the spring of 1999 when she singlehandedly brought her nine older sisters together for the first-ever Spruell Sisters Retreat.

The idea for such an event came to Jean while she was attending a weekend retreat for work. There, amid various meetings and seminars focusing on enhanced worker relations and job productivity, a thought easily occurred to her: "If I can come down here and bond like this with these people, why can't I go somewhere and do the same with my sisters?" From there the idea for a sisters' retreat took root, but it would be a while before it came to full fruition. Due to added responsibilities at work as well as preparations for her own upcoming nuptials, she had to put her plan on the back burner where it continued to percolate. Just as soon as things settled down for her, however, she made the retreat her mission.

First, in typical little-sister fashion, she ran the idea by big sister Vina, the second eldest, imploring her to keep it a secret. As Vina recalls, "I thought it was an excellent idea. I was so elated when she told me about it, I said 'You do the planning and I'll do the praying.' " Then, with a vote of confidence from Vina, Jean sent out

surveys to the rest of her sisters to gauge their interest. Two of them responded the very same day they got their surveys, and the others poured in soon afterward. The answer was a resounding yes, but to Jean's surprise they wanted to do it as soon as possible rather than wait until the fall as she had originally suggested. "I think Vina wanted to go that next weekend," says Jean, chuckling about her sister's enthusiasm.

So on May 21, 1999, Gertrude Taylor and Dorothy Moore of Virginia; Lue Vina Cody, Hattie Spruell, Magdalene Jackson, Mary Spruell, and Joyce Collier, of Maryland; Rubye Spruell and Jean Spruell-Boyd, of North Carolina; and Hazel Williams of Washington, D.C., descended on the Hampton Inn and Suites in historic Williamsburg, Virginia, intent on making a little history of their own.

Now the Spruells, including their three brothers, have always been a close-knit family. It's a quality, the sisters say, that their parents, Amos and Arrena, instilled in them from day one. As children growing up on the family farm in Oak City, North Carolina, they learned that cooperation and participation was imperative and to keep discord to a minimum. "My dad used to say when one is up, all of you are up. When one is down, all of you are down," remembers Joyce. "Whatever you do, don't forget each other and stick together." And they do, gathering for their biannual family reunion as well as holidays. It's nothing for one to spend vacation time with another, and they all talk to one another by telephone at least once a week. You couldn't imagine a closer clan. For this retreat, Jean's challenge was to come up with something that would be a departure from what they were all accustomed to. It had to be special and, above all, meaningful. Jean, whom all her sisters credit with being very creative, managed to pull it all off without a hitch.

"When they got there, they had no idea what to expect," Jean recalls. "I think they thought we were going to sit around all weekend and laugh and talk and gossip." What they got was a carefully devised itinerary full of fun and uplifting activities that they would not soon forget. Prior to the retreat, Jean had each sister send her their three favorite recipes, anecdotes about the funniest and scariest thing that ever happened to them, and words of sisterly wisdom, which she compiled into little booklets distributed when they arrived. After a casual greeting session, she took the floor and stated the purpose of the retreat. In her opinion, they already had a lot going for themselves. "Where in the world can you find ten blood sisters, with the same mamma and same daddy, still living, still communicating?" she asked. This weekend would just be the icing on the cake. Next, they all gave their reflections on the true meaning of sisterhood, then assembled for a rousing "funeral service" for

"Sister Negativity," an opportunity to bury any differences between them once and for all. It was a ceremony peppered with emotional testimonials as each sister first acknowledged a personal "demon" that she felt threatened true sisterly relations, wrote it down on a slip of paper, and one by one deposited it in a miniature wooden coffin made expressly for the occasion by a friend of Jean's.

Other highlights from that weekend included a loving salute to Ma and Pa Spruell, a tour of Colonial Williamsburg, a craft hour, and a delicious turkey dinner with all the trimmings prepared by Jean and Rubye. But the real hoot came after dinner when each sister got her moment in the spotlight during a videotaped family talent show. Mary and Hazel sang the humorous spiritual "Rusty Old Cross" in duet. Hattie shared the wisdom of her parents, calling their wise words "a road map that I was able to follow" through life. Dot recited a poem entitled "Monkey Stole a Pumpkin," and Jean, in a minidress and wig, did a hilarious Tina Turner imitation that left her elder sisters doubled over with laughter.

On the second night, the Spruell sisters sat in a circle in their hotel suite and reminisced on what it was like growing up as "Amos's Girls," as they were affectionately called in their small community. The elder sisters recalled a household that may have been short on space (having one's own bed was not an option) but filled with so much love that it didn't matter. Said Hattie, "The house was crowded, but we did not know it because [there was so] much love and closeness." Rubye agreed, adding, "We always had plenty to eat, regardless of what it was, and we never sat down without asking God for his rich blessing. We were raised in a Christian home."

Some remembered when the family didn't have a car, which meant walking miles to school and church regardless of the weather. And living in the segregated South made the experience unpleasant at times. Recalled Hattie, "Them white children were on the bus and we'd have to get over in the bushes when they came past 'cause they would put the window down and try to spit on us." Relieved once their father finally purchased the family's first car, a 1937 Ford, the girls soon found that they were still subjected to crowded conditions because he was notorious for picking up anyone heading their way. "We were always the first ones to get to church and the last ones to leave because he would take us to church and go back and get anyone else who wanted to go. After service he would take them home, and then come back and get us," said Hazel. "By the time we got there we would have to smooth out the wrinkles on our clothes, but we still went," said Rubye, chuckling with her sisters at the thought of it.

According to Jean, however, she "grew up in luxury" compared to what her sisters had to endure. "Joyce and I shared a bedroom, and I didn't have to walk to school. I just walked right out the front door and got on the bus, so things had changed." Eventually the Spruells' address changed, too, and Jean got something her elder sisters never had while living at home: a room of her own. While on the subject of rooms, Mary, who had been quiet during most of their trek down memory lane, quietly voiced a confession. "Jean, I gotta tell you this, you never knew this. I came home one time and your room was so stirred up. . . . It was terrible, as if a hurricane had hit it. I took pictures of it." At this point, the sisters burst out laughing and Jean, reverting to baby-sister mode, sat pouting. "I'll send you the pictures next week," Mary teased. "I'm gonna' take you to jail for doin' that!" Jean rebutted in mock indignation.

Vina spoke on the constant dialogue between parents and children that went on in their home and admitted that when she was younger she didn't always appreciate it. "They talked to us an awful lot. I got tired of my daddy having conferences with us—he would repeat the same things over and over." But one lecture in particular had a significant impact on her. "My father used to say to us 'Hold your head up high. Just because we're poor doesn't mean that you have to look down at the ground. You are still somebody.' He was instilling high self-esteem in us. He did not know anything about the word 'self-esteem,' nor did we, but today we know what it is because we are ten proud Black women."

Eldest sister Gertrude, who came of age during the Depression, clearly remembers the sacrifices her parents made to make the girls feel special despite hard times. "We always had a new dress for children's day and homecoming [at church] and Easter." Back then she never understood why their mother never bought a new dress for herself for such occasions, settling instead for something she already had. It wasn't until she became a mother herself, she said, that she fully understood her mother's actions. "Those things in life that your parents teach someday will come back to you." Their conversations lingered long into the night, and they watched the videotape of their talent show and laughed just as hard all over again.

By the final day, the Spruell sisters were basking in the joy of renewed sisterhood. Everyone agreed that the retreat had been a success and some were already making plans for the next one. Joyce was especially moved by it all. "There's been a change, a growth," she announced. "We got rid of all of the negatives so when we leave here all of those things are behind us. Things will never, *never* be the same among *these* sisters. We're gonna leave here closer, stronger, and more determined."

Nodding enthusiastically, her sisters agreed with a unified "Yes!" Vina put the entire weekend in perspective best when she said, "[We are a part of] one big circle but one day the circle will be broken. God has given us a chance to come together and to enjoy ourselves and do some of the things that sisters are supposed to do while they have a chance." Jean just looked lovingly into the smiling faces of her sisters as they bid their farewells and thought to herself, "Mission accomplished!"

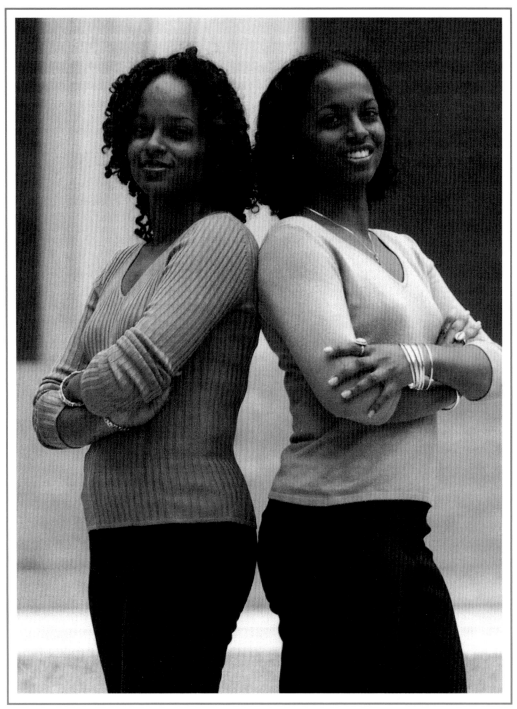

The Williams Sisters: Lorelei and Andrea

WORLD CITIZENS

I THINK IN A LOT OF WAYS WE KEEP each other sane," says Lorelei Williams of the relationship she shares with her twin sister, Andrea. "Growing up, we were constantly switching between worlds, but remaining the frame of reference for each other, no matter where we were. It helped us to at least make our lives seem normal."

Their primary world was a drug-ridden section of Harlem, where homelife was dysfunctional and very unstable. "Actually, we didn't start off poor," remembers Lorelei. "We used to have money. We had a big apartment, and our father used to drive a Cadillac or a Lincoln Town Car."

"But then he started messing up," she says, referring to their father's disastrous bout with drugs. So they moved around a lot from one low-rent apartment dwelling to another, for most of their lives. At one time, "It was the four of us and all our stuff in a one-room studio," says Lorelei. "The crazy thing about it was our parents had an abusive relationship, and we'd be in the middle of that when they fought because there was no place for us to go."

"Off and on our mom would kick our father out of the house, and then he'd come back and they'd be together," says Andrea. "When she started supporting us solely it was harder because she didn't really have that much work experience. Sometimes we didn't have electricity."

"We'd have candles," says Lorelei.

"And pork and beans was a staple," adds Andrea with an ironic laugh.

As if that wasn't enough, they were later joined by a younger nephew and then a niece, whose parents could not care for them. "I just remember being eleven and waking up at three in the morning to change my nephew's diapers and feeding him until he went back to sleep," says Andrea.

In stark contrast to the chaos at home, every day the sisters would board the city bus and head to the Upper East Side to attend two of New York's toniest schools. As participants in Prep for Prep, an educational program for gifted children, Lorelei was enrolled at Sacred Heart and Andrea, the Spence School.

"It was an interesting dynamic," explains Andrea. "My school was upper crust with the kind of people who would ride up in their limos in the morning, and I'm coming from our drama-filled Harlem studio. I wouldn't compare myself with these white people. I did sometimes, but in terms of how I felt when I was younger, being self-conscious and feeling like I didn't fit in, I compared myself more to Lori. She seemed so confident."

"I think you thought about things more than I did," says Lorelei. "You'd be having these deep thoughts and I don't think I worried about stuff as much. Now it's switched somehow. Andrea is more carefree and I overanalyze things. I had two Black girls in my class and she had ten. So it's kinda like she compared herself to them and maybe I just didn't have anybody to compare myself to. I was always like, whatever, and participated in more leadership types of things."

"Optimism has been our biggest blessing," says Andrea. "All logic would say we shouldn't have had it. We'd be remiss if we didn't credit our mom and what she did to shape us. From the time we were little she was teaching us stuff on her own, like how to write and read the newspaper."

Even in the confines of their tight living arrangement, their mother set up a makeshift desk where they could study and do their homework. "Every weekend she would take us to museums, the zoo at Central Park, dog shows, cat shows—just anything she could find to expose and teach us about different things. She taught us that you may not have as much as everyone else, but you're as intelligent as anybody else and education was the key to success."

Their mother's lessons on being well rounded and developing one's mind helped to propel them successfully into larger worlds. After completing high school, the twins went on to Yale, where they both majored in political science and African American studies and served as co-chairs of the university's Black Student Alliance. They are the recipients of several academic honors and distinctions, and have studied in Africa—Lorelei in Capetown, South Africa, and Andrea in Ghana.

Every accomplishment, say the two who are currently analysts at a New York—based consulting firm, are stepping stones to bigger goals. Lorelei plans to attend public policy school and hopes to one day establish a Pan-African leadership institute for high school students. Andrea, who's documentary *From Slavery to Hip-Hop*

was featured at the Black Filmmaker's Foundation's New Artist Series, is focusing on film school and wants to teach film production to young people.

Things could have easily gone the other way for these two, yet they've managed to defy the statistics. "I think we keep each other at a certain standard," says Lorelei. "We're real anal. If Andrea is doing something productive, I'm like, 'I can do that, too.' It forces us to get ourselves together so that we're on the same level all the time. We keep each other up to par."

In one memory that typifies their relationship, Lorelei recalls a period during her undergraduate years at Yale. "I was really into the poet Lucille Clifton and fiending for this book of hers that I'd discovered called *The Book of Light,* but being the po', broke student that I was, I didn't have the money for it."

She didn't think about the book again until she arrived in Capetown for a work study program. "When I opened my suitcase the book was there." And inside was the inscription with the little nickname they use for each other: "WITH LOVE THAT CROSSES THE SEAS, MAKIDADA."

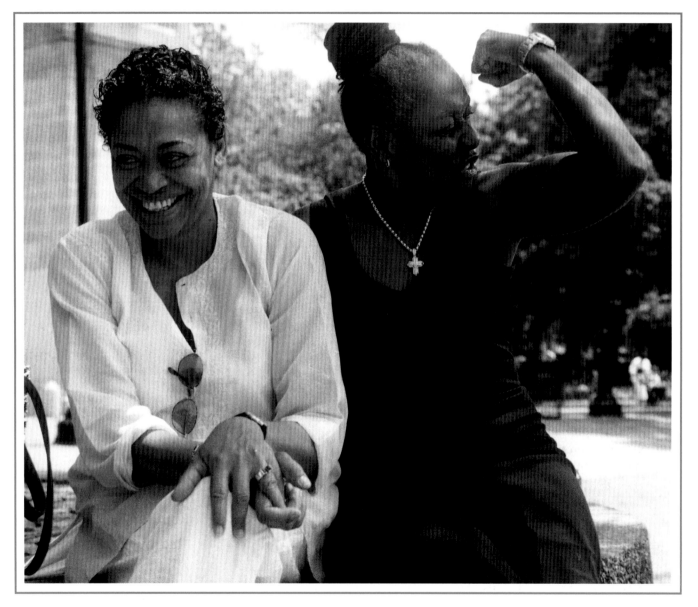

Sisterfriends: Marta Vargas and Bethann Hardison

COLLECTED CALLS

IT'S EASY TO UNDERSTAND WHY Bethann Hardison and Marta Vargas call each other sisters. The two have been tight for more than thirty years and there is a lot they have in common. For starters, both are New Yorkers: Bethann is from Bedford-Stuyvesant in Brooklyn and Marta grew up in Spanish Harlem after leaving Puerto Rico with her mother at the age of six. They are fashion industry veterans: Marta, now a consultant, spent years sourcing and producing garments for clothing manufacturers like Harve Benard and Issey Miyake. Bethann, who has worked with celebrated designers like Stephen Burrows and Willi Smith, also made history as one of the legendary Black models to turn Paris on its ear in the early 1970s before establishing her eponymous modeling-agency-cum-talent-management company.

In addition, both women have sons, one each, whom they madly adore: Bethann is the mother of actor Kadeem Hardison, and Marta is a self-confessed "hockey mom" to teenaged Tyler Metcalfe. They have many of the same friends and acquaintances, and through their relationship their mothers became best friends. Finally, they share a peculiar parallelism: According to Marta, "I look like Bethann's father and she looks like my father." Perhaps that accounts for some of their attraction.

With all that they share, it's not hard to imagine the two catching a Broadway show, chatting over dinner at a posh New York City restaurant, attending some fabulous fashion fete, or simply dropping in on each other at home. Yet, these "sisters" say that there is little that they actually do as a pair. "That's the interesting thing about us," says Bethann. "We're very close, I mean we're like true family in the sense of communication, having a lot in common, but we're not into doing hardly anything together." Instead, they choose to "reach out and touch"—incessantly. "Our relationship is very much a telephone relationship," says Marta. "We don't spend a lot of physical time together, we spend a lot of phone time together," which

translates to almost daily phone conversations that can last for hours. And they've found that one doesn't always have to be present for the other's conversation to transpire. "Bethann is great for leaving long messages," says Marta, adding, "and when the voicemail cuts off, she'll call back and continue her conversation."

Over the years, no amount of distance has been too great to keep them from phoning. When Marta's work took her to destinations throughout the world, she wouldn't think twice about calling Bethann, usually to tell her that she'd met someone she knew, almost always to her sister's bafflement. "I would call Bethann from Hong Kong or wherever I was and say, 'Oh I met a friend of yours,' tell her their name, and she would say 'Who?'" They have a running joke that if Bethann ever writes her book, Marta will have to help her fill in names. "She doesn't remember diddly squat," laughs Marta.

For both women, who follow world affairs the way some people follow sports, issues in the news make for fervent phone discussions and debates. "We're always thirsty for knowledge," explains Bethann. "For information of the world, how it's shaped, how it's happening, economically, ideologically, socially, politically." Or, as Marta clarifies, "We get crazy." It was she who passed on her sister-in-law's prenuptial brunch in Oregon in order to watch the Clarence Thomas hearings with Bethann who was in New York. "I told my husband 'I'm not going, I'm gonna watch this.' And I called Bethann, and she and I, bicoastally, were carrying on, going, 'Can you believe this?' back and forth, back and forth."

At times their telephone relationship has been a great source of immediate comfort, like the night Marta's mother died and she and Bethann spent twelve hours on the phone crying, laughing, and reminiscing. But mostly, talking on the telephone is simply their preferred way of touching base. Says Bethann, "We update each other on things personally and professionally. If something is happening or if there's a decision I have to make, I ask her what she thinks because quite often she has a good sense of reason."

Still, considering their mutual ties, it's curious that these sisters choose to cross wires more than paths. But they don't see it that way. As Bethann explains, "I'm one story and she's another. We've always been such individuals, and we weren't dependent on each other socially. I always knew what was happening in her life and she always knew what was happening in mine. We complement each other, but we don't need each other to walk up the road, so to speak." Marta agrees, adding that she gives Bethann, the more high-profile of the two, the space to be herself. "We talk, we laugh, we joke and carry on and whatever, and we feel that we don't have to see each other to have that." Granted, technology has provided us all

with a sense of being there. And certainly for every example of biological sisters who are seemingly joined at the hip, there are those who barely speak. But what makes two unrelated women, who barely see each other despite their ties, claim unequivocal sisterhood? That depends on who you ask. Bethann, who is typically rather transcendental, offers a surprisingly fundamental answer: "Our ethics are the same, I think, in so many ways, and that allows us to have that connection." In contrast Marta, the realist, views it more, well, transcendentally. Her take: "Ours is a spiritual, soulful, mental connection." In which case the telephone is merely a tool.

Their initial connection was made during the 1960s amid the stimulating, bohemian backdrop of New York's Greenwich Village, a place both young women liked to frequent. Marta recalls their first encounter like it was yesterday. "I was working in a boutique, and she came in and introduced herself. There was such a dynamic. I found her so attractive, positive, and energized."

Bethann, on the other hand, is a bit sketchy on the details. "You know, I get a little mixed up. Sometimes I think was *this* the first time or was *that* the first time?" What she does remember is the impression Marta made on her. "Well, there were two things. Physically she was very thin," she laughs, "but mostly she was eager and she was very bright, and still is. I think people don't really change, they only become more of who they are."

The two became fast friends, but it wasn't until later that the sister reference came into play, and it was actually initiated by Kadeem. Again, Marta remembers it vividly. During the height of Bethann's modeling career, she traveled a lot and would sometimes leave her son in Marta's care. On one such occasion, Marta took Kadeem, then four, to a neighborhood child's birthday party. There, a girl in attendance kept calling for her mother. Seeing this, Kadeem immediately wanted to call Marta mommy.

"I said 'Well you can't call *me* mommy because *Bethann* is your mommy.'" Then to appease him she made a suggestion. "I said 'I'm like your aunt, so you can call me Aunt Marti,' and that's where it clicked."

Bethann and Marta say there may come a time down the road when they feel the need to come together more than they do. But for now, they're content with phoning in.

Not long ago, however, they managed to put their phones down long enough to do something they'd always dreamed of: vacationing in Cuba together. There they took in the sights, combed the beach, and met lots of interesting people. Both say it was an experience nothing short of incredible. Best of all, says Marta, "We had no phone and no fax machine. We just had each other."

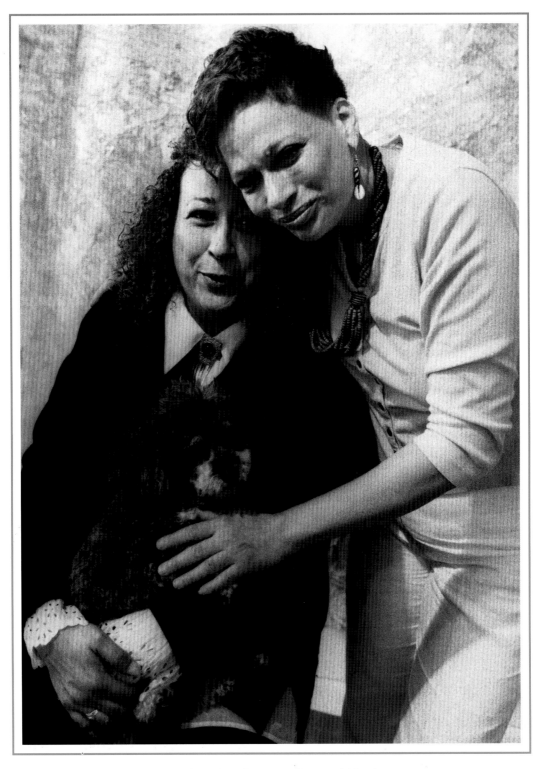

The Sandler Sisters: Eve and Kathe

ACCORDING TO SANDLER FAMILY LORE, when younger sister Kathe was born, older sister Eve was not particularly thrilled. "When she came home I went and looked at her, and I went over to my mom and said, 'The baby is very nice, but when is she going home?' " Eve recounts with a deep-bellied laugh. "I don't know if this is really *my* memory or I *think* I remember because so many people told me."

But, she says, "most of my memories are of really being physically joined, like being toddlers and taking her hand and sort of dragging her along everywhere. The two of us were constantly holding hands."

In many ways they are still hand-in-hand, supporting each other creatively while making their art. Eve, a multimedia artist who focuses on Black female identity, culture, loss, memory, and the sacred, has exhibited her works in museums such as the Smithsonian Institution in Washington, D.C., and the Studio Museum in Harlem. Kathe is an award-winning filmmaker with various documentaries to her credit, including *A Question of Color,* an exploration of color consciousness and internalized racism in the African American community, which aired on PBS. Though their crafts differ, they can definitely relate to the challenges the other faces in seeing the work come to fruition.

"We have different truths and different ways of representing those experiences," says Eve, "but I find that we are actually dealing and struggling with a lot of the same issues as artists. On a creative level, there is this sort of inner work you have to do to get to your work, to be in your voice and to be your true expressive self," she explains. "That can be a difficult thing to do. Then there is the work you

do to support it, the hustle and the financial uncertainty." But in those moments one becomes a cheerleader for the other.

"I very often go through funk phases in my creative process and I'm doubting myself, and Eve will always help me clear the brush and point me on this path," says Kathe. "I find I can really go to her for clarity, forward thinking, and moving ahead. I can count on her in a way that I can count on very few people in this life."

"I get a lot from Kathe on the collaborative tip," says Eve. "She gave me opportunities to work on her films, and I think that was a really great blessing for me as an artist because it helped me really get in touch with my own narrative voice, which was something that was really emerging in my work. It gave me new tools which I've been exploring in my installations, using video, and opened up a whole world of things that I can use in my work."

And sometimes it is just as much about the paperwork that goes into making a project happen, as their late-night proposal writing sessions prove. Once Kathe convinced Eve that she could make the deadline for a very prestigious grant that seemed totally out of the realm of possibility. "I really wasn't going to go for it and it really was an irrational thing to go for." But Kathe backed her encouraging words with action and assisted Eve with everything, from getting copies made at Kinko's to hand delivering the grant proposal herself. "She was so sure that I merited it. She wouldn't have me busting my butt or bust her butt like that if she thought it was, like, why bother? I just thought that was really great. She saved the day."

Eve and Kathe are native New Yorkers, born and raised in Harlem, where life for them was anything but typical. "We grew up in such a different kind of family," says Eve, starting with the uncommon union of their parents in the 1950s: a Jewish, Brooklyn-born father who is a painter and a Black Harlem-born mother whom the sisters consider an immensely creative soul with a real appreciation for all types of art. She designed children's clothing when they were young and later became a pioneering arts administrator.

"Our parents were really activists. They were very independent thinkers, very political, very outrageous," says Eve. As a result, "we grew up surrounded by probably some of the most brilliant Black artists, intellectuals, and thinkers of our time." Novelists Rosa Guy and Louise Meriwether are their godmothers. Lorraine Hansberry, James Baldwin, Maya Angelou, and artist Faith Ringgold are counted as family friends. And when their mother threw a party, everyone came through, from Black theater types to African ambassadors.

"We come from this interracial background, and we grew up at a time when

the whole apartheid system was being challenged in America," remembers Kathe. "In our house we were exposed to left-wing politics, Pan-Africanism, and cultural activism."

Eve still has an old newspaper picture of the two of them as kids on a demonstration line. "The caption says, 'Negro and white youth march together.'" Both sisters crack up at the mistaken assumption that Kathe is white. "Those experiences are unique," says Eve, "and forge a very deep sense of sisterliness."

"There was this tremendous richness of spirited creativity," she continues, "but on the other hand, it was very puritanical and there weren't a lot of material things. We weren't encouraged to play like children. As a matter of fact, that was very boring to my father."

"We didn't have a lot of the toys that other kids had," says Kathe, who jokes that instead of getting Mr. Potato Head they got a potato and were told to make something out of it. "Our father would give you food coloring and sour cream to play with. He'd do strange things like that," she continues, adding with a laugh, "he would sue us if we said bad things about him."

"Yeah," Eve confirms, "he will sue us. You think I'm kidding?" Both crack up at the thought.

Eve and Kathe have always been sources of inspiration for each other. Kathe calls Eve a "prodigy" whose "phenomenal" talent served as a model for her growing up. "There is a certain kind of creative focus that Evey has, and she goes into that space a lot as an artist. As a filmmaker I would like to be in that space more often."

"I've come to really respect Kathe as an artist, as a really brilliant woman who is extremely thoughtful and really has a pioneering vision about a lot of things, and who struggles to look at things that can be really difficult. She has a lot of personal integrity," Eve says thoughtfully, then quips, "And she can *stay* on a diet."

"But what I really get a kick out of is when people see Kathe and me, they see us as 'those Sandler women,' like it's an army!" says Eve.

"Our little bloc," adds Kathy, smiling.

"It's like we take up space, and I love that!" says Eve.

The Hopkins Sisters: Shirley and Lynn

A TIME TO HEAL

ASK SHIRLEY AND LYNN HOPKINS what they get out of their relationship, and the answers are, well, unexpected. "Clothes," chuckles Shirley, the elder of the two. "I give her clothes that are too small for me."

"And I give Shirley my MAC makeup," Lynn shoots back with a laugh.

But seriously, folks . . .

"I enjoy having a sister," says Shirley. "My brother and I are close, we shared a lot of things growing up, but I couldn't tell him the things that I tell Lynn. He either wouldn't understand or would behave differently since he's a guy."

"I agree," says Lynn. "I think there are certain things you can say or do, certain ways you can be with your sister that are different from how you might be with somebody else. I think that's important—to have someone who is a good girlfriend *and* family."

"Only a sister can relate to how you feel about some things," Shirley continues. "She may not have necessarily experienced what you have gone through, but she knows where you're coming from. She's around when stuff comes down."

And Shirley is a witness. Several years ago she experienced a terrible car accident, the effects of which still linger. And through it all, Lynn has been one of her biggest supporters.

Shirley, who lived in Virginia with her husband, was on her way to work when a car struck hers on the driver's side. "My head kind of swayed to the right and then back to the left and hit the window." She suffered brain injury and was in a coma.

"Seeing my sister in that condition was probably the most trying thing for me," says Lynn, who still gets choked with emotion when she thinks about it. "It was

29

hard," she continues. "Her head was swollen and her hair was matted. Our mom wanted me to comb her hair, and I couldn't do it because I was just so scared. The nurses ended up braiding her hair back."

"Oh my gosh!" says Shirley to Lynn in surprise. "I've never heard all this!"

"When Shirley was first in the accident, I stayed down there for a week," says Lynn, who at the time lived with their parents four hours away in northern Virginia. "After that it was every weekend."

While Shirley remained in a coma, Lynn and their parents did everything they could to keep her comfortable and speed up her recovery. "My parents bought her a Walkman so she would have constant stimulation, and tennis shoes so that the soles of her feet would have support," says Lynn. And, she adds, "I was there when Shirley first started to come out of the coma."

"I was in the coma for two weeks and I have no memory of coming out of it," says Shirley. "I don't even know how long it was after I came out of it that I had memory."

To celebrate Shirely's progress, "Our mom and I went to the mall and bought her a dress," recalls Lynn. "You remember the dress?"

"I have the dress," Shirley replies soberly. "I still wear the dress."

"When she was still in the coma but doing better, they moved her from the hospital to a rehabilitation place. There were signs up in her room that said, 'You have a sister, Lynn, and you have a brother, John,' and our ages. She had to be reminded of things like that."

Shirley also had to relearn basic skills. "I was there for physical therapy, speech therapy, and occupational therapy, that type of thing," she says. "I think my first memory was of being in speech therapy class. My speech was definitely slurred."

"Well, I think that was partly due to your brain injury and the tracheotomy as well," Lynn reminds her.

"Yeah," agrees Shirley, "I had difficulty breathing. I had the trach when I was in the coma."

While Shirley spent the entire summer rehabilitating, Lynn and family cheered her every step of the way. "When I was there one time she was kind of doing the peace sign, and we'd say, 'C'mon Shirley, do the peace sign! Do the peace sign!' She wouldn't always do it, but every once in a while she'd kind of put her hand up." And once she was released from the rehabilitation center, "I can remember pushing her around in her wheelchair, and talking to her and reading books to her."

Aside from the accident, Shirley suffered other setbacks. Not long after returning home her marriage ended and she had no job. Faced with starting over, she headed to her parents' home, where Lynn continued to help her adjust. "I didn't have a car so Lynn would take me places. If I had to go somewhere, I had a ride."

"I was her chauffeur," Lynn says proudly.

Shirley still suffered from the injuries she sustained. "The biggest problem for me was my short-term memory."

"I think she's a lot more short-tempered now than she was before," says Lynn of the frustration that Shirley feels when her memory lapses.

Balance and coordination were also an issue. "Remember the time you took me to a basketball game?" she asks Lynn.

"Oh Lord yeah," replies Lynn.

"I couldn't walk up the damn *bleachers,*" Shirley remembers. "I was like a little kid trying to climb a high flight of stairs. Lynn had to grab hold of my hand."

Even now, says Shirley, "I don't know if I can say I'm fully recovered. Could I be better? I think I could, I feel like I'm stronger than I was this day a month ago. It's a gradual process."

But Lynn is there to keep her spirits up and to remind her of just how far she has come. "I think we were pretty optimistic throughout all of this," says Lynn. "It was a time we all pulled together. Shirley has had some really hard times in her life, and I admire the way she's come through everything."

The Brown Sisters: Velma Wilson, Thelma Merchant, Edna and Selma Brown

UPON MEETING VELMA, THELMA, AND SELMA, one naturally thinks that their names were part of a lyrical scheme on their parents' behalf. "When people hear our names they say, 'Your father must have been a poet,' " tells third-born Selma. "Ironically he was, but that's not why we were named like this." In fact, their names came more as poetic coincidence than design, as Velma, the eldest, explains. "When my parents came to Chicago they lived with a family who had a daughter named Velma—I was named after her. Thelma was named after our mother's college roommate, and my mother let our grandmother name Selma, after a white lady that she ironed for. So that's how we became Velma, Thelma, and Selma."

So why is their youngest sister Edna and not Zelma? "You know, people always ask me, 'Why don't you have an 'elma' name?' So I have to tell them the *Edna Lucille* story." She is the namesake of a maternal and paternal aunt respectively. "I'm the only one named for anybody in the family," she boasts jokingly. But as Velma points out, her name came with a certain stipulation. "We called her Edna Lucille because if you called her just Edna or just Lucille, the other aunt would get mad."

The Brown sisters are a striking foursome who possess a flavorful blend of Southern charm and Northern sophistication. Originally from their mother's hometown of Oxford, Mississippi, they grew up in a supportive Black middle-class enclave, somewhat shielded from the harsher realities of racism and the Great Depression. "We had some experiences that just were unusual for Black people growing up in Mississippi," recalls Thelma. Their parents, Ruby and Joe, were college-educated teachers who were politically active. In addition, "our grandfather, the town

barber, was the only Black man in our town who voted." As children, says Thelma, "we felt like we owned the world."

When the family settled in Chicago in 1948, however, they were met with opposition by a school principal who wanted to keep Thelma, Selma, and their two brothers back a grade simply because they were Black children from the South. At their mother's insistence they were tested, and the sisters still laugh about what resulted. "There was an article in the big white newspaper at that time that said these little Black kids from the cotton fields of Mississippi were unusually bright," Thelma smirks, adding, "and we had been in a cotton field *once.*"

When they are reminiscing about their childhood, it's delightful to see the child reemerge in each of them. Velma, according to her sisters, was the prissy one. "She never got dirty, and she could do no wrong," says Edna.

"I think I was just naturally good," Velma counters. "They call me 'Miss Ann' to this day, but I thought I was just a regular person."

And Thelma, they point out, was the most "radical" of the bunch. One Thanksgiving she coaxed a cousin into "accidentally" breaking their grandmother's good china with her so that they wouldn't have to wash it. "You know how your mother tells you if you tell the truth you won't get a spanking?" asks Selma. "Thelma always told the truth and she always got a spanking."

"I am a true case study of a middle child," offers Thelma in her defense.

Selma, everyone agrees, was the sensitive one. "Selma has always been the one that Mother protected," recalls Thelma. "She was tenderhearted."

"Selma is very special," says Velma. "She's the one who wants everything to be right."

And finally Edna, the sisters say, is the one most likely to make them laugh. Even now, "she will sit next to me in church, not crack a smile, and say something [funny], and I will have tears running down. People think I have the Holy Ghost," says Velma, cracking up at the mere thought of it. "She's still my baby sister because she's still crazy."

Like most siblings, these sisters have had their share of disputes. But they learned a long time ago that grudges hold no merit. "There were disagreements," says Edna, "but if we have disagreements of substance, we usually air them out."

"Whatever we go through we pretty much work it out," adds Selma. "That's kind of hard with six adults, but we've been able to do it. That's why I think we get along as well as we do."

As adults, the Browns have made quite a name for themselves in the Windy City. Be it in education, politics, public service, or business, each has made her

mark in at least one field. And, as Thelma says, "there are very few people in any group you go to in Chicago who will *not* know one of us. And Chicago's a big city."

Velma, who is married with two daughters, was the late mayor Harold Washington's scheduler before becoming the city's director of tourism. Now she owns a conference-planning firm. Thelma, divorced with two sons, has taught students in every grade, from preschool to university, and has been a principal and an assistant school superintendent. The self-proclaimed "child advocate" now serves as an education consultant who also lends her expertise to the Girl Scouts of America.

Selma is a program coordinator with the Community Renewal Society, a 118-year-old organization associated with the United Church of Christ, where she oversees management training for hundreds of community-based organizations a year. And Edna worked in public relations and advertising for a major insurance company before switching gears seven years ago to become an educator.

But more than what these sisters do for a living is how they do it. The four have earned such a reputation for doing things well that oftimes they are sought out by friends and associates to assist with various projects. Case in point: When Judge Arnette Hubbard was running for office, she was adamant about getting the Brown Sisters involved in her campaign. "She said, 'Oh the 'Elma girls are going to help me,' " remembers Selma. " 'Anything they touch is successful.' " That's because sisterhood, they say, is at the root of all that they do.

"It really affects how you relate to other women," says Selma. "I work with a lot of women, and because I've had sisters all my life, it makes it a bit easier for me."

"I have always mentored a younger woman in any job that I've had," says Edna. "I think that comes from having the support from my sisters."

"I can be intolerant of people's behavior," admits Thelma, "but when you have to love some of those behaviors in your sisters, you can handle outsiders."

And as Velma has learned, having sisters can also be a lesson in patience. "Even now they get to talking and I can't get a word in edgewise. I just sit back and listen."

Most important, they have been able to pass on the values that have helped to shape them. "I think that all of us became all that we are now because we had such a strong sense of who we are," says Thelma. This fact became especially apparent to her once during a book discussion that she attended. "They were talking about how we're unable to transfer what we did to the next generation, and I thought, man, how different we are, because I think we've been able to transfer it to our next generation—that whole concept of the struggle of Black people and also the idea that you have to put something back. If we have accomplished nothing else as a family, we have truly accomplished that."

The Brandon Sisters: Barbara and Linda

WHERE WE'RE COMING FROM

Linda Brandon, entertainment lawyer, New York, New York.

Barbara Brandon-Croft, cartoonist of the syndicated comic strip "Where I'm Coming From," married and mother of one, Brooklyn, New York.

HOME BASE
Brooklyn born, Long Island bred.

THE KINSHIP
We're close. We talk on the phone every day, several times a day.

TWO OF A KIND
We share animated gestures, infectious laughter, quick wit, and bouncy, spiraling tendrils.

HOUSEHOLD STAPLE
"Say what you mean and mean what you say" was something our parents instilled in us. Consequently, we're real reliable and we don't lie.

THE WAY WE WERE
Linda was the serious-minded A-student and, according to her, Barbara was the funny one. "She was hilarious—a kooky girl. She had a Pebbles Flintstone doll that she used to make talk in a funny voice. It was like her alter ego. Pebbles was very entertaining."

CHILD'S PLAY

Going to the beach, roller and ice skating, family night at the drive-in, putting on talent shows with friends in the neighborhood.

BARBARA: Linda and her friends were the Supremes, and my friend and I were the audience.

LINDA: Actually, Barbara and her friend had more performances going on than my friends and me, and they would make us *pay* for those performances.

ADULT PLEASURES

Going to movies, having drinks, partying, hanging out, and every year baking Christmas cookies for friends in the old neighborhood.

BARBARA: We're lively girls. We used to do a lot of things together. Now we don't see each other as often—Linda lives in Manhattan and I live in Brooklyn.

OLD-SCHOOL ANTICS

We used to fool people on the telephone by pretending to be each other.

WHAT HAVE YOU DONE FOR ME LATELY?

LINDA: We help each other through day-to-day difficulties. I'll tell her, "I can't believe what this person just said to me on the phone," or "I'm going to write this e-mail. What do you think?" Barbara's like, "If I change Chase's clothes, will I insult my husband?" Any obscure thing. On a scale of difficulty it may not be that great, but cumulatively . . .

BARBARA: Linda and I want to comment on every little thing that happens. I mean who do you tell these stupid stories to? In her I get a great sounding board.

CH-CH-CH-CHANGES

Growing up, Linda was delicate and Barbara was rough and tumble.

BARBARA: I think I embarrassed Linda when I was little. I was running around, dusty, dirty, with hair all over the place, not well kempt at all. She'd say, "Put some lotion on those knees," which of course I did—put lotion *just* on my knees.

LINDA: When her socks fell down, her legs were ashy. I was looking out for her, but these days she will redress me.

BARBARA: When we go shopping, I say, "Oh no, that won't do. You can't get that." I won't even let her try on some things.

LINDA: She's like, "Have you lost your mind?" The roles have reversed in our old age.

YIN-N-YANG

BARBARA: Linda goes. She travels and she's busy. If I had an older sister who was just sedentary when they reached forty-five or whatever, I would probably think that's just what life is supposed to be. But Linda's been active always, so I've decided I'm going to travel like Linda, and I have. You don't have to adhere to what people say you're supposed to do at a certain age.

LINDA: And the corollary is that I admire Barbara's ability to relax. I'm so busy going, planning, and doing that I get tense and my neck hurts. Barbara says, "Well sit down. Take a nap," so I have to learn how to slow down. I'm learning that from her.

MUTUAL ADMIRATION SOCIETY

LINDA: Barbara's good at male-female relationships. She works through problems. I always had a lot of boyfriends. But my M.O. has been *Oops! Nope! Next!* You'd think with all the practice I'd have it better. Whereas Barbara never really had any boyfriends and then she met somebody and she's been able to form a really good open, working relationship. I wish I had that patience. Sometimes I think, "Oh let me pretend to be Barbara in this situation." I like her people skills and her creativity.

BARBARA: Linda doesn't stay mad at people for very long. She doesn't really hold grudges. That's not easy to do, but it's something to aspire to. She's very articulate. I wish I possessed that. I remember once she said to me, "You're not as nice as you think you are," which made me think that maybe I work too hard at being nice. Sometimes I'm doing more for friends and business than I should because I'm trying to be nice. I don't want to be thought of as not nice. Linda has helped me to see that saying no doesn't mean you're mean, you're just saying what you can and cannot do. She's helped me readjust my thinking.

The Terrell Sisters: Bevadine, Michelle, and Mona

GIVING AND SHOPPING

HOW BEST TO DESCRIBE the Terrell Sisters? "If there's a common thread among us, it's that we care a lot about people and their conditions," says Mona, the youngest. "We do what we can to help, within our jobs or on our own, any way we can. Coming up, we didn't have a lot, but we were taught to always help people. And we don't have a fear of anyone exceeding us." In fact, she says jokingly, "Most of the people we know are probably doing *better* than us because of the things we've done for them." But that's mighty hard to believe, because the Terrells are doing quite well themselves.

Bevadine, the eldest, is a junior-high school principal; Michelle is a personnel officer in the State Department Office of Overseas Employment Policy; and Mona, the only mother of the three, is a corporate communications manager for a gazillion-dollar pharmaceutical company.

But, "you would think we were still young kids when we get together," says Michelle. "The fun never ends." They are definitely three of a kind, as they will tell you.

Bevadine "is the designated person in charge, even though our brother is the oldest," says Mona, the baby of the family. "She's the parliamentarian and archivist. She's the one who puts together the memory books that kind of publicize who we are to the members of our family who don't get to see us that often. She's our in-house publicity agent."

Michelle, say Bevadine and Mona, is the one with the beautiful singing voice, the hostess with the most-ess, the meticulous style maven. According to Bevadine, "She's like the diva," whose fashionable ways were apparent early on. At the family breakfast table, says Mona, "a T-shirt and a pair of shorts were fine for me,

but Michelle would have on some kind of leopard-print something with a sun hat, like she was going to plant flowers."

And, adds Bevadine, "she's real quiet sometimes," but when she speaks, "she speaks her mind."

"And if she doesn't speak," says Mona, "sometimes that's worse than when she does. The point is, you get the point."

Mona? "She's all over the place with her hands in everything," declares Michelle. "She's very intelligent and witty, and sometimes has a twisted logic, but always ends up right. There isn't anything she can't do. She's very gutsy."

For example: Once they were at a Stevie Wonder concert with four friends, and Mona told everyone that she would introduce them to the musical wonder himself. "I said, 'Right,' " recalls Bevadine. "She said, 'Just follow me, do what I do.' The seven of us followed Mona and we met Stevie Wonder."

"Got pictures with him and everything!" Mona states proudly. "I still keep in touch with him."

When these three personalities get together, what's the first thing they do?

"Shop!" they say in unison. And shop they do.

"We just jump in the car and head for the mall," says Mona.

"The whole day is a big event," says sister Michelle.

"We eat there," says Mona, "we just don't come back."

Where do they go?

"Any place that has a clearance rack!" exclaims Mona. That means that any store from Washington, D.C., where Bevadine and Michelle live, to their home state of New Jersey, where Mona resides, is fair game.

In fact, one of their favorite bargain haunts valued their patronage so much, "they had a special kind of payment plan for us and our friends," recalls Bevadine. "They'd say, 'Oh you know the Terrells? Credit good!' You wouldn't even have to give a license or a credit card."

These three were born with the shopping gene. "Our mother is the consummate shopper," says Mona. "She can find a sale *anywhere.*" But their true inheritance are the lessons they learned from their parents.

"I like seeing some of the good qualities of our mom and dad in each one of us," says Bevadine. They stressed honesty. "They showed us that you don't have to be slick or conniving to get what you want. Hopefully people will appreciate you and see your light shining by the good things you do."

Says Michelle, "If there was something that we knew in our hearts that we

wanted to do, they would encourage us to go after it and work really hard. They were always very positive."

"I attribute a lot of who we are as people to our parents," says Michelle. "Our mother used to say, 'When you learn to do without, you can appreciate what it is you have.' With us, we didn't have much of anything but each other. And that turned out to be so much more valuable than the material things."

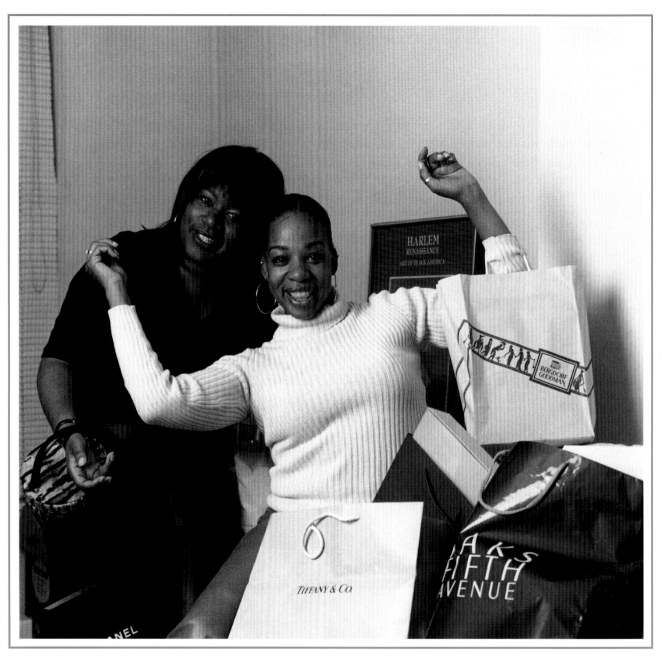

The Raines Sisters: Jenyne and Stephanie

THE RAINES OF QUEENS

Jenyne Raines, freelance writer, Brooklyn, New York ("Crooklyn in the house!").

Stephanie Raines Harris, math instructor—homemaker, Atlanta, Georgia ("Dirty South!").

HOME BASE

Laurelton, Queens, New York.

MY SISTER IN THREE WORDS . . .

Jenyne on Stephanie: assertive, risk-taker, mother.
Stephanie on Jenyne: witty, stylish, dramatic.

I COULD PICK MY SISTER OUT IN A CROWD BECAUSE . . .

"Steph would be the one with four kids hanging from her hips, shoulders, arms, and legs."

"Jenyne would be the one with fifty shopping bags and the maniacal gleam in her eyes."

FAMILY ROLE

Jenyne plays Rodney King: "I'm always moaning 'Can't we all just get along?'"
Stephanie's attitude is more like the Godfather: "Cut 'em off at the knees!"

IF SHE WERE REINCARNATED AS AN ANIMAL . . .

"Stephanie would be a proud lioness fiercely protecting her cubs."

"Jenyne would be anything that sleeps during the day and dwells at night. A bat, perhaps!"

SONGS IN THE KEY OF OUR LIVES

"We Go Together" from the musical *Grease*, "Tougher Than Leather" by Run-D.M.C. (Queens represents!), and "Material Girl" by Madonna, of course.

BIRDS OF A FEATHER

Physically, we both share the famous "Raines nose" and have great gams. In spirit, we both are pretty sensitive and possess sarcastic wit. We're also hypochondriacs and shopaholics (even if it's blatant spending in the face of financial drought). Says Stephanie, "We helped to put Monsieur Vuitton's family through school as well as finance his private Caribbean island."

NIGHT AND DAY

Jenyne is the social girl-about-town with tons of friends and functions to attend. "Steph can't be bothered with all the hoopla. I love English and reading. . . ."

"I'd rather do the math than read," says Stephanie.

Stephanie is active and athletic. "She dances and does gymnastics. I always liked more sedentary pursuits, like drawing," says Jenyne.

FIRST TIME EVER I SAW HER FACE . . .

"Steph was always clutching a pink blanket with her thumb in her mouth."

"She was at a picnic in our aunt's yard, where she was playing with a ball. We have a picture of Jenyne holding the ball."

SHE COULD GET AWAY WITH . . .

"Everything, it seemed. Steph was 'the baby.'"

"Jenyne didn't have to get away with anything—she never got in trouble."

OUR MOST MEMORABLE TIME TOGETHER . . .

"It would have to be purchasing Kymba the dog for our mother as a Christmas gift. We just knew she would love to have a puppy to keep her company because we were all grown up and out of the house and our father was "Joe Social Butterfly." We had the best time picking Kymba out and charging her on Steph's Amex Card. In hindsight, we should have gone our brother's route and bought Mom a nightgown because Kymba went the way of most Christmas gifts. She now lives with Jenyne.

THE GRASS IS ALWAYS GREENER . . .

"I wish I had Steph's confidence and talent for telling people off. I also sometimes wish for the house and the family in a quiet suburb."

"I wish I had Jenyne's sense of style and fashion."

BACK IN THE DAY . . .

"I always viewed Steph as the favorite child. It seemed she could get anything she wanted. She reminded me of 'Veda' in the Joan Crawford classic *Mildred Pierce*, albeit not as dastardly."

"I felt Jenyne and I lacked a true relationship because it seemed she valued her friends more."

HERE AND NOW . . .

"Steph's and my relationship is great! We are much closer, and although we are miles apart we talk more and I tell her everything."

"Jenyne's and my relationship is the strongest it's ever been, and getting stronger."

FAMILY VALUES

Always do the right thing (the Raines Family mantra), and family first.

LEARNED LESSONS

"Steph has taught me the power of love and faith. She always believed that with God and the love and support of family we could do anything."

"Your family will always be there. Consequently, I try to help my children to develop respectful relationships with each other."

LIFE IS BETTER WITH HER BECAUSE . . .

We have an open, honest relationship, and she always has my back.

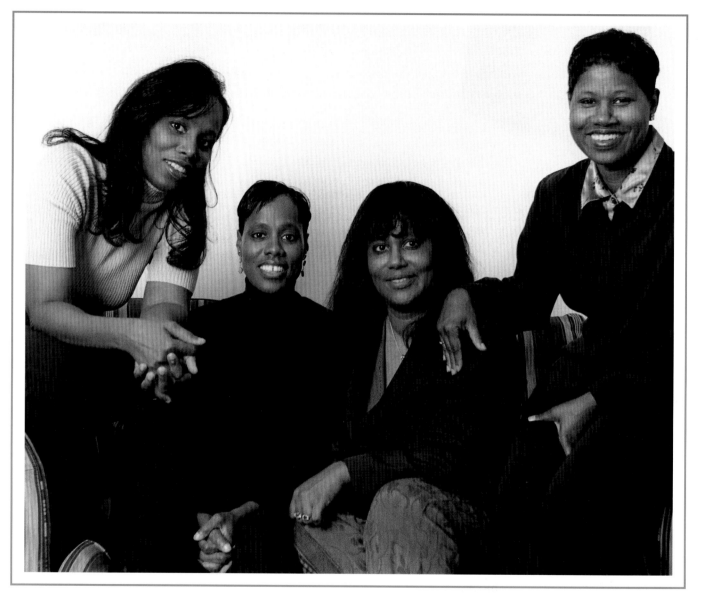

The Ali Sisters: Cheryl, Kamil, Sharon, and Karen

LIFE AFTER DEATH

WHEN KAMIL ALI JACKSON had her first child, a boy she named Ross, it was really cause for excitement. "He wasn't the only child," she explains. Her youngest sister, Cheryl, had a daughter, "and I also had my daughter, Kendall. But he was the first child and little boy in the family in five years." A real charmer and a handful. "From the beginning my sisters were intimately involved with him. They embraced him as their own."

One sunny July day in 1994 began as a hectic one for Kamil. With both children in tow, she took three-year-old Ross, who had been under the weather, to the doctor. Then it was off to the mall for Ross's haircut appointment. Mother and children were then to return home to enjoy lunch together before Kamil left for work that afternoon. Unfortunately, that never happened.

"I don't even know how far we'd driven," says Kamil. "We were on this road beyond the mall, and in seconds our lives were changed. One second we were crossing the highway and the next minute it was *BAM!*" They were in a three-car accident that left Kamil seriously injured, her daughter with a minor concussion, and Ross in a coma.

As soon as Kamil's three sisters got word of the accident, they rushed to the hospital in Pennsylvania—Karen and Cheryl from nearby communities, and Sharon from Chicago. Says eldest sister Sharon, "I was actually at work and got a phone call. I just remember having a feeling of disbelief. None of us had ever been involved in a serious accident. When I arrived I was in shock."

"You know how you see yourself going through the motions but you don't really believe what's going on," recalls Cheryl, the youngest. "To be quite honest, it felt unreal. I didn't realize the extent of it at that time."

Karen remembers the uneasiness she felt when a hospital guard hurried her up the steps instead of waiting on the elevator. "That was not a good sign."

When Karen first saw Kamil in the hospital, "I was very upset and very, very sorry." She also felt helpless. "She kept asking how Ross was, and Sharon and I kept saying he was okay," to keep from upsetting her. "She was kind of angry because she wanted us to say he was awake and well, and walking and talking, and we couldn't say that."

While his condition was not critical, there was brain damage, and the doctors thought that he would heal and at worst need rehabilitation. At this point the sisters sprang into action, doing whatever they could to help. They donated blood, decorated Ross's bed with family snapshots, and read his favorite stories to him. "I stayed at Kamil's house and helped take care of my niece," says Karen. "I was also at the hospital with Kamil when the guy from the National Department of Transportation and Highways came to talk to her. God, it was such a nightmare."

In fact, Karen was in the process of rearranging her work schedule in order to visit her nephew daily when his condition took a turn for the worse. About a week after the accident, Ross was pronounced brain dead.

Says Kamil, "We asked everybody to come in to see him and say good-bye" before she and her husband Michael allowed life support to be discontinued. That would be the last time the Ali sisters would spend with their dear Ross.

In the days to follow, they all pitched in to help with the funeral arrangements—selecting a burial plot, writing the funeral program, notifying relatives and friends, and buying an outfit for Ross to wear. The sisters were so supportive at the funeral. Says Kamil, "The thing I really liked was the speech Karen gave, because of all the nice, wonderful, funny things she said about him. It was so uplifting instead of making everybody sad. I really appreciated that."

"A lot of those people at the funeral didn't even know Ross. They came to support all of us," says Karen. "What I tried to do was give people who didn't know Ross some sense of him."

The loss of a child, especially one so young, leaves parents grieving for the rest of their lives. In the case of the Ali Sisters, the weight of Ross's death also fell on each of the three aunts as though it had been their own child.

"It's a life-altering event," says Karen. "You never get over it. You don't even necessarily get beyond it."

"Ross was a little boy who, for all intents and purposes, had four mothers," Sharon says. "His death is just the kind of thing you don't get over," says Sharon. "I still get very teary-eyed when I think about it."

"Cheryl had internalized it so much that she'd shown signs of extreme depression and had anxiety attacks for a while after," says Kamil.

"I certainly saw how we act in a real crisis and how we deal with a devastating event," says Karen, "and I think some of us have dealt with it better than others."

Still, life goes on. Since then, Karen has given birth to a son, Kamil has had two more daughters, and Cheryl has had another daughter and a son.

"Coping with Ross's death certainly gave us pause," says Sharon. "We cherish and live for today because tomorrow's not promised."

"I'm more affectionate and loving where my children are concerned," says Cheryl. "Every day I say 'I love you.' I'm trying to deal with the present and have no regrets. This is not a dress rehearsal, this is life."

And Kamil's "built-in support group" has helped her to deal with the loss, and she finds solace in the familiar. "Our roles are consistent," says Kamil. "They always remain the same no matter what. Sharon's the big sister—she saw what needed to be done and delegated. Karen is reliable—she was running around like crazy doing everything. Cheryl's the baby—I think she was overwhelmed by it all. But there is some comfort in that continuity, in that sameness. We've had some drastic changes as a result of Ross dying, so it's good when there are some things that never change. Moreover, I thank my mother for this great gift—this legacy of support— my sisters."

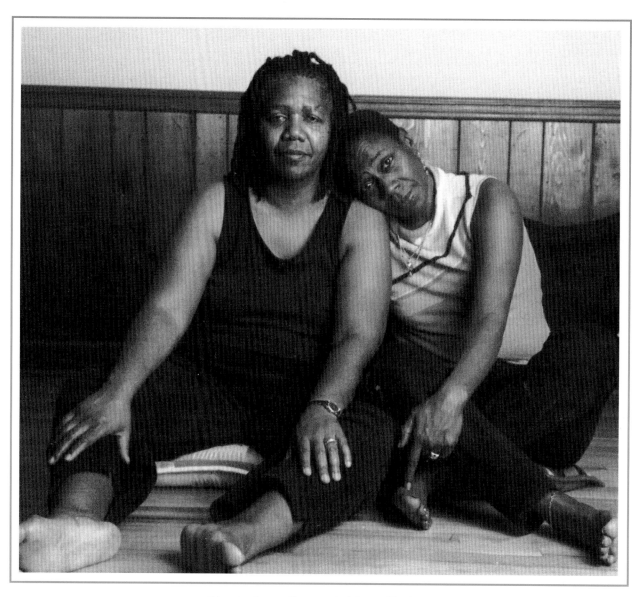

Gloria Jean Cox and Afeni Shakur

A CIVILIZED PAIR

ONE OF MY EARLIEST MEMORIES of my younger sister Afeni was when we were very small children—she was about three and I was probably five—and we were both sitting in our little rocking chairs. The man who lived in the apartment beneath ours was watching us, as my mother was about to scrub the floor. He asked us to be still while my mother was working. I remember this because Afeni wouldn't be still and ended up falling in the bucket of lye water and burning herself. He had to put lard on her skin to keep it from blistering. That early experience is characteristic of our personalities.

I was a serious kid and always did what I was told. Afeni was the baby and always active, which usually meant she got into a lot of trouble. I'd be in the house cleaning up and doing chores, and she'd be outside playing. Sometimes, if she didn't want to do something she was told, she rebelled, and could push buttons in ways that never crossed my mind. Despite the trouble that she'd get into, to me it seemed like she had all the fun.

She wasn't a bad kid per se, she just always had big ideas and dreamed big. In junior high she had a little boyfriend who would want to just come and sit and hold hands, but Afeni wanted to talk about being a brain surgeon. Later, she wanted to be an actress, so she went to the High School of the Performing Arts in New York City. She always wanted to get beyond our circumstances, which were not that great.

Our mother left our father when we were young, so for a couple of years we were raised by our grandmother and great-grandmother in Lumberton, North Carolina, while our mother went off to New York to work. Our grandmother worked as a domestic, and our great-grandmother got a check every month that may have been ninety dollars, if that, but I can't remember ever being hungry as a kid.

We were just poor. But they took good care of us. Mostly I remember Afeni and me crying ourselves to sleep some nights because we missed our mother. You know how it is when kids are separated from their parents.

Actually, we were never really alone. In addition to our grandparents, we had lots of first and second cousins around to play with. Sometimes we got into the typical childish mischief, like stealing pears and plums from the neighbor's tree, which usually resulted in us getting our butts beaten by our grandmother. But for the most part, we had fun. When we were teenagers we joined our mother in New York.

One of the lessons we learned early on was to take care of each other. As the eldest, it was my responsibility to look out for Afeni, give her guidance and protect her. Since she was younger, she was supposed to look up to me and show me respect. Shouting matches were never tolerated and physical fighting was out of the question. My grandmother would reach out and hit Afeni just for calling me Jean, my middle name, and not "Sister," which she thought was more appropriate. It's not that we never had disagreements, we just never acted on it. We were taught to be *civilized*.

Years later, I came to realize that aspects of our relationship had not fully evolved. We were close and supportive of each other through all our lives' trials and tribulations—from my abusive first marriage and raising several children at a very young age, to all of the events leading up to and after Afeni's arrest as a member of the Black Panther Party and her drug addiction and recovery. But when it came to confronting each other on certain issues, the old childhood mandate to be civilized got in the way of our progress as sisters. I'm sure that there were days, months, and even years when Afeni would be disappointed in me, or I in her, but we never really quarreled. Instead, we kind of avoided each other.

When we did speak, we were terse with one another. If one of us called the other the conversation was brief—"Just calling to make sure you're all right." Unless you knew us well, it was hard to detect that there was something wrong, but our children would know because there was just something in the air that wasn't right.

One time in particular we were on the outs for about a month, when Afeni's son Tupac, with whom I was very close, caught wind of it. She told him that we weren't talking and he went nuts. "How can that be?" he asked. And since he was not one to sit on things, he decided to do something about it.

On his last birthday, he flew me out to California, where he and Afeni lived, and sat us down to talk. During this discussion, he pointed out our differences and

how we were alike. I was the person, he said, who nurtured everybody and provided a stable home. Afeni, he explained, was the one who brought the world to everybody—taught us about Black Power and standing up for our rights. What he was doing that day, that we didn't know then, was showing us how much we needed each other.

From that point on, we decided that whatever cropped up to keep us from fully relating to each other wouldn't get in our way again. Truth be told, whatever it was that came between us then, we couldn't tell you today. Did we get to the root of it? I don't even know if there was a root—it may have just been sibling rivalry, 'cause it wasn't that deep. It couldn't have been that deep if all it took was for a twenty-five-year-old man to sit us down and say, "Check it out, you need her, she needs you. Get it together." That's when I made the decision to work on myself. That's where it starts, and I'm sure that's what Afeni did too. We didn't make a conscious effort to work on our relationship, we made a conscious effort to work on ourselves. When you get into yourself, the relationship is easy. Through working at being better people individually, we became better sisters.

Now we have a very close and loving relationship. We talk on the phone every day at least once, and since we live just a mile apart, we try to visit each other every day when Afeni is in town.

The things that I admire most about Afeni are her passion and her ability to express herself and stand up in front of a crowd of people and speak. She's a very giving person, sometimes to a fault. I'm more like, What do you need it for? When can I get it back? She just gives. And she makes me laugh. She's one of the funniest people I know.

Moreover, I know that she loves and depends on me. When Tupac was murdered I took it as hard as she did. He was not only my nephew, he was my *baby*. But I had to be strong for her, and support her with unconditional love. As painful as it was for me to lose him, it was more painful knowing that she had lost her only son.

To me, sisterhood means that I'm never alone. If anything happens to me I know Afeni will look out for me. It's safety and sanity. We come from the same place. I can't escape her and she can't escape me.

as told by Gloria Jean Cox

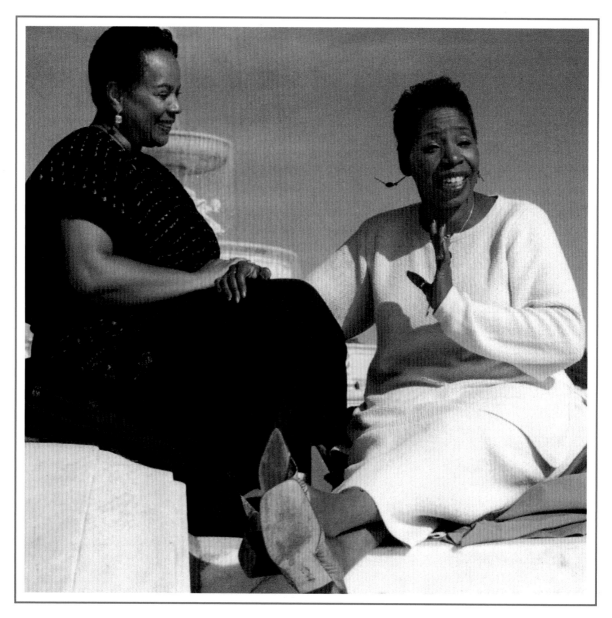

Shaheerah Stephens and Iyanla Vanzant

*Sisters are lifelines for one another, whether it's your blood sister or sisterfriend.
It's about unconditional love and being able to stand eyeball to eyeball and embrace and
accept without judgment all that you see.*

—*Iyanla Vanzant*

CONCEPTION

L ONG BEFORE MANY OF US HEARD of tapping the spirit within, learned acts of faith, or found value in the valley, the Reverend Shaheerah Stephens, a unity minister in Detroit, was struck by the spirited words of Iyanla Vanzant.

"Someone brought me her tape from the National Black Holistic Retreat, and I wanted her to come to Detroit to speak," recalls Shaheerah. "I called her and we ended up talking on the phone for hours. In fact, when I heard her speak it was like I couldn't stand still. I felt a certain energy. Her voice was earthy and grounding. I just felt connected."

"Maybe it was the way Shaheerah presented herself," says Iyanla, "but there was an immediate connection."

That connection sparked subsequent telephone conversations through which Iyanla and Shaheerah realized just how much they had in common.

"We both had children around the same ages, and our spiritual beliefs were similar. And we had the desire to do something for our community," says Shaheerah.

Some of their community work centered around helping women who, like themselves, had been sexually abused, and that, too, was an issue that came up in conversation. "I didn't say 'I've been abused,'" says Iyanla, "but I talked about my upbringing and she talked about hers. We talked about our bad days, our wild days,

and the similarities we had in terms of our relationships. That's probably how it came up."

While their pasts may have served as a prologue to their friendship, their sisterhood was solidified more by where they were going rather than where they had been. "I think the primary thing we had in common was that we were both on the path to healing," says Iyanla, "and we were both looking for a deeper relationship, a closer walk, with God."

The two finally met in person when Iyanla accepted Shaheerah's invitation to speak for a weekend of activities aimed at spiritual healing and empowerment for women.

In the ten years since, through transitions, challenges, and accomplishments, their friendship has flourished to where the two are closer than many blood relatives. "There's a part of me that I can bare to Iyanla that I cannot bare to anyone, including my husband," says Shaheerah. She has two sisters with whom she is close, "although there are differences in faith and a lot of spiritual things that I would never be able to discuss with either of them. I call Iyanla my sister because there's nothing I can't share or tell her. She's just gonna be able to understand it and accept it and love me no matter what."

"You know, I don't have a birth sister," says Iyanla. "I have a cousin who I was raised with, but as we grew older we'd come together and fall apart. It was never anything negative, but I never had that connection with her. Shaheerah has taught me what unconditional love and trust are. I would trust her to sleep in the bed with my husband and not bat an eye. I would trust her with my life. You know you can tell a lot about a person by looking into their eyes. Shaheerah has no problem making eye contact and really sharing herself—and being fully present. She may get on my case, or I may get on hers, but no matter what I do or how I do it, she loves me."

A sister is somebody who loves, understands, and wants the very best for you. They believe in you when you don't always believe in yourself.

—*The Reverend Shaheerah Stephens*

RITUAL

When Shaheerah was turning fifty, Iyanla wanted to do something really special to mark the occasion. "We started talking about how women just move through

different life passages without always recognizing the gifts of each age," remembers Shaheerah. "In African tradition, turning fifty means entering this eldership piece, and as an elder my focus is giving back to my community. So we decided to have a public rites-of-passage ceremony."

The ceremony was on a crisp fall evening at the First Congregation Church in the heart of Detroit. More than seven hundred women from teenagers to seniors, of various faiths, turned out for an event that was both a celebration of them and an homage to Shaheerah. Garbed in white with a colored ribbon to represent their particular generation, they partook in a moving ritual of womanhood, complete with spoken affirmations of life's phases and jubilant song.

"It was like a dream," Shaheerah recalls. "Just seeing the beauty of all those sisters of different ages gathering in that one room was powerful for me. I just felt a lot of gratitude."

The following day Iyanla led a private ceremony for Shaheerah. In a nod to African tradition, Shaheerah's mother, daughter, and spiritual mother washed her head (for purification), and sister Iyanla washed her feet (to symbolize her stepping into a new venue of life). "I really just wanted to celebrate her for all the love she has given in the world. I talked about how *love* was her power, and spoke on the people she has touched . . . and healed . . . and supported. And how good she makes everyone feel. She's turning wise, and I talked about what it means to be a wise woman and moving into that power," explains Iyanla.

It was an experience that Shaheerah says she will always cherish as a milestone. "I was really overwhelmed. I cried in a way that I would not have wanted to in the presence of other people—that's how deep it was for me. And even though I was turning fifty, I felt like a baby, like I had been reborn. I want sisters, and people in general, to revere aging and to appreciate where they are. There's something wonderful in every passage, especially when there's a sister to share it with."

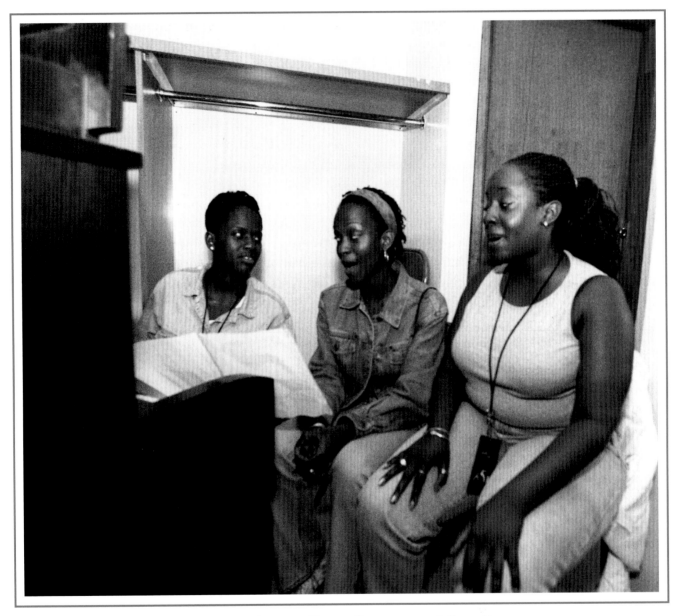

The Reed Sisters: Tanya, Brittany, and Brandi

SISTERS IN HARMONY

WHEN THE LATE JAZZ LEGEND Betty Carter first heard Brandi, Tanya, and Brittany Reed singing in a hotel lounge in their native Milwaukee, Wisconsin, she couldn't believe her ears. Out of the mouths of youngsters came voices so mature, so nimble, so downright jazzy. Could these teenaged prodigies be the ones to carry on the legacies of Ella, Sarah, Carmen, and herself for that matter? Knowing a good thing when she heard it, Carter wasn't taking any chances. She invited the three to participate in her prestigious *Jazz Ahead*, an annual showcase at the Brooklyn Academy of Music. There, an elite group of young jazz musicians get to work on their chops and, in some cases, launch stellar careers of their own—such as these of noted bassist Christian McBride or pianist Cyrus Chestnut.

Having an opportunity to study under the tutelage of Carter was nothing short of a miracle for the Reeds. Finally, all those music lessons, theater programs, talent shows, and pageants that their mother, Linda, carted them to were beginning to pay off. Carter not only helped them to hone their talent, she taught them to be consummate professionals, a concept that's amiss with many young artists today.

Working with Carter exposed the Reed sisters to larger audiences. They've wowed listeners at the Indiana Jazz Festival, Chicago's Jazz Showcase, Ohio Women in Jazz Festival, the Apollo Theater, and the Spoleto Music Festival in Italy. Yet the sisters say that their most memorable performance was as special guests of Carter at the famed Blue Note Jazz Club in New York. Sadly, Betty Carter died in 1998, and

while the sisters miss her presence, they value all that she instilled in them as a master teacher and a cherished friend.

In between gigs, the junior jazz divas lead lives that are typical of most young women their age, juggling school and work. Brandi, who is taking time off from her studies at the University of Wisconsin Whitewater, works as a bill collector; Tanya studies voice at Columbia College in downtown Chicago; and Brittany, who just graduated from high school, is studying tap and ballet as well as Chinese. As sisters and pals, they enjoy going to the movies, attending cultural events, eating out, or just hanging together in their mother's downtown Milwaukee loft apartment.

On this day, Brandi and Tanya are at Britanny's high school watching her rehearse for a musical she starred in during the school year. Though Brittany has graduated, the drama teacher has insisted that she rejoin the cast for a European summer performance. The two older sisters watch their younger sister intently as she goes through various routines with the cast. Every so often Brittany looks out at them and makes a face or flashes a smile. As rehearsal continues, Brandi and Tanya speak on their budding careers as young women in jazz, and the beauty of working together as sisters, with Brittany commenting each time she gets a break.

WHAT DO YOU LIKE BEST ABOUT SINGING WITH YOUR SISTERS?

BRANDI: I feel that a lot of times I have the advantage because I'm with my sisters. If I'm having a problem with a part, I can just look at them and they'll understand. Or maybe I'm singing a part and they just give me a vibe, like "Yeah, do it!" It's cool. Practice isn't so boring because with them it's fun. But at times it's hard to separate the music from regular life.

TANYA: It's hard, as she said, to separate sisterhood from music, also from a business aspect. Sometimes you just want to get together and talk and just be sisters, like it was before we were singing. We still do that, but because we all love music, even our older sister—the conversation always drifts to music. When we're not talking about our music, we're talking about somebody

else's music and how it relates to our music. It's not a bad thing that we're always talking about singing.

BRITTANY: To me it means more than words. I can look at them and know the exact thoughts going through their heads. It's like being so finely in tune with each other, sometimes it's unbelievable.

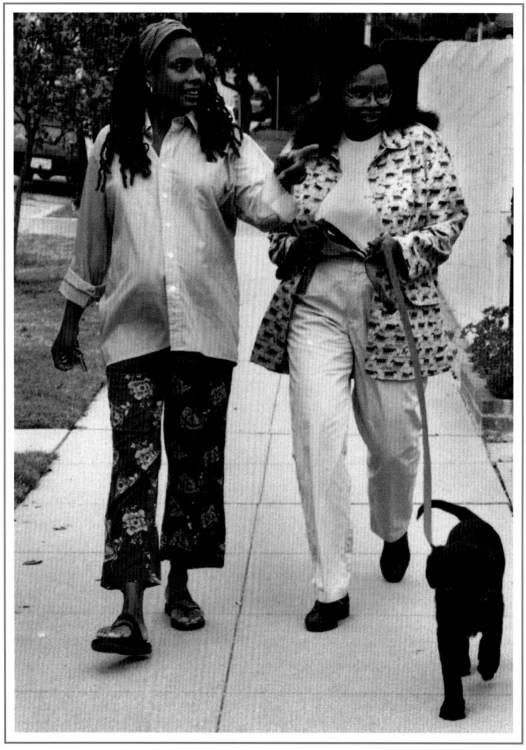

The Butler Sister: Adriane and June

SEASONED BY SEASONS

A S A YOUNGSTER, ADRIANE BUTLER remembers "idolizing" her big sister, June. "I just thought she was the most beautiful, coolest woman," she recalls, "and she always brought these good-looking guys home to date."

And the accolades don't stop there. "She bought me children's books on Picasso and Gauguin. She taught me how to look up every word I didn't know in the dictionary and write it on index cards so I would remember the definition. I used to read her *Newsweek*s so that when she talked to little me, I would know what to talk to her about."

Such praise leaves June feeling a little taken aback. Referring to the manner in which she managed to keep Adriane engaged, she jokes, "If that would work on my kids that would be wonderful."

What makes praises such as these even more endearing is the fact that June and Adriane are not blood sisters. Adriane, affectionately known as "Missy," came to live with June's family when she was a little girl and June was away in college. "I liked her," recalls June of the precocious four-year-old. "She was curious about the world." She was also a hit with June's friends. "She was a people magnet as she is now, and everyone wanted her around." And around she went with June, enjoying ferry rides, Mardi Gras festivities, and various other pleasures in their hometown of New Orleans. "It was fun to see Missy's impressions," says June. "I liked seeing the world through her eyes."

Fast forward to Adriane's teenage years and all the angst that accompanied it. "Teenage girls think they know everything, and I was probably going through some of that," says Adriane. At that point, June "was definitely an adult and I was definitely a teenager. And that's when things just sort of started to change." Suddenly

June seemed very conservative to Adriane, yet, "she always made herself available for talking and deconstructing things."

Adriane went to New York to attend the Fashion Institute of Technology. To alleviate their mother's fears about the big bad city, Adriane agreed to stay with June, who'd moved there with her husband. What seemed like an ideal arrangement, however, grew stressful.

For the first time, Adriane was miles away from their mother's stringent rules, and she reveled in her newfound freedom. She was so excited, she says, "My skin itched. There was just so much to do and what felt like so little time to do it in. I went through a punk phase; I was going to clubs and hanging out at all these places," she recalls. "It was the first opportunity I had to do the things I wanted to do and to express myself the way that I wanted to, and that my mother was not about to allow."

She would stay out late, if she came home at all, and her bedroom became a drop spot for friends staying overnight, or longer. Adriane's behavior left June stuck between a rock and a hard place. "Our mom was very, very strict, so I decided I would be what I thought was reasonable. My rules were much looser than my mom's, but there were some transgressions. I was responsible for Missy and I thought I wasn't upholding my part of the bargain with our mom." As a result, she internalized the pain the situation brought and "I would just hurt."

"Finally," June says, "a revelation came that this child was maturing and that she had to make her own mistakes. I couldn't live her life for her." In addition, says June, "part of it was me also breaking away from my mom and realizing that I was not a parent." The clean break came when she and her husband moved to New Jersey. "It was hard, I had to explain it to my mom, who did not approve of it, and I was upset with my husband for forcing the issue. Part of me didn't want to let go of Missy, but when I reached the conclusion to let go, we were much better."

Initially, says Adriane, "I remember being a bit pissed, thinking she was kicking me out and I didn't deserve it," but, "I'm sure I did. She had every reason to say 'It's time for you to go.' She sat me down and was very civil about it."

Adriane continued to ride the wave of excitement of being on her own. "The first night I was in my apartment I was on the verge of hysterics. I thought, This is my house. This is my life. I don't have to answer to anyone." But soon she would. A few years later, in the midst of losing her job and with plans to return to school, she learned she was pregnant.

June was not happy. "I was so upset with her. I thought, Oh my God, Missy

thinks this is the solution to life," remembers June. "I tried to be as supportive as I could, but I knew she had chosen a tough path."

Says Adriane, "Objectively speaking, I think that was a fair opinion to have. I probably surprised everybody because I had to go from being 'crazy club kid'—hanging out with all the drag queens—to being mom. But I was so ready to be a parent, I knew that it was the right thing to do." Oddly enough, it was. At twenty-two she had her first son, Noah, and motherhood could not have suited her better.

"In retrospect," says June, "she has proven me absolutely wrong. This is why you have to let people live their own lives and you can't make choices for them."

"It was the best decision she ever made," she continues. "Noah is absolutely wonderful and Adriane's a great mom."

Time brings about a change. Says Adriane, "Ten years ago I was a single parent, working full-time, living in a small apartment. June was married with two kids and living a bit more comfortably than I was. We were really just in two very different places, even after we had the kids."

Today Adriane is married, has a second son, and is a stay-at-home mom living in Santa Barbara. "There are less differences between us now and more similarities."

"Missy and I have grown alike," says June, citing their shared ambition in life: to be happy and to make a difference. And according to her, even their husbands are similar. "We're both married to very caring men who are not selfish and who love people," although, "my husband's probably a little bit more crotchety," she jokes.

What has sisterhood meant for them? June describes it as "the warm comfort you experience in family. It's also being able to see bits and pieces of yourself in that other person."

Says Adriane, "It's knowing that no matter how far you fall, someone's going to be there to catch you, and they'll bend over as far as they need to, to pick you up."

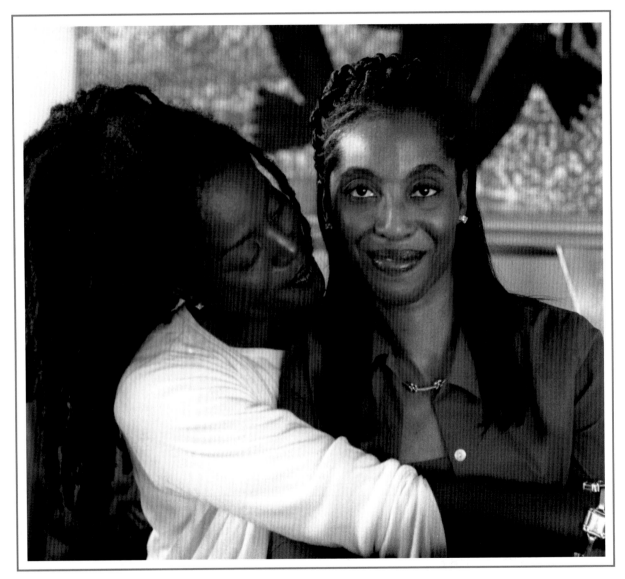

Jelani Bandele and Raechelle Scott

THE YEARS THAT UNITE US

Jelani Bandele, clinical nutritionist, publicist, journalist, mother.

Raechelle Scott, clerk, New York Department of Transportation.

NATIVE LAND

Brooklyn, New York.

I.D.

JELANI: I've always been the smart, reliable one. When I was a teenager, taking care of Raechelle was not a requirement, but when I had her, my parents were confident that she would be well taken care of.

RAECHELLE: I'm just the spoiled baby of the family. What can I say?

IN THE BEGINNING . . .

JELANI: I'm a baby-boomer. When I came into the world, Harry S. Truman was in office, we called ourselves "Negroes," and TV was the hot thing.

RAECHELLE: I'm strictly Gen-X. When I was born, Lyndon Baines Johnson was president, we'd just lost Martin Luther King Jr., and a man had walked on the moon.

THAT'S ENTERTAINMENT

JELANI: My favorite TV show was *Shindig!,* and I'd twist and shout to "Tighten Up" by Archie Bell and the Drells, anything by James Brown, and anyone on Motown. I rushed to the movies to see *In the Heat of the Night*—when Sidney Poitier proclaimed, "They call me MISTER Tibbs," I got goose bumps.

RAECHELLE: I blinked along with Barbara Eden on *I Dream of Jeannie,* and I was a Michael Jackson fan from back in the day, when he still appeared Black. *A Nightmare on Elm Street* is my favorite flick. I had nightmares.

TERMS OF ENDEARMENT

JELANI: When I was a teenager, my friends were "my girls" or "my boys." Acknowledging that something was "boss" was the best compliment you could give someone.

RAECHELLE: My buddies were my "homegirls" and "homeboys." If we wanted to pay a compliment, we'd say "That's fly!"

FASHION STATEMENTS

JELANI: You couldn't tell me nothin' when I donned my peacoat and Russian boots with fishnet stockings.

RAECHELLE: I loved to rock my burgundy goose-down coat, complete with fox-trimmed hood.

EARLY IMPRESSIONS

JELANI: I was sixteen when Raechelle was born, and I remember her being a beautiful baby with a head full of curly hair. According to our mother, as a toddler she was a lot like me. She laughed a lot, was mischievous (she stole drinks when the grownups weren't looking), and showed great admiration for me and my friends. I really enjoyed her.

RAECHELLE: My memory of Jelani began at about age five. I remember spending weekends at her house and pushing my nephew in his baby swing. I always felt safe when I was with her.

BIRDS OF A FEATHER AS YOUNG CHICKS

As teenagers, we were both very tall (close to six feet), thin as rails, with huge amounts of hair.

"We both used to have gap-toothed smiles until Jelani had hers closed."

We loved to dance and did so very well. We also loved to party and wear the latest fashions. We weren't into causing our parents grief, and we were good students in school.

DIFFERENT STROKES

JELANI: In my late teens I couldn't leave home soon enough. I wanted to be out there on my own. Raechelle, on the other hand, had no desire to flee the nest.

RAECHELLE: Jelani has always been more health-conscious and energetic than I am. I like to feast on all kinds of food, and like an old lady, I need my sleep.

GIMME THAT

JELANI: I wish I had her beautiful almond eyes, and her feet are gorgeous—pretty toes, great arch, and a lovely shape.

RAECHELLE: I wish I shared Jelani's expertise with numbers. She's a math whiz, but I can hardly remember how to add a fraction.

HANGIN' BUDDIES

JELANI: I loved showing Raechelle the world as I knew it, taking her to Greenwich Village . . .

RAECHELLE: I always begged her to take me.

JELANI: . . . the big New York department stores, museums, and special holiday events. I also got a kick out of getting her to do foolish things, like making her entire body tremble on command.

PAST, PERFECT

JELANI: Our relationship was exactly what one would expect it to be. I was the older sister empathizing with Raechelle's teenage complaints about our parents. She stayed at my house on weekends to have the benefit of more hang-out and party time. My benefit: some damned good dance lessons to help me keep up!

RAECHELLE: Jelani was like a mother to me, but not as strict.

PRESENT TOO

JELANI: Today we are both grownups and it no longer seems like there are sixteen years between us. She no longer needs a big sister to tow her around or to give her the refuge that teenagers sometimes need. We still share information and intimacies, and we look to each other for help in certain situations. And we still know how to have a good laugh together.

RAECHELLE: I still feel the little sister/big sister thing between us. I still look up to her and admire all of her accomplishments, both personal and professional.

SPECIAL MOMENTS

JELANI: I'll never forget helping Raechelle get ready for her high school prom. She looked beautiful, and I was so excited and proud.

RAECHELLE: Jelani did my hair and makeup and dressed me in my gown. It was like having a fairy godmother.

JELANI: Another fond memory I have is taking her to Buffalo, New York, for her first semester of college. I was such a mother; I checked out everything and everybody. I even connected with some people on campus beforehand—actually they were my spies—to look after her. I was so afraid of leaving her alone, even though she was eighteen, the same age I was when I left home.

SISTERHOOD MEANS . . .

JELANI: There's a connection by paternity and gender that you have with no one else in your family except your sister. Raechelle is my girlfriend and reflection.

RAECHELLE: Having a best friend and confidante to share things with that nobody but a sister could understand.

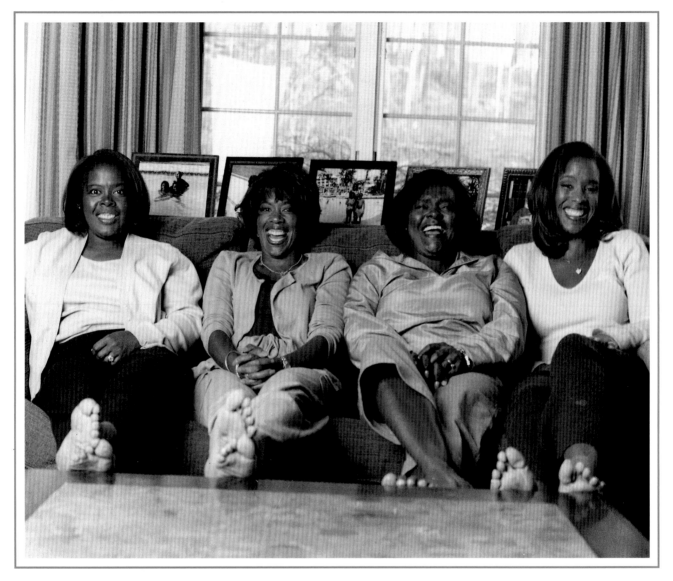

The King Sisters: Caryn, Lynne, Sharon, and Gayle

FAMILY ORDER

SO WHAT'S IT LIKE BEING THE SISTERS of America's best-known best friend?

"Oh, is that what I am?" asks Gayle King.

"I'm proud," Sharon beams. "I don't broadcast it, but if Oprah comes up in conversation, I might say, 'You know Gayle who she talks about? Well that's my sister.'"

"I don't even bother to say anything," says Caryn, "because then they want to know all about Oprah."

"Which," as Sharon is quick to point out, "we don't know."

"We forget sometimes," says Lynne of their eldest sister's renown. "When we're out with her somebody may say, 'Oh my God! It's Gayle King!' and I just crack up because it's funny."

"That's more so here, in Connecticut," Gayle explains, "because I've anchored the news for eighteen years. But because Oprah talks about our friendship so much, people do feel as though they have some type of connection to me, and I think that's nice."

"I forget sometimes, too, that I'm on TV or that people know me," she continues. "I really don't think about it because if I did I wouldn't walk around looking like a schlep. Our mother used to say to me, 'You're in the public eye. You should always have your makeup on and look good.' If I'm just going to the store to get some milk, I'm *not* doing that."

The King Sisters mention their mother a lot in conversation. "Because I think our mother was truly a friend in addition to our mother," says Gayle. "We always felt very secure, very loved—very traditional upbringing. Dad worked, Mom stayed home," in Turkey, where their father, an electrical engineer, had diplomatic status. Dad would go to work in a limousine while Mom stayed home baking cookies and cakes.

Family vacations took them to destinations like Paris, Greece, and Spain. "Our dad was pretty adventurous," recalls Lynne. "He liked to take vacations and travel."

"I can remember a real hot afternoon once, walking along the Acropolis and saying to him, 'Why do we have to look at these rocks? Can't we just go back to the hotel so we can go swimming?'" recalls Gayle. "'One day you're going to appreciate this,'" she continues in a deep voice imitating their father. "Now I pull out my little pictures, 'This is me at the *Acropolis*.' You don't appreciate it when you're a kid that this is an experience most people don't have."

In fact, "when people ask about our childhood, I try to come up with a story, because everybody seems to have one, of woe, and I just can't," says Gayle. "And I don't think it's being in denial, I think we had a really good childhood."

"I agree," says Sharon. "I don't have a bad memory or story to tell."

Growing up they were the big guys, Gayle and Sharon, and the little guys, Lynne and Caryn, with four years between each pair.

But, "we never traveled as the King Sisters," describes Gayle. "We all had different friends. Just to show how much we didn't hang out as sisters, there's Lynnie who gets the family car and she tells Caryn she can't have a ride home from school because the car is full of her friends." There are uproars of laughter.

"Your sibling relationship is the longest—or should be in most cases—the longest relationship you'll ever have. Longer than your parents or a spouse," says Gayle, taking on a more serious tone. "A sibling is the person you're going to know the longest on this earth. So I think it's important that you are close and like each other. You should really care for and nurture that relationship and not take it for granted."

And sometimes birth order can offer clues on how sisters relate, as the King clan well illustrates.

Firstborns are like the directors of the whole sibling operation. They set the tone while simultaneously being the test model for those who follow. Characteristically, they are goal-setters, high-achievers, responsible, perfectionists, organized, rule-keepers, determined, detailed.

"I'm the matriarch of the family," declares Gayle, holding court with her sisters around the kitchen table of her palatial Connecticut home.

"If there's a problem," says Sharon, "we go to Gayle. She's rational, and even if you don't agree with her, by the time she's done with you, you're like [small voice] 'Okay,' and you limp back to your place. She doesn't pacify you."

What if she's wrong?

"I'm not really wrong," replies Gayle, playfully smug.

Middle children are the balanced negotiators. So what that they never get their parents all to themselves, they won't throw a tantrum over it. They're too busy

being team players. The flexible, diplomatic, generous, social, competitive peace-makers are usually the mids.

"Sharon is the family communicator," says Caryn. "She got that role after Mom died."

"I think it's because she's a stay-at-home mom and all of us work," says Lynne. "So she's easiest to reach."

According to Gayle, "You can call Sharon and find out where anybody is."

"Um-hum," agree the sisters in unison.

". . . and when they're coming back," she finishes. "My ex-husband used to call it the King Network. You tell one, who calls the other, who calls the other, who calls the other."

Finally, babies-of-the-family are often the clowns of the family and work hard at keeping everybody entertained, in between their rebellious outbursts. When these outgoing, creative risk-takers (who tend to question authority) get going, they motivate everyone.

While Lynne certainly isn't the last born, she fits the profile. "She's the entertainment," says Gayle. "Her nickname is 'Jokester' 'cause she's very young at heart. She's going to be in her forties soon, but she still seems twenty-something to me, doesn't she to you all?"

"That's true," agrees Sharon.

"Um-hum," nods Caryn.

"And she's the best one with the kids," Sharon adds.

"Which is so ironic," Gayle says thoughtfully. "All of us thought Lynnie would have the most kids and she has the fewest."

"And we thought Sharon would have the fewest," Caryn says.

"And I have the most," says Sharon.

" 'Cause you wouldn't describe her as being really good with kids," Gayle says under her breath, nodding in Sharon's direction.

More laughter.

And Caryn?

"She's, uh . . ." starts Gayle.

"The youngest," Lynne offers, laughing.

"She's the youngest and to-the-point," completes Sharon.

"She's serious," says Lynne

"Oh, I don't know," says Caryn softly. "I don't think I'm that serious, I'm shy."

"Caryn's the brain," states Gayle absolutely. "She'd be the executor of my estate."

So there you have it. The King Sisters, in perfect order for life.

The Lee Sisters: Lynell and JoAnn

SUMMER SISTERS

JOANN LEE AND LYNELL KOLLAR are as tight as two sisters can be. "She's probably the closest thing I have to a soul mate," says JoAnn, a trial attorney who lives in Houston, Texas. "She is the one person that I feel comfortable with just being myself, with all my faults, just hanging out. And I absolutely do not worry about her abandoning me."

"It's unconditional love just like she said," concurs Lynell, the owner of a real estate transaction company who lives in East Brunswick, New Jersey. "I can be myself and say what I feel and not worry about judgment. It's just very comfortable."

Part of what makes Lynell and JoAnn's kinship such a unique testament to sisterhood is that the two never lived in the same house, or even the same state. Lynell is from New Brunswick, New Jersey, and JoAnn is from Fort Worth, Texas. But cohabitation, they say, has never been a prerequisite for closeness. "I think some sisters that were brought up in the same bedroom still don't have the bond that we do," states Lynell. Sometimes it's more about where your heart is than where you live.

It was never their parents' intention to separate the family, as they both explain. "When my parents decided to move to Texas, they left Lynell with my grandmother until they got jobs, found a place, and got settled." Once that happened, they sent for three-year-old Lynell. "But by this time my grandmother was extremely attached to me and vice versa. So I eventually ended up staying with her."

Lynell would rejoin her immediate family during summer vacations, much to both girls' delight and anticipation. "It was exciting because now I had a sister that was going to be there with me, and I could take her around and show her to everybody else, because all my friends had sisters. I remember cleaning out my closet so she

could put her stuff in. And then just having her sitting there with me in my room . . . I remember staring like she was some big movie star or something."

"I appreciated JoAnn so I tried not to be mean," says Lynell. "A lot of my friends in New Jersey had little sisters and they were always mean to them. I was just happy for the time we got to spend together. I decided to be a good big sister."

Lynell never knew back then, however, the pains her family would go through to try to convince her to stay. "My mom would go out and buy her lots of stuff—you know, try to find all the things that we thought she liked—and we'd fix up my room and change it around so that she had her little space." And JoAnn tried especially hard to win Lynell over. "I tried to be the perfect sister because I always thought that the reason she was leaving was because she didn't like me." But ultimately Lynell always returned to New Jersey, leaving JoAnn crushed and vowing to be a better sister next time.

"I didn't realize that she was going through all of that emotional stress," says Lynell. "I was like 'C'mon, I'll be back next summer.' When you're young you just think about what you feel like doing or where you want to be."

Of course, the girls had their own perceptions about who was making out better in their lives apart.

"I was there with Eugene, Oberian, Mom, and Dad, but she had such a large extended family with her. In addition to Nan and Pop, she had all the cousins and everything." To make matters worse, by the time JoAnn was eleven she began to sense their parents' marriage souring. "I think that's probably when I needed Lynn the most."

But as far as Lynell could see, JoAnn had it made. "I thought, Wow, all of you are together—Mom, Dad, brothers, and sister—like the little family you see on TV. I had a grandmother and grandfather, and there was always an uncle there, you know, between marriages. I mean it was happy and warm and full of love, but it wasn't what you saw on TV. Texas looked like the perfect picture."

While distance may have helped their hearts grow fonder, both say that their genuine admiration for each other is what sustained their relationship through the years. They really like each other. For JoAnn, who describes herself as kind of shy and conservative, big sister Lynell has always been a model of social grace and exuberance who could make friends easily. "Even as a kid she could work a room. She could be in any setting whatsoever and talk with anybody about anything and never seem to make a fool of herself." Lynell simply chalks it up to necessity. "When you're raised as an only child, you've got to make friends somehow."

In JoAnn, Lynell always found a voice of reason to balance her own impul-

siveness. "I get told common sense from her. I'm a little on the edge—I opt for what's fun as opposed to what's right. But she makes me approach things differently and look at things rationally. Could be some of the lawyer in her. She's a woman of few words, but they're always very well thought out and they always make sense."

Disputes between them were practically nonexistent, they say, probably due to their history of treating each other with kid gloves. JoAnn remembers the closest time they ever came to disagreeing was as young women soon after their grandmother died. Their mother, by this time divorced, moved back to New Jersey expecting to regain some of what she'd lost from being separated from her eldest daughter. But Lynell had a new "mother" in her life, an aunt with whom she'd grown close, and JoAnn felt as if their mother was being short-changed.

"It was hard for me to understand her perspective," admits JoAnn looking back. "It was like 'I don't care what Aunt Mary does. This is your mother and I'm not going to let you just make her feel like nothing.'"

"But the beauty of it is, we didn't fall out about it," says Lynell. "We just kept talking to each other, trying to get each other to see what the other was feeling. We were always willing to just work through it, no matter what. We'd talk all day, all night if we had to. I think a lot of people, friends or sisters, can't say that."

So no matter where they are geographically, or in life, they are a constant source of support to each other. When Lynell's first marriage was disintegrating, JoAnn, then in college, counseled and consoled her sister. "She always seems to appreciate and want my advice, which is kind of weird since I'm the youngest."

When their mother died, Lynell had nothing but empathy for how the loss would affect JoAnn. "When our mother passed away, I was really worried that she was just totally lost. With no husband or kids at home she had nothing to fall back on." In fact it was Lynell, herself a single mother, who encouraged JoAnn to eventually adopt a child to help circumvent her grief. "I felt like she was just alone and the only thing that would help her would be to become a mother."

Losing their mother also ignited a yearly ritual for Lynell and JoAnn. "Every year we do a Betty Lee vacation in her honor because she would want us to." Together the sisters have traveled to many destinations in their mother's memory, but their first trip was to a special place that their mother longed to visit. "We went to Disney World. For her," says Lynell solemnly. "And the weirdest thing was—I'm one of those silly spiritual people, so I took one of Mommy's earrings to Disney World and buried it in a plant there. So, you know, she'll always be there. And we may go back there actually."

The Burks Sisters: Emily and Dorothy

In 1829 Elizabeth Clarissa Lange, a free Black woman from Saint-Domingue, now Haiti, founded the Oblate Sisters of Providence, the world's first order of nuns of African heritage. Their mission was to educate and evangelize African Americans. More than a century and a half later, today's Oblates continue Lange's mission of education and service.

Of the order's many nuns, two of its members, Sisters Emily and Dorothy Burks, happen to be real sisters. Here, in her own words, Sister Emily expounds on the virtues of sisterhood both sacred and secular:

THE ROLE OF A NUN IS TO BE an authentic witness of Christ by proclaiming the Kingdom of God to the world. Also, to grow in personal holiness and to lead others to a more profound experience of God's love and making God ever-present by our actions and teachings. We must be Christ-like, sympathetic, helpful, compassionate, and self-giving, especially to the needy and underprivileged.

Historically, the primary work of the Oblate Sisters of Providence was to educate Black children, but our role has expanded greatly since then. Now we do all types of ministries, from pastoral to social work. We work with the young and the aged, the sick and the underprivileged. Most of all, we happily share the love of God by giving our time, energy, and talents.

For fifty years my sister, Dorothy, and I have been members of the Oblate Sisters of Providence. We took our vows at the same time. We were raised in a strict, religious Catholic family. Our saintly mother was our model and inspiration for becoming nuns. She had excellent religious training, deep values, an ardent faith and love for God, and led an exemplary life. So rightfully, we attribute our vocation first to God and then to her.

Our family was very happy about our choice to serve God. In fact, it was our oldest sister, Mary John, now with God, who was instrumental in us joining the Oblate order. Our mother summed up her joy in these words: "Happy but not vain, there's no better way than being religious, serving God and His people in such a unique way, giving one's self to God by living in the richness of God's love and grace."

We ourselves cherish our vocation, enjoy spending our religious life together in our second extended spiritual family.

Being committed to God, however, in no way diminishes our commitment to our actual family. Sister Dorothy and I are from a very close and happy family that included six girls and one boy. We keep in touch by telephone, written letters, annual visits, and most of all by our prayers for each other.

We often reminisce on our childhood days at home with our family in Louisville, Kentucky. Oh what happiness and indelible memories! Especially on Sundays. We'd be spread out on the floor reading the funnies and munching on peanuts and chocolate drops while our mother prepared a sumptuous dinner which always included layer cake and homemade ice cream. When she called, "Come and get the dasher!" we'd scramble to the kitchen to share a small taste of ice cream. Sharing things, no matter how small the amount, was a lesson in unselfishness for us. Sharing and togetherness was a must in our happy home.

My sister and I still do practically everything together. We pray, eat, work, care for and support each other. We also partake in recreational activities, celebrate, and share days of joy and sorrows. We share our lives with each other in the community, too. Together, we journey each day to get closer to our Heavenly Father.

For all that we have in common, we are still individuals. Sister Dorothy likes to sew, dance, shop, and go out, and she generally makes friends quickly. I'm usually reserved when I meet people, and enjoy more solitary pursuits, like playing the piano, baking, watching movies, and writing.

When asked what advice I would give young African American women who may be considering the sisterhood, I would encourage them to be positive, dedicated, and religious. We are women of faith animated and inspired by God. "By your fruits you are known." Come apart and dwell with us to witness the lives of the Oblate Sisters of Providence in action. We don't just talk about it, we live it.

as told by Sister Emily Burks

The Cammock Sisters: Florence, Agnes, and Jean

A THREEFOLD CORD

"WE COME FROM A VERY SMALL FAMILY," explains Florence, the eldest of the Cammock Sisters. As the only offspring of Jamaican immigrant parents, family life was very contained. "We didn't grow up with cousins, aunts, and uncles close by. We lived in Upstate New York in a white town where there were only two or three other Black families, so our family just stuck really close together. And it's always been that way."

When Florence, Jean, and Agnes get together that closeness is evident. On one sunny winter afternoon, all are gathered around the kitchen table of Florence's tasteful home located in the Flatbush section of Brooklyn, New York. The conversation is lively, peppered with exclamations, revelations, smiles, and laughter, as they reminisce on their lives as sisters. Their mother, visiting from Florida, looks on proudly from a corner of the room, interjecting when necessary to keep everyone's stories straight.

"The three of us are very different," points out Agnes, the baby sister.

"Flo" (a.k.a. Florence) "is the beautiful, motherly one," describes Agnes. "People gravitate to her automatically because she's very talkative and she makes them feel warm. You never feel bad around Flo."

She's also the most outspoken. "Well, I definitely have strong opinions," explains Florence, "but I don't try to force them on somebody else. I make it a point to say what I believe."

"And what she's feeling," injects Agnes, speaking from experience.

By contrast, Jean, who's a year younger than Florence, is the soft-spoken artist of the family. "Jean was always the *cool* one," says Agnes, turning to her eldest sister with a "Sorry, Flo."

"She went to the Fashion Institute of Technology and always had the best

jobs. All of her friends were cool. She knew the designer Willi Smith and his sister, Toukie, who was a model. Jean was definitely my inspiration. When she came home with *W*, that's how I knew I wanted to work there." Both Jean and Agnes now work at *W* magazine and *Women's Wear Daily* as art director and fashion editor respectively.

Agnes was born when Florence was thirteen and Jean was eleven. "Our mom had Agnes when she was forty-three," says Florence, "and in the sixties you did not have forty-three-year-old women having babies so often. It was wonderful. Agnes was like a baby doll for us. But when she got to those teenage years . . ."

"I was a big problem," Agnes says, casting her head down in a mock pout.

"You weren't that big of a problem," consoles Jean from across the table. "You were more *experimental*, which goes with your nature. Everything about Agnes is a little bit more experimental than . . . well a lot more than Flo and a little bit more than me."

But as Florence sees it, "Our parents brought the two of us up differently than they did Agnes. They were much more easygoing and lenient with her than they were with us, whether they realized it or not. She wasn't a teenager that got in a lot of trouble, but she didn't want to. . . ."

"I didn't want to stay in," says Agnes of her youthful days out on the town. "I wanted to go out and party at the discos and Mom and Dad said, 'No you cannot.'"

"I was twenty years old and attending NYU and would *still* have to be home by twelve when my now-husband and I were dating," says Florence. "They tried that with Agnes," but with different results.

"Those were some difficult days," Agnes admits. She was also cutting class regularly, which "got to be a real problem," according to Florence. She and Jean intervened by having Agnes live with Florence during the week and with Jean on weekends.

But even then, Jean, being the cool one, managed to bond with Agnes. "In the eighties I started going to the discos with her," she remembers with a smile. "And when the guys realized my age they must have thought, Whoa, this is an old lady here!"

At this the sisters all burst out laughing.

"We're different people," says Agnes, reiterating her initial point. "There can sometimes be problems when sisters are different, but we've all managed to keep it together and stay extremely close. None of us has thrown away our roots so to speak."

Not hardly. If anything, through life's highs and lows, their roots just seem to get stronger. They share holidays and vacation together on Martha's Vineyard in the summer. And if you're friends with one Cammock, you're friends with them all.

Says Florence, whom chronic and severe asthma has left mostly housebound,

"Jean and I always did everything together. When I got sick and had to miss my senior year in high school, Jean transferred schools so that she could help me. And she would never come home with anything for herself and not bring something for me."

"It's been a very difficult experience," she goes on to say, "because I was always a very active, outgoing person." Now she relies on her "mother figures" to be her eyes and ears to the outside world. "Agnes will call three times every day and makes it a point of trying to keep me up on what's happening out there, which is a lot of fun. And if I'm feeling well enough she'll take me into a showroom to get some things. I've even gotten to be friends with some of her designer friends. One sent me a jacket just the other day. Now it's a little bit harder for Jean to see me as often because she has a demanding job and kids, but we talk on the phone almost every day."

Jean, the only mother in the bunch, appreciates the role her sisters play in the lives of her children. "I didn't go through the college applications with my daughter, Flo did," says Jean. "She spent the weekend working with my daughter to get everything organized, because Flo is very organized. And I like Agnes to talk to my kids. And they come to her because—"

"I was a monster!" shouts Agnes, laughing.

"—she's an example of someone who has tried a lot of things," says Jean, ignoring Agnes's outburst. "Because she has a lot of experiences, definitely more than I, she can bring those experiences into the discussion. They all get each other and can talk and relate to each other in a lot of different ways. Many times people think that my son and Agnes are brother and sister."

Being the youngest, says Agnes, "you're always the little sister, no matter what. They give me the beans about boyfriends and money problems, and wearing things that are not 'appropriate,' " she says with a playful smirk. "But Flo and Jean stepped in and helped me through that bad time. And I think if they didn't inspire and constantly tell me to get myself in gear, I'd probably still be a big mess."

What's more, "we each have different things, but we're never envious of each other. Flo has a fantastic husband and this wonderful house. Jean has a great husband and the best two kids you could ever think of having. I feel happy for them. I don't have that. I aspire to—but if it doesn't happen, they make me feel that that's okay, too."

"I think everyone is each other's head cheerleader," concludes Jean. "You cheer the accomplishments, encourage their ideas, and pick them up when they feel they've failed."

The Reid Sisters: Jill, Sheila, and Clarice (not pictured)

SISTER IN THE LIFE

I T WAS A SEEMINGLY TYPICAL OUTING for Sheila Alexander-Reid and her youngest sister, Clarice. "Rece was home from medical school and we went out for drinks," recalls Sheila. "We were standing at the bar having daiquiris, and she was giving me the rundown on who she was dating. Then she asked me the inevitable question. Are you seeing anyone? I said, 'Well, I'm dating someone,' which surprised her because she had never really seen me with anybody. I was sort of living this asexual life. I told her 'You're going to be surprised because the person is white.' Rece was, but she said, 'Well, as long as you love him.'"

That's when Sheila dropped another bomb. "It's a woman," she revealed. "Rece really got quiet for a minute there. I could tell she was struggling with it."

According to Clarice, "I almost fell out of my chair. It caught me offguard. I just didn't know that aspect of Sheila. And I guess when she shared it with me, it was new to her, too. It had just developed."

"I don't think I said 'lesbian,' " says Sheila, "I don't think I was that informed. It was more like 'I think I'm gay because I'm attracted to this other woman.' "

Regardless of the terminology, the reaction from middle sister Jill was the same. "It hit me like a truck," Jill recalls clearly, as though it were yesterday. "I completely had no clue. I was shocked. I was devastated. This is my big sister who I'd always looked up to. How could she be telling me that she's in love with a woman? I kept saying, 'Stop using the word *love*. Don't use the word *love*. I could have comprehended it easier if she'd told me it was a sex thing."

"Their reaction was 'How could you?' and mine was 'How could I not?' " says Sheila. "If you're attracted to somebody, you're attracted to them. It would be

stupid for me not to try and find happiness because the person I'm attracted to is a woman."

But it wasn't that simple. As Sheila came into "the life," her relationship with her sisters became strained. Jill made it clear from the jump that she did not care for the girlfriend and stopped dropping by Sheila's house as often as she used to. Clarice avoided staying at the house altogether during visits home and eventually penned a letter stating her disappointment with Sheila, who up until then had been her role model.

"There was a good several months when we would just talk about surface stuff," remembers Sheila. "I could tell she was hurt, and that sort of hurt me. But what could I do?"

When she and her girlfriend split two years later, "I cannot tell you how happy Jill was when it was over," chuckles Sheila. "Rece was happy because she thought it had just been a phase. But by then I was there. I was in the zone. I was not coming back."

Indeed, she was moving forward. With a solid reputation around the Washington, D.C., area for throwing the more happening parties, Sheila began hosting regular "Women In The Life" events aimed at young, socially conscious lesbians of color like herself. Relying on her years of experience as an advertising executive for one of the city's weekly rags, she launched a four-page newsletter of the same name that has evolved into a full-fledged monthly magazine that has helped to mobilize Black lesbians around various political and social issues.

Both endeavors led to her role of community activist, which happened as much by circumstance as by choice. "I don't think I'm an activist, which everyone likes to call me," Sheila says modestly. "But if I see a scenario that I know is wrong and don't speak out about it, I can't face myself in the mirror. I'm a person with a conscience who has the unmitigated gall to follow it. I'm not going to back down and mince words just to keep from rocking the boat. I *believe* in rocking the boat."

In time, Jill and Clarice began to see that there was much more to their sister's new lifestyle than who she was dating.

"I think when she started this 'Women In The Life' business, it became clear to me how important and deep-rooted this cause was to her," says Clarice. "It wasn't something superficial. Although I'm not condoning the lifestyle itself, being her sister, loving her, and wanting her to be happy, I support her in that sense. I admire her courage in standing up for her convictions."

"After about a year and a half, the light bulb in my head clicked on and I realized it wasn't right how I felt," admits Jill. "I was somewhat homophobic, but as

I got to know Sheila's new friends, I saw that they were everyday people who ran the gamut—doctors, lawyers, accountants. I realized that I was the one tripping and there was nothing wrong with Sheila because of her sexual orientation. I think we actually got closer around her coming out."

"They see these articles on me and the awards I'm getting so they have this newfound respect for me," says Sheila. "It's like, yes she's gay and has taken on this incredibly tough life of totally going against the grain of society, but look at all the good she's doing in the community. They're proud of me regardless."

So much so that when Sheila, who had yet to come out to their parents and brother, announced that she was marrying a woman, they were there for her.

"We thought our parents probably knew for years, although Sheila had never discussed it with them," says Jill. "That was a challenging, stressful time for her, and we rallied around that and provided her with a little moral support to get through that episode."

"We reassured her that as her parents they were going to love her no matter what, just like we do," recalls Clarice, even though she herself was torn over the marriage. "I love her partner Lois to death, and I struggled with that because I am a Christian and I have some deep convictions on homosexuality from a Biblical perspective. I told her, 'I can't really celebrate your union with her, but I'm happy that you're happy, and I'm going to support you.'"

"I said, 'Fine, that's all I want,' " says Sheila. "I'm at peace with my choice."

Reflecting on the turns her life has taken in the years since she's come out, Sheila acknowledges that it hasn't been easy. "It does take a lot of guts to get out there. You've got to have a lot of support, and I feel that my family supports me. I admire the fact that Jill and Rece are each strong in their own way and that they love me unconditionally, and that's hard to do. They've grown up to be very good, positive women. Ethical, honest, just good, down-to-earth people. They've given me years of entertainment and joy. And they're the ones who keep me grounded, especially in light of this newfound recognition. They're the ones who can say, 'You've got a stain on your shirt,' and I need to hear that."

The Conway Sisters: Marion and Rita

HAVE SISTER, WILL TRAVEL

TRAVELING HAS ALWAYS BEEN A TREASURED pastime for sisters Rita Ross and Marion Daniels. Either as a pair or with husbands and children in tow, the two have journeyed to destinations throughout the country as well as the Caribbean. Their most recent trip was an enlightening eight-day cruise to various Alaskan seaports. There they experienced whale sightings, watched glaciers break off into the ocean, and soaked up local history and culture. "She's the one who decides where we go," says Rita of younger sister Marion. In turn, says Marion of Rita, "She's the great packer. I just throw things in my bag, but she packs very well. So we sort of complement each other." And they've done so since the beginning.

"Marion and I have always been very close," says Rita, "even growing up." Back then in their West Baltimore neighborhood they were known as the Conway Sisters. Theirs was an insular community of Black folks who maintained quite well in the face of segregation. "When we were growing up, families just seemed to be together," says Marion of the close-knit community she remembers as a child. "You knew everybody, everybody knew you, from the shoemaker up the street to the dry-cleaners."

"Everybody knew each other even in the schools," says Rita. "The teachers knew our parents. That's why we did what we were supposed to because we knew if we didn't they would call our mother or father."

Their upbringing was built on a foundation of trust, honesty, and respect. Their father, an engineer, and mother, a homemaker, gave them lots of privileges but still laid down the law. "We were allowed to go places, but if they said we had to be in by a certain time, that's what they meant," says Marion. "So we would try our best to get back. And as we got older, of course, they were a little more lenient."

"Our house was sort of like the place where the kids on the block would come," says Rita. "Our best friends lived right down the street from us and they were always at our house. We were the first on the block to get a television, so everybody gathered there to watch TV."

"We just had a good time," says Marion of their youth. "It was fun."

Even back then the sisters traveled together, mainly to the library, the movies, or to the YMCA on Druid Hill Avenue for swimming lessons, and at Christmastime they headed downtown to marvel at the animated window displays of the department stores.

"And there were house parties—everybody had a club basement," says Rita. "We would go to parties at night and walk home with no fear of anything happening to us."

Sometimes they would entertain at home. "We had these white marble steps. We would wash them every day because we knew the suitors were coming along in the afternoon," says Rita. "They would come and sit on the steps, but they didn't come inside. Our father kept an eye on all of them. In that sense, he was very strict."

For top entertainment, continues Rita, they journeyed to the Royal Theater to catch acts like Nat King Cole, Billy Eckstine, Dinah Washington, and Lionel Hampton's big band. "That's where most of the teenagers went on Saturday. We would go to a matinee and get a whole show for seventy-five cents."

These were the 1940s, when "separate but equal" was the law. At Frederick Douglass High School, "we got old books. We never saw new books," remembers Marion. Yet, "we had some excellent teachers who instilled a lot of things in us. They were committed to teaching us. They inspired us. And we learned a lot." Both sisters excelled in school, each skipping two grades. Upon graduating from high school in 1950, Marion followed older sister Rita's footsteps, attending Morgan State College and receiving a postgraduate degree from Coppin State College.

Over the last three and a half decades, the sisters have gone on to teach, marry, and raise families. And during that time they've seen a lot change in their hometown: A once-thriving downtown has gone from grand department stores to nail salons and carry-out joints. Now the integrated schools get new books, but the sisters say they see the teachers doing more policing than educating. And the cohesiveness of their old community has given way to short-sighted self-preservation to the detriment of the gains from a generation ago. "Today nobody seems like they're really interested in knowing anybody," says Marion. "Everybody's doing their own thing."

They've traveled through many changes, but the one thing that remains the

same is that they're best friends and sisters. In fact, Rita and Marion could be viewed as the *quintessential* sisters. They trust each other. "We could tell each other secrets that we didn't tell anyone else," remembers Rita. "I knew if I told her something it wouldn't go any further."

They learn from each other. "Rita is more patient than I am," admits Marion, adding that as a result, "I try to be more patient with people." She in turn encourages Rita, who is soft-spoken, to be more vocal. "I tell Rita to speak up. Don't let anyone take advantage of you."

They help each other. When Rita, a first- and second-grade teacher, was apprehensive about teaching pre-kindergarten, her sister, already a Pre-K teacher, helped ease her worry and showed her the way. "She kept telling me 'Oh you'll be able to do it. It isn't hard.' She was really my backbone, my support in that. She helped me plan my lessons, and after that it was smooth sailing."

"Once she got into the program, she was coming up with ideas, too," says Marion refusing to take all the credit. "We would talk just about every night. She would share her ideas with me, and I would share whatever I had with her. In fact, we did this even when we were teaching first grade. The things we told each other sometimes worked and sometimes didn't, but we helped each other quite a bit and it was great."

They are there for each other in times of need. When Rita's husband of twenty-three years died, "Marion was the one who really helped me the most. I would go to her house every day. One day she said to me, 'I'm going to take you to the hairdresser and get your hair fixed.' And over to the hairdresser we went. From then on I just sort of came out of my shell. That was just the little boost I needed."

They say there's no great secret to the sisterly bond they share, they simply like each other and always have. But if they had to cite a role model for sisterly dedication, their mother and aunt come immediately to mind. "They were just like Marion and me," says Rita. "And they talked every day just like we do. They went places together, did things together." Adds Marion, "They were very close."

Sorority Sisters: Ayana Mandisa Davis, Virginia Blalock, and Flozie D. Vaughn

ALPHA TO ZETA

During a time in this country when Black women were not permitted to join white sororities, they did something powerful: they established their own. Since then, millions of sisters have joined the ranks of our Greek letter organizations—Sigma Gamma Rho, Zeta Phi Beta, Delta Sigma Theta, and Alpha Kappa Alpha—in pursuit of fellowship and community service. Here, in her own words, a member of each organization speaks on the sisterhood from a sorority perspective.

Ayana Mandisa Davis
Alpha Kappa Alpha, Theta Epsilon Omega Chapter, Hartford, Connecticut

ALL OF MY LIFE MY MOM has been an active member of Alpha Kappa Alpha Sorority, so that showed me what it meant to be in a sorority long before I pledged. As a child, I often accompanied her to various sorority functions. I got a kick out of looking through the scrapbook she made when she pledged the Beta Xi chapter at Central State University in North Carolina. Or I'd pull out her college yearbooks and challenge myself to find Mom, my godmother, and my brother's godmother among the perfectly assembled AKAs pictured in their crisp white shirts, knee-length black skirts, and sensibly heeled shoes. I had even attended two boules [national conventions], where I got to meet the directors and various members of AKA prior to becoming a member myself. Maybe it was the "Hello, Soror" Mom got from a total stranger as we walked through a shopping mall, or the proud way she sported her pink-and-green "AKA With an Attitude" T-shirt, or all the

cards and notes she'd receive from sisters near or far, but I just always knew I wanted to be a part of this organization.

Attending Spelman College in Atlanta always made me feel like I had a lot of sisters, so I chose to pledge the graduate chapter of Alpha Kappa Alpha in my hometown of New Haven, Connecticut. There were six of us on line, ranging from ages twenty-one (me) to fifty-something. In the course of pledging I learned just how much I had in common with my line sisters. One used to work with my mother and remembers when I was born. Another shares my love of writing and has invited me to creative writing retreats. And one sister, in particular, I'd always known as mother to a friend and administrator at my high school, but in the years since we've become sorors I've really gotten to know her and have come to respect her sense of community activism.

Being part of a sorority can be like having actual sisters in some aspects. As with a family, there are often disagreements and differences of opinion, but in the end we have each others' backs. I try to look out for my sorors professionally and otherwise.

What I like about sorority life is the fellowship between successful, motivated African American women. Knowing that we have a presence in the community as upstanding, culturally connected, college-educated women is quite awesome. AKA was the first Black Greek sorority, founded in 1908. I always pride myself in being a part of the first and finest! And many of the women I admire are members.

I always try to encourage other women to join our worldwide sisterhood and hope that they get as much out of it as I have. We represent more than 150,000 women from diverse backgrounds with varying occupations and interests. Gathering our resources collectively is an effective way to initiate change for Black people in general and Black women in particular.

Flozie D. Vaughn
Zeta Phi Beta, Delta Alpha Zeta Chapter, Brooklyn, New York

I was close to forty and had been out of school for twenty years when I decided to leave my job in New York City and return home to North Carolina to attend Fayetteville State University. At first I wasn't really interested in joining a sorority, because I was there to get my degree. Besides, I saw it as something mainly for the younger women on campus.

But the more I spoke with some of my professors about various sororities,

and observing how the young women who were members carried themselves, I grew curious. The thing that also attracted me was the community work they did. I always figured if you wanted to help someone, it was easier to do it in a collective way as opposed to individually.

I decided to join the Zetas because those were the ladies on campus who seemed a little bit more reserved, and I liked that. The others were more boisterous. That's not to say that all other sorority women are—just the ones that I'd observed at my school. The Zetas were just very quiet and studious. I used to watch them around campus and got to know some who were in my class, but when I attended their rush I got to see them up close.

A few of the older ladies who were in school with me talked about joining a sorority, but I was the only one who eventually did it. My three line sisters didn't mind that I was older than them. They had no objections. But some of the sorors would ask me why a person my age would want to go on line in undergraduate school.

I went through the hazing, but it was probably easier for me because I lived off campus. When other students saw me on line they didn't really seem to make a big deal of it. Of course, when you're on line you're not supposed to talk to anyone except your line sisters, big sisters, and professors of course—nothing takes priority over your academic studies. We had to dress alike and we went through hell week and all of that, wearing long black dresses and veils during the "mourning period." One of my professors asked if someone had died in my family.

If I'd gone to a white university, I probably would not have pledged. It just seems like Black colleges are more supportive of their Greek organizations, and I like that. What I found interesting was how being part of such an organization seemed to inspire a greater sense of sister- and brotherhood among the student body in general, because everyone would come out in support of various Greek activities.

After graduating I returned to New York. To be honest, I don't stay in contact with the women I pledged with. Everyone's living in various places. But I did transfer to the Brooklyn chapter of Zeta. I feel a sisterly connection with my sorors—I love them dearly, I feel a closeness. I would be exaggerating if I said I met a soror who I feel as close to as I do my own sisters. It's not the same. I've tried to get my sisters to join, but they were never interested. They'll travel with me to various Zeta functions and boules, though, and we always have a good time.

Socializing is nice, but like I said, I joined a sorority to give a hand to those in need. When we go into the shelters and feed the homeless, or visit the sick in

hospitals and nursing homes, I feel good about being a part of it. I'm not there for everything we do, but I'm active.

Any woman who wants to be involved in her community should consider joining a sorority, especially younger women who've just graduated. Our communities always need help, and we need to be out their to help and encourage people. I like the idea that our sororities and fraternities work very hard to give scholarships to deserving kids who wouldn't ordinarily get an opportunity to go to college. Join and be an inspiration to someone.

Virginia Blalock
Sigma Gamma Rho, Alpha Iota Sigma Chapter, Savannah, Georgia

We didn't have a chapter of Sigma Gamma Rho at Savannah State College when I went there, but later my friend Fannie Jenkins, who was a member, started a graduate chapter in town. My sister and I were known in the community because we participated in all kinds of things, so they really wanted us to join because they thought we would be an asset to the sorority.

Four of us were inducted into the Alpha Iota Sigma chapter in 1944. We had to learn the Greek alphabet, the sorority pledge, and memorize facts about the founders, like where they were from and how the organization got started. That was a lot of memory work there, but that was it.

Once we were in, my sorority sisters and I did a lot of things together, like go to the movies and hold picnics and other socials. And we were very good at dealing with the youth in our area. We'd hold plays and musical productions every year, and invite the children to come out and see it for free. And we did a lot of other good things, like making food baskets for the underprivileged and sewing for the older people in nursing homes.

I was an active member for years until the sixties when we went through a period of bad leadership. Members stopped coming, projects went uncompleted, and eventually our chapter just went down.

Then in 1985 my soror Gwendolyn Goodman and I decided that we were going to reactivate Sigma Gamma Rho. We went to regional sorority meetings and a few boules to learn how to get our chapter up and going again. That helped a great deal because we'd get a lot of good ideas and suggestions.

We contacted all of the members who had been Sigmas before and encouraged them to come back. It was a job getting them to rejoin. I continued doing

community work after we had disbanded, so I used my resources to set up projects that we could work on. It was a lot of work but we did it, and I intend for our chapter to remain as long as possible.

In 1987 we established an undergraduate chapter of Sigma Gamma Rho at what is now Savannah State University. Unfortunately, we've had quite a time trying to retain members there. They either move away after they graduate, or some don't maintain their grade point average to stay active. But sisterhood means sticking together through thick and thin, no matter what the obstacles are. So we've begun to reach out to high school girls with hopes that they will join us one day and help to carry on our legacy.

The Tenison Sisters: Rosie and Renee

BODY DOUBLE

36–24–32. *Times two.* That's one way to look at twins Rosie and Renee Tenison. As models and actresses, they work what their mama gave 'em, appearing in magazines, advertisements, commercials, and on television. There's even a Tenison Twin website and two pin-up calendars where they strike sexy poses wearing little—or nothing. Yet, while looking gorgeous pays the bills, Renee and Rosie say being sisters is really what helps them get joyfully through life.

Renee, according to Rosie, is the more outgoing of the two. "If there's something that I'm unsure about doing, Renee would probably do it first," describes Rosie. "She likes to talk, and she's very personable, really caring, and a good listener. If I ever have a problem, she's the one I run it by first."

"I think with twins, one will take on the shy role and the other will take on a more dominant role," explains Renee. "Rosie is a little shy at first, but once you get to know her, she's really funny. Some of the stuff she does is really cute and she just makes people laugh."

"Having one another as sisters is like always having a best friend and confidante, someone you can trust," says Rosie. "We've been through the same things and lived a lot of the same life, so the bond is definitely strong. Our point of reference goes back a long way."

They were born in Caldwell, Idaho, a small quiet town where everyone knows just about everyone else. Their arrival was a big surprise to their parents, who weren't expecting twins. Says Renee, "Our mother had me and they brought her out to show me to our dad, then she went back into labor and they didn't know why." Twenty minutes later Rosie made her entrance into the world.

In the early days, Renee and Rosie were major tomboys, running around the

family farm, climbing trees, and generally just getting into mischief. "We had a lot of animals," says Renee, "and Rosie and I did like every sport there was. Softball, volleyball, track. We were very active."

As teenagers, though, they came into their creative own. "We loved to sew," says Rosie. "We were like baby Versaces, designing outfits on the farm. If we were anywhere else but on a farm it might have worked." Needless to say, their unique fashion statements, coupled with a car they painted pink, raised eyebrows around Caldwell. But they were well-liked and extremely popular in high school, and they both were voted most likely to succeed.

Yet, as two Black girls in a predominately white school, they were never asked to go to the prom or dances. "We didn't get that many dates," says Renee, something that's hard to believe now. "But it didn't matter so much because we had plenty of activities, like band, drill team, cheerleading, and Future Homemakers of America, that occupied our time."

Country life was what they knew well, but they also knew it was not their destiny. After graduation, Renee, at the urging of a boyfriend, submitted pictures of herself to a certain contest. *Playboy* magazine was sponsoring a national search for a playmate to grace the cover of their thirty-fifth anniversary issue. "I didn't really follow *Playboy* that much, but my boyfriend subscribed to it, so I would kind of look at the photos." The next thing she knew, she was being whisked off to Chicago for a cover try, and soon after was selected as the first African American Playmate of the Year in the history of the publication.

"Coming straight from Idaho to *Playboy* was kind of a shock," remembers Renee, who was only nineteen at the time. "I was representing *Playboy* doing interviews, doing *Oprah, Larry King Live,* and all of these things I had never really done before." And being the first Black playmate carried its share of controversy. "It was an interesting time in my life. A lot of people were calling me a role model and a lot of people didn't agree with it because of the nudity."

Back at home it was challenging for Rosie, who was then in college and working at a grocery chain. She had been supportive of Renee throughout the contest and was ecstatic over her success, but, "it was hard because we were so close and then all of a sudden I didn't have my twin. I kind of felt left behind." Naturally, once *Playboy* learned that Renee had a twin they pursued her as well, but says Rosie, the prospect never appealed to her. "Coming from where we come from I was a little more leery." Fortunately, her sister's celebrity made it possible for them to head for the bright lights of L.A., where they say they fit right in.

From dateless in Idaho to hanging in Hollywood, the Tenison Twins were now living the life they had dreamed of back home. They're especially grateful to have each other in the glitter-glam, smoke-and-mirror, beautiful Land of La-La.

"It would be real easy to get swept up," says Renee. "I see it happen all the time. But with Rosie, if I hook up with someone who isn't looking out for my best interest, she's going to tell me, and I can trust her opinion."

"We keep each other grounded and real," says Rosie. "I have someone here who truly cares about me and not what car I'm driving or how much money I have. We're in the big city but we're still small town 'cause we've got each other."

The Curry Sisters: Anna and Clara

SOMETIMES WHEN SISTERS put their heads together the results are lucrative, as Anna Curry and Clara Anthony have discovered. Together they own Sepia, Sand & Sable, a popular Black bookstore in Baltimore, Maryland, and for them it is truly a labor of love.

"It just feels right," says Clara, a longtime teacher in the Baltimore school system, who has worked in publishing and still teaches African American literature. "It's an extension of what we know and love."

"I guess we always thought we might do something entrepreneurial together," says elder sister Anna. "A bookstore seemed natural since both of us had careers that were related to literature and the arts." Owning the store is her second career. She spent twenty-four years as a city librarian and eleven as the system's first Black director.

But honestly speaking, they were into books long before their careers. As girls, says Anna, "We always got books for Christmas and we were always reading." Before there were Black bookstores and a proliferation of books for Black children, Anna's favorites were *Alice in Wonderland* and the now politically incorrect *Little Black Sambo.* "I liked *Little Black Sambo,* I really did. Especially the one where he turns to syrup or something."

"I liked to make up stories," says Clara, whose tastes ranged from *Heidi* and *My Friend Flicka* to the "Penrod" series and poems of Paul Laurence Dunbar. "Our father would recite those poems." In fact, says Anna, "Some of my fondest memories of us as a family were going up on the roof on a hot summer night, before air-conditioning, and having him recite poetry to us." In general, "we were reading or

reciting to our father or he was reading to us. His legacy to us was a great love and respect for ideas, and both our careers and values were shaped by that." Their father's entrepreneurial spirit influenced them as well.

"Our dad had been chased out of his hometown in Georgia by the Klan," says Anna. "He came to Baltimore in his early twenties, sent himself to trade school, and opened his own tailoring and dry-cleaning business in East Baltimore. His shop was called Anthony the Tailor. He taught our mother how to sew, and they worked together for the next forty years."

"Having my own business was always a desire for me because our father was a businessman," says Clara.

And books were never far away from the shop. They could see the library through its plate-glass windows. "My mom took me over there when I was three and I joined," remembers Anna. "All you had to do was know how to write your first name and mine was easy—two *A*'s and two *N*'s. It didn't take me long to master that." Clara joined when she was five.

Sepia, Sand & Sable began as a kiosk in a mall and steadily grew into a full-fledged store that the sisters maintain with a small staff. Anna is the people person. "What I enjoy most," she says, "is the interaction with the public and talking to people about what's good to read." Clara takes care of business. "I do the record keeping and books, and keep up with the purchases."

Together they enjoy the perks of their job as owners and as sisters. "We do things now with the business that also end up being pleasurable," says Clara, including hosting book signings for authors like Earl Graves and Iyanla Vanzant, conducting book fairs, and attending several industry conferences, trade shows, and seminars across the country. "I told Anna we have probably done more traveling together in the last two or three years than we had in the previous ten." Mostly, having a bookstore has been just plain fun for the two who like to pore over many contemporary Black novels. Says Clara, "We'll get excited about the same books."

Yet, she says jokingly, her biggest challenge has been getting Anna to work long shifts. "She tells me all the time, 'I'm retired.'"

"I move at a different pace than Clara," explains Anna, who, unlike Clara, is single and at times is content just puttering around the duplex that they share. "On days when I work from ten until nine P.M. I say, 'Why am I working eleven-hour days?'"

"But she's a *CEO*," stresses Clara. "It's not as if she was slinging hash somewhere."

They may not agree on that issue, but there is no denying the degree of sis-

terly dedication that makes their venture work. "Our parents talked about the need to be committed to family, and there's a certain kind of tenacity which has allowed us to sustain our relationship, even over distance," says Clara. "We've taken that same tenacity into the business—the ability to not give up. The ability to dream. You can't be in business without having some dreams. Those are all the things that were nurtured in our relationship as sisters and as a family that we've brought into this."

And it shows. The sisters say customers often comment on the good vibes they feel upon entering Sepia, Sand & Sable, and for them that is the utmost compliment. "What we hear them saying," says Clara, "is that the level of love and caring and commitment that we bring to it can be sensed when they walk into the store."

Lise, Clara, and Linda Villarosa

MOTHERSISTER AND SISTERMOM

WHEN I BIRTHED MY CHILDREN, we lived in Denver. My first baby, Linda, was perfectly formed, with very light skin and hazel eyes. She cried only when hungry or wet. She often fussed when picked up, preferring her toys in the crib. The second baby born three years later was anxiously awaited by Linda, who was disappointed when her sister "could not play." I expected the second girl to be just like the first, so you can imagine my surprise when Lise was dark brown and scrawny, with green eyes. She cried not only when hungry and wet but when sleepy, and just most of the time in general. Lise was so demanding we nicknamed her the "logger" as she wanted to be carried all the time.

The differences between the sisters became even more evident as they grew older. Linda was tall, neat, disciplined, organized, and conforming, whereas Lise was round, disobedient, stubborn, and a risk-taker, and her room was always a mess. During adolescence Linda presented no problems, behaving like me when I was growing up. Lise broke the rules, pushing me to the limit. The easygoing, compliant Linda rarely needed to be disciplined—"Miss Goody Two Shoes." On the few occasions when she was disobedient, she accepted punishment with no backtalk. Lise would sneak out at night, questioned the house rules, resisted discipline, and demanded an explanation for everything, including parental decisions. I thought, *Why couldn't Lise be more like Linda, they were reared by the same loving parents?*

What I failed to realize until later was that Lise's behavior was the norm for adolescence and Linda's was the exception. It was my expectations and the contrast that made me feel Lise was so bad.

I discovered Linda was a lesbian while she was in college, and as punishment

I said she had to tell her sister. Lise's response was, "Am I one, too?" When Linda said no, Lise replied, "Let's go shopping," as if to say, "what's the big deal?"

After college Linda left for New York to pursue a career in journalism. She eventually became the executive editor of *Essence* magazine. Lise, with assistance from her sister, obtained a job in New York in public relations. She was often annoyed because she was asked, when introduced, if she was the daughter who worked at *Essence*. Both lived in Brooklyn and were never far from each other, maintaining regular contact. Linda developed a writing specialty in health and became the mother of two children. Lise changed careers and became a psychiatric social worker, which was my profession, and she also pursued her passion as an aerobic instructor and a personal trainer.

Over the years, with great pride and joy, I have watched my daughters develop distinctly different personalities and relationships with me as they grew toward each other. Linda became more relaxed, less orderly and conforming, with a more real sense of comfort with herself than I did. Lise in contrast is quite orderly, disciplined and downright anal. She is so much like me as an adult that it's like looking in a mirror. Their positions reversed. They even relate to me in different ways. As grandmother, I see Linda is a wonderful mother. She is warm, giving and at ease in her new role. She asks me for advice in child rearing, personal relationships, and career management. The bond with Lise and me has grown as she shares her issues in her mental-health work and her new role as a coach in private practice. We also take vacations together at least once a year, as we have the same single status and because we all enjoy laughing and having fun in the sun, sea, and sand. They are both my friends.

Now that we all live in New York, there is much opportunity to be together in these middle years. They still live near each other in Brooklyn. I live in Harlem so we can all commune without my having to get on an airplane. Their opposite ways seem to blend but not become rivalrous. Their independent characteristics are more of a match. They are loving, caring, and share interests in movies, theatre, culture, and ballet. They are culturally connected and involved in individual and participatory competitive sports. They show respect for each other's time and place in the family. Linda is agreeable and wants to make everybody feel good. Lise is aggressive—the stubborn Taurus. She tells it like it is and lets the chips fall where they may. They have done some joint writing projects for Nia Online and *O* magazine, focusing on issues related to health and fitness. As a mother, I watch the interactions and see their joy in being together. Their paths were separate, but they con-

dened demeanor. She worked in the fashion department of the magazine where I had my internship, and I frequently visited her office to chat, eat lunch, and develop a closer relationship. I began to look forward to her company because she unveiled a side of me that was unconventional yet feminine. One of the limitations of not having a sister role model is that I was influenced by my brother's b-boy style, and as a result never fully grasped the concept of dressing sexy. Sharon helped me to acquire confidence in my female form. By the end of the summer, we could be spotted strolling down Fulton Street in Brooklyn wearing short-shorts and baby-tees together. Although her style had a bit of exhibitionism, it was always tasteful.

It was easy to be in her presence because she never put on airs. Sharon also challenged me mentally. She has the vocabulary of an Ivy League scholar, and I found myself wanting to carry a dictionary around to better converse with her.

In a period of just three months, I felt comfortable enough with Sharon to confide in her like the sister I never had. In fact, it was not until that summer that I realized that sisterhood was as necessary to my development as having a brother. With my newfound sister, I could talk more openly about womanhood, dating, and the intimate dilemmas that came along with those issues. At last I felt comfortable enough to express my thoughts aloud because I knew that a voice with firsthand experience would respond.

Four years later, the sister bond that Sharon and I had already created was finally recognized by God when she and Daryl got married. The wedding was indeed a prayer manifested. In addition, I also met Sharon's older sister, Michele, and again an instant connection.

Soon after, Michele moved down to Atlanta where I was attending school and that was when we had a chance to build a friendship. Unfortunately, a tragic incident brought us closer together than I could have imagined. Not more than a month after Michele had arrived, I was attacked outside of my house on my way home from work. The experience was shattering—mentally, physically, and emotionally—and Michele was the first family member to see me through it. Her approach to my healing was entirely spiritual. She introduced me to a Christian way of life that was emotionally uplifting and essential to my total recovery from the horrible violation.

We attended church together and eventually joined the same congregation. Over time, Michele and I became so close that other church members assumed we were blood relatives. Although we bear no resemblance, we found it flattering and rarely denied it. Like Sharon, Michele was also instrumental in helping me to discover my womanly power; however, her way was spiritually, through Jesus Christ.

LOVES-IN-LAW

I WAS THE ONLY GIRL in my kindergarten class who absolutely idolized her older brother. With more than eleven years between us, we did more than co-exist, we developed a friendship that became a soul bond. Aside from his typical brotherly antics, he treated me with the same respect he gave his peers. While my friends were being terrorized daily by their older siblings, Daryl was a constant source of comfort for me. His humor, sense of motivation, and role as personal counselor overshadowed any desire for a sister that I may have had.

As I got older, and became more selfish with my brother's attention, the very notion of sharing him with another woman was an uncomfortable reality. I learned to dismiss his girlfriends because I had convinced myself that their affections were merely shallow and temporal. However, as Daryl matured, pursuing of girlfriends evolved to pursuing a potential wife. I felt threatened by the thought of gaining a sister-in-law, so I prided myself on becoming "the final word" in his selection process. In other words, if you wanted to be with my brother, you had to earn my approval as well. Needless to say, I was a tough grader.

While Daryl was busy looking for a wife, I made it my self-appointed duty to judge his choices. Finally, while I was in my sophomore year in college, he met the woman who would eventually tear my guard down. I was nineteen when I met Sharon, and I was instantly impressed. Unlike many of the other women my brother had dated, she acknowledged me as a young woman and not just Daryl's lit-tle sister. In that way, she reminded me of him.

However, it was not until the following summer, when I had an internship at Sharon's job, that I had a full opportunity to see what she was really all about. From the moment we started hanging out together, I noticed her carefree and unbur-

Michele Chatmon, Sharon Pendana, Sakena Patterson

verged as they matured. The support is necessary for a small family and the strong need to maintain closeness. There is mutual respect for each other's talents and capacity. There are times when I see tempers flare up, there are disagreements and the surfacing of the different characteristics that the other finds annoying. They may argue, complain, walk away, or hang up the phone angry, but the relationship is resilient and they always seem to remember that they love each other and that they are sisters.

I raised my girls to be independent and competent. They have each drawn from me the best of who I am. I will always be Mother and they will always be my babies, but we can also now view each other as women. They have the opportunity to benefit from my wisdom and I from their generational experience. We can share common concerns and confidences. Within our relationship we now know each other as women, mother, sisters, and friends.

by Clara Villarosa

Sharon is youthful and relaxed. Michele is more reserved and mature. They are almost complete opposites, yet they have adopted me into their family with unyielding hearts and open minds. In fact, their two distinct personalities are what attracts me to them the most. Together they have highlighted the importance of individuality and strength in being a woman and a sister. For the first time, I became aware of the fact that I could be a sister *and* a woman of my own accomplishments. In retrospect, I can finally admit that there were more than a few elements I was missing in having just a brother.

by Sakena Patterson

Dianne Reeves and Sharon Hill

Jazz star Dianne Reeves is known for singing about the early ties that bind and shaped her life. Her hit song "Better Days" was a loving tribute to the grandmother whose lessons guide her today, and in the delightful "Nine" she eloquently captures the joys of girlhood friendship. After years of Los Angeles living and globe-trotting, she returned home to familiar roots to Denver, Colorado, where reuniting with her older sister, Sharon Hill, has played a significant part of her homecoming.

SHARON HAS ALWAYS BEEN SOMEONE whom I've admired, and as a kid wanted to be like, because she's so amazingly smart. Whenever I have a business question or concern, I always call Sharon because she's organized and on top of things and has this ability to assess a situation quickly."

"I am about checks and balances," admits Sharon, who is sometimes irritated by Dianne's lapses in organization. "She gets a little absentminded simply because she's moving so fast, and she loses stuff. She'll tell me she lost her wallet, and I'll just go into a tizzy."

"My sister is just extremely outgoing and social," says Dianne. "You know, it's funny, I'm on stage and you would think I would be like that, but when I walk off I'm like totally different. Sharon is very charismatic and has the gift of gab, so people love being around her."

"Dianne has a tendency to be a little shy, but it's only because she's cautious about her surroundings. And I can understand that. I enjoy talking to people but

I'm not the best listener in the world. She picks up on things that I may not pick up on and I wish I could do that."

Dianne has the gift of gab, too. "I think the proudest I have been of Dianne is when she does these music clinics at various schools and universities," says Sharon. "She has a good speaking ability and can attract a crowd and keep their attention. I told her she should accept requests to speak a little more often."

But the thing that Sharon really respects is Dianne's ability to make the transition from jazz diva to plain ol' folk. "I've traveled with her and it's like an entourage of photographers, marketing people, and musicians," she describes knowingly. "When she comes home she wants things to be really normal."

Says Dianne, "I have on my sweats, no makeup, and it's just regular." And spending time with Sharon is a welcomed respite. "On the weekends we can talk all day long."

Or they might hang out at their favorite nightclub or spend an afternoon traipsing through the mall. "Shopping is always a wonder with Dianne because she doesn't look at price tags," chuckles Sharon. There's a lot that Dianne likes to share when she's home. "I work in the government, where everybody wears three-piece suits and so forth," explains Sharon. "There's no glamour about it. So she kind of upgrades me."

However, "she eats that tofu stuff, and makes greens with olive oil and garlic," sniffs Sharon, admittedly more of a ham-hock-in-greens-kinda gal. But openminded sister that she is, she'll at least give Dianne's culinary offerings a try. "I figure if I don't experience it, I won't know anything about it."

Much more fascinating for her, though, are their conversations on world affairs. "I mean, the things that come out of her mouth," says Sharon incredulously. "The history of different nations and countries, or her insights into various cultures is just amazing to me, because I'm not exposed to it."

Yet there was a time when Sharon was doing most of the educating. "For a long time she worked for the Civil Rights Commission and when I was in high school she gave me my first job down there with her, filing or something," remembers Dianne. "She would talk to me about different cases, so I was privy to a lot of things that were going on. She taught me all kinds of business etiquette and took me around in circles with a lot of people that I wouldn't have ever had the opportunity to meet." Most of all, she says, "Sharon never talked down to me. She always spoke to me in a mature tone and encouraged me to do my best."

Sharon was also very supportive of Dianne's musical interests and aspirations.

When an underaged Dianne got her first club gig, "My chaperon was my sister," she says. "On the weekends she and all her friends would come and sit while I performed. It was really cool because it was just a happening place to be."

Sharon reflects: "Dianne's always been vocal. You couldn't ignore her. Even in the crib she was always singing and playing with little toy instruments." But then, she says, "Everything we did was surrounded by music and joy." She played the flute when she was younger and their mother once played the trumpet. "We have an uncle who just retired after forty-eight years of playing the bassoon with the Denver Symphony," and keyboardist George Duke is their cousin. "Whenever we got together there was always someone playing the piano or the cello or whatever. There was always conversation about the history of music."

"Across the board our family is very close," says Dianne. "We never needed a reason to gather; we were always coming together. The thing that I loved was the way the elders in the family celebrated all kinds of things. If times were really bad, we never knew it. They took care of business and there was always plenty for us. Our mother and aunt made sure that as children we traveled, even if it was just in Colorado, and that just made us all more like world citizens."

But at that time, all Dianne wanted was to be around Sharon and her friends. "She would get on my nerves, following me everywhere. But there wasn't anything I could do about it because our mom was a nurse and she'd often times have to work nights or afternoons, which meant I had to get Dianne from school and take care of her."

"I can imagine having a sister ten years younger than you and a mother who's saying 'Take your little sister' was kind of hard to deal with," says Dianne, now more sympathetic to her sister's plight. "And I was a rambunctious kid."

But Sharon always knew how to keep her in check. "Once I decided I wanted to go and stay with her because my mother had all the rules," recalls Dianne. "I thought maybe I was going to have a little slack," but Sharon didn't take no stuff. "She put me to *work*. . . . Man, I wanted to go home so bad. She was very, very protective of me, but if I did things that were just really out of line, goodness gracious! She was the force I had to deal with. *Before* my mother."

"Ten years can make a difference during certain ages of your life," reasons Sharon. "She left home when she was a teenager, so I'm sure there are a lot of things that went on in her life that I'm not aware of. But since Dianne's been back, I've gotten reacquainted with my adult sister. We've had a chance to grow closer and stronger. I'm happy she's here."

The Shabazz Sisters: Janice, Hamidah, Sumayya, Djuana, and Simbi

HEALING. IT'S A WORD THAT comes up a lot when sisters Janice, Hamidah, Sumayya, Djuana, and Simbi talk about their relationship. In fact, in recent years it's become sort of a unifying theme. "The whole family is going through a healing process," says Djuana, the sixth child and fourth sister of the family. "So sometimes when we all come together it tends to be, for lack of a better term, like a twelve-step meeting. Sometimes it's rough, emotionally draining. We kind of go our separate ways for a while, but we all come back. And we say 'No work this time, guys,' but it always tends to be some work."

The work is their attempt as sisters to reconcile some of the dysfunction from their past. Dysfunction rooted in the experiences of their mother that seeped into their lives as well. Says youngest sister Simbi, "Our mother is a survivor of incest and rape." At seventeen she had her first child, and by age thirty-three she had six more. Each were by different men: some were husbands, most were not. "I remember not realizing that there was something off about it. I used to brag about it," says eldest sister Janice. In fact, back then she felt they were lucky to each have their own father.

Says third-born Sumayya. "I think I was probably in the fourth or fifth grade when I learned that everybody didn't have the same daddy."

And that fact was sometimes disheartening. "It was hard for me to accept it at first," says Djuana. "I remember thinking that my mother didn't have the greatest character at that point."

Yet, in spite of any shame the sisters may have felt, says second eldest Hamidah, they never let it divide them. "In most cases children [related] like that say that they are half-sisters or -brothers," she says. "We have always seen each other as full sisters."

Much of their life revolved around change as their mother sought ways to improve life for them. A significant transformation was converting from Catholicism to the Nation of Islam, something Janice remembers well. "One year she announced that it would be our last Christmas because she decided to practice this faith and we were all going to be joining."

Another big change came when she moved the family from their home state of Mississippi to Chicago. "I think her life was so turbulent in Mississippi," says Simbi, "she did not want us to have to deal with the same kind of affliction that she did. She found a place to stay and then came back for us."

On the whole, these changes were positive, as their mother progressed from being a domestic worker in Mississippi to working for the Nation of Islam and later for Operation Push. But it also presented the sisters with some tough issues. Janice, a divorced teenaged mother herself, often felt burdened by her family. On one hand, she assumed the unofficial role as caretaker to their mother. "I think we all did to a certain degree, but I felt like I was her friend and her confidante. I took care of her emotionally, and there was a period when I was helping her financially."

During this time, Hamidah was grappling with her own pain. "My grandfather molested me," she says solemnly. "I learned to disassociate and that's how I survived." She does recall one horrific moment as a teenager in Chicago. "I remember being nineteen and sitting on the side of the bed with pills in my hand, popping pills in my mouth and thinking no more pain. It never dawned on me that this was suicide."

According to Sumayya, "It became very difficult living with Mother. I remember her being very affectionate and loving when I was a little girl—sitting on her lap, holding her hand, her kissing my face—but once I started developing breasts, my mother became very distant. There was no closeness, incredible separation. I always knew something was wrong, but didn't know what."

"The level of attention that I probably required as a child I couldn't receive because my mother had to work to support us," says Djuana. "And then my father wasn't there, so that lack of strong male influence really, really played a heavy part in my life." From early on she was consumed with boys and says, "For me, being promiscuous was a way of acceptance, so I found my identity in being good at sex." In addition to sex, she experimented with drugs.

"My mother was not emotionally available. I don't think she knew how to be because her mother never showed her," says Simbi. "We were all just floundering in our feelings, not knowing what to do with them. After a while I think we looked for [emotional support] outside of the house, in all our different ways."

Now, as adults, they understand their mother better. "She's a very determined woman and she didn't have a lot of parenting skills—you do the best you can with the tools you have," says Simbi.

And through it all valuable lessons were learned. "She did teach us how to be self-sufficient and to always be willing to work to get what you need," says Djuana. "She taught us, 'My kids will eat no matter what. I will take care of my responsibilities, no matter what, to the best of my ability.'"

Janice reveres their mother's sheer strength of will. "She's like a bright star whose life's circumstances or society or the neighborhood tried their best to stomp out, and she wasn't having it. The steel would come through."

And to Simbi, it all boils down to one thing: "I think determination is what she instilled in all of us."

Through the years, they've witnessed their mother as she has become an advocate and speaker on behalf of women and youth at risk. And by her example they continue to heal individually and collectively, looking to one another more than ever for support and acceptance. "I don't know how we got to the point we did except by the grace of God," says Hamidah. "We all have come a long way in that we can have conversations and talk about what happened, even with my mother."

This became apparent when, after a long separation from one another, the family, who are no longer members of the Nation of Islam, came together for Christmas back home in Mississippi where their mother ultimately returned. "It was scary. Everybody was nuts because we didn't know what to expect," says Hamidah. "My mother was terrified because she felt we were going to blame her for everything that went wrong in our lives." What began as a heated discussion around the kitchen table late one night became a recovery session where everyone had the opportunity to clear the air. "I saw then that everybody was at some level of healing." And though it is work, they've made a commitment to come together more often.

Through their experience, the Shabazz sisters have a deeper perspective on what it means to be sisters. "I see each of us as part of a whole," says Janice. "I get validation from my sisters. When there's something going on with me or my children, my sisters are the first ones I go to for support and unconditional love."

Says Djuana, "When I think sisterhood I think growth. It's our job to come together to ensure growth. God didn't have to give us sisters—he knew that I needed to have those other people in my life to become who I am and vice versa. I think we need to recognize that we are the tools of one another's lives."

Hamidah sums it up simply: "Sisterhood is unity." Even through pain.

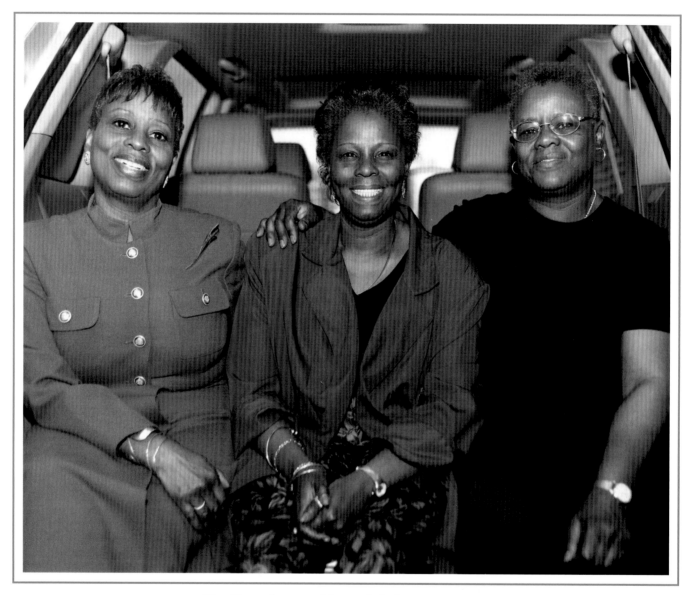

The King Sisters: Mary, Othelia, and Lillie

SOMETIMES SISTERHOOD IS NOT the big hoorahs, ta-dahs, and grand exclamations of life. Sometimes it's just the constant hum of being. Mary, Lillie, and Othelia King don't necessarily make much of a big to-do about their relationship.

"Basically, we, like most sisters, have the same problems and concerns or whatever, and that's all right," says Mary, the eldest. "I don't think we're much different than any other sisters. We each had our own insecurities, ambitions, and jealousies. We even disliked each other at times."

Yet when asked what they did for fun together, or what they get out of their relationship with each other, they respond with heavy sighs, pregnant pauses, and brief answers, if any.

"We have good conversations," says the youngest, Othelia. "We ask each other for advice sometimes."

"Sometimes we give it when it's not asked for," says Mary.

"Sister (a.k.a. Mary) combed all of our heads when we were young. She left home at eighteen. We were excited when she came back at age twenty-six. That's when we started interacting more. Pete (a.k.a. Othelia) and I played together, but we had different interests. Carolyn, another special sister, was the one I played with. She was four years older than me. We played board games and cards together. She took me roller-skating for the first time, told me the facts of life. She died when I was a senior in high school."

Maybe age and temperament factor into how they interact. Mary is ten and twelve years older than Lillie and Othelia respectively. And according to Lillie, "We played together, but I was the tomboy of the family, the black sheep. I was a loner so

I'm looking for a place where I can go off to myself, and I never had that because there were so many family members around all the time." There were twelve children in the family.

Or perhaps it has to do with their upbringing. According to Mary, "When we were growing up we were never allowed to go to other people's houses. Our mother told us don't and we didn't."

"Our mother told us we had enough of each other to play with and we didn't need to go to nobody else's house to play with them," says Lillie.

"I guess that's the reason why we don't socialize that much now, because that was instilled in us," Mary concludes. "Now that we've gotten older, we still do things together, often—shopping at thrift stores, lunches, and holiday dinners. The most fun is when we just sit around talking about the stupid things we did when we were younger, and in some cases, crazy stuff we're still doing now."

And like most households during the early part of last century, the rules were not democratic. "Our mother was a good mother. In other words, she kept the family together, but, she was stern. She was very strict. We couldn't say any thing. With our father, whatever he said went. There was no what he called 'talk back.' It was no discussion there. It was always his word or nobody's word."

In fact, it was their father and his *word* that encouraged the King sisters to work for the same company.

" 'You go to GM [General Motors], they're hiring out there. You go get it.' That was pushed through our heads by our father," says Lillie. "GM was a good place to work, though. The job got monotonous at times, but the people were great. They always kept something going, so we laughed a lot and it made the time go by quickly. I had some great supervisors, one in particular who I called Mr. J because he was the Michael Jordan of supervisors."

"I lived in New York for a while. I wanted to be a clothes designer. Matter of fact, I went to the Fashion Institute of Technology. When I came back to Flint, Michigan, I got a job at a bank, but GM is where everybody around here works. The pay is very good," says Mary, who eventually landed an administrative job at GM.

"I always wanted to be a nurse when I grew up," says soft-spoken (when she speaks at all) Othelia, who came to the auto plant in 1968 at age fifteen. "I planned to do three years at GM and leave, but the money got good and I stayed."

"To be honest, I still don't know what I want to do, but this is not it," says Lillie, though she's done it for thirty-plus years. "I can say I have a good job at GM. I've always had a production job there, as did Othelia. Mary worked in an office as a

senior clerk. By Mary being salaried, she wouldn't get laid off or nothing like that. Strike? They have to keep working. They're what you call the 'big wheels,'" she says, half joking. "So anything that happens to us didn't necessarily happen to her, and she made more money than we do.

"When we were all working, we always met on Sunday mornings and had breakfast to catch up on each other's life. We shopped, bowled, and took trips together."

Like them, their father, too, toiled at the same plant. The King family was originally from Lewisburg, North Carolina. "Our father came up here to Flint and got a job at GM," says Lillie, and they relocated as a result. "He worked twelve-hour days, six or seven days a week."

"He worked production, making the case for the motor," Othelia remembers. "It was hot and muggy, there were no air vents, it was just a lot of fog and stuff around there. It wasn't a place for nobody to work at, really. His handkerchief would be filthy when he blew his nose because all that stuff he inhaled collected in his nose. I think the job really aged him."

"It's aging me," says Lillie, who plans to retire soon.

"Yeah," agrees Othelia. "It's aged all of us."

As the days turn into weeks, and the weeks turn into years, Mary, Lillie, and Othelia simply live and let live.

"I guess I would say we're all human, we all make mistakes," says Mary. "We have to just look at people as people and not as superhuman. Just accept people for who they are, not the way you'd like them to be." And that's how they are with one another.

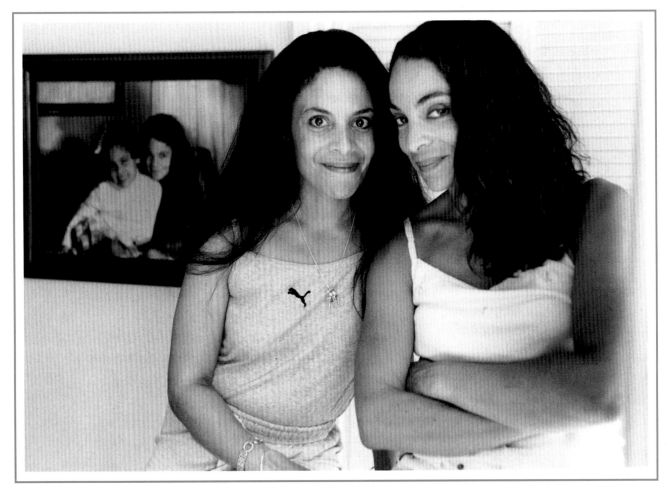

The Guy Sisters: Monica and Jasmine

TWO GUYS FROM ATLANTA

JASMINE AND MONICA GUY are two sisters who define their relationship on their own terms. They have no tolerance for those who assume that they are competitive. "People are always looking for that rivalry angle," says Monica, a dance instructor and former broadcast journalist. "Not all siblings are rivals, and I don't get those who are. That's so far from my experience."

"I think that as you grow up and you live, you have friendships and relationships and they are what you make them," says Jasmine, a veteran of dance, stage, and television.

"Even though in the movies and literature the sibling rivalry thing is a more interesting thing to see, I don't think it is as common in real life as it is portrayed through media. I choose not to live like that."

Instead, they both focus on the positive: raising their children, watching *Oprah* while having great, juicy conversations, reading avidly, and visiting each other at home and on the road.

Sure they've had spats, but says Monica, "They were mainly territorial kinds of things when we were little or just basic stuff."

Such as when Jasmine felt the need to establish boundaries in their shared bedroom. "I had a roommate who would steal my Now & Laters, steal my money, and *lie* about it. She would suck a jawbreaker all week long—put it on the head of her bed at night and then wake up every morning and put it back in her mouth!"

Monica remembers well the limits that were imposed on her. "She had drawers that I couldn't open because they were private. 'My private island,' and 'Don't touch this,' and 'You can't come on my side.' Of course, I didn't respect most of that. But the thought of hurting her or having that evil energy was just

something I dreaded. The few times when anything has ever happened where things weren't right between us were terrible, so we don't even use our energy that way."

"Our parents were also trying to make sure we were individuals and that Monica wasn't in my shadow so to speak. But Monica has a strong personality."

In fact, by the time Monica reached high school she really came into her own, becoming class president and editor of the school paper. "She had her own thing going on. She didn't really need me," says Jasmine. "I think my friends tried to call her 'Little Jas' for about a week."

It was during this time also that Jasmine began to regard her sister differently. "I started to share more with her, and started looking at her as a person and not my little sister. I would talk to her about boys and friends of mine, where as before I was very private about it because I thought she was still a little kid."

Having her sister as a friend and confidante became increasingly important once Jasmine struck out on her own at age seventeen. "There were a lot of adult issues I was dealing with being away for the first time—living in New York, paying rent, and shaping my life—and she really had a lot of insight for someone who was still in the ninth grade," recalls Jasmine. "There was a lot of communication on that level that brought us closer together."

While her sister's move may have reinforced their bond, Monica suffered a bit. "When she left home it was very hard because we were always a pair and very close. Not having her there created a very big emptiness in the house for me. And then it was right in the middle of my high school years and we had just become confidantes."

Even now separation is still difficult for them both. "There have been periods when she's gone away, or I've been away for months at a time, out of the country or just really far away," says Monica. "It was hard even though we were talking on the phone every week."

Jasmine remembers a time when talking on the phone wasn't even an option. "Monica performed on a cruise ship for a while and I hated that because you can't call *anybody* on a ship."

Interestingly enough, one of the benefits of Jasmine starring on the long-running NBC sitcom *A Different World* was that it allowed them to see each other regularly. "I had more money, so I could fly home or I could fly her out to L.A.," says Jasmine.

But with that came a certain liability as Jasmine became a recognizable face. "We would go anywhere and just get into heavy, deep conversations," says Jasmine,

but on one such outing they noticed people staring. "We realized at that moment that I was being recognized. It was really weird."

"It didn't affect our personal relationship. It just made us know that we had to be a little more careful," says Monica. "My sister is my heart and my closest friend so when I talk to my friends she comes up naturally in my conversation and so I had to curtail that too because people were a little too interested all of a sudden."

Another adjustment both sisters had to make came when Monica got married and had children, before her older sister. "Jasmine is used to being very maternal and protective and usually based on her experiences she can help me or at least have a feeling for what might happen to me. But this was the first time she had no idea."

Says Jasmine, "My challenge was figuring out how I fit into that trio in the positive way, without being the meddlesome sister-in-law." Jasmine is now married with a child of her own, and it's become easier and they have even more in common.

From girlhood in Atlanta and teenage confidantes to working women to wives and mothers, the circumstances of their lives have changed but their relationship remains constant. "When I look into the future, I see us like the Delaney sisters," says Monica. "Hopefully our husbands will be there, too, but I see us real old together, still doing whatever and being whatever we are."

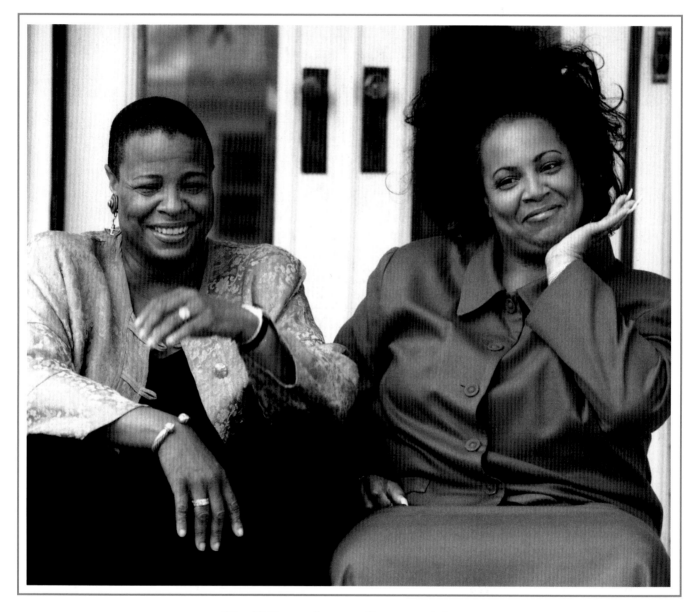

The Williams Sisters: Terrie and Lani

VARIATIONS ON A THEME

I FEEL LIKE SOMETIMES WE GREW UP as individuals rather than as sisters because of our age difference," says Lani Johnson of her relationship with her older sister, Terrie. "Now five years is not a big deal, but growing up, it seemed like ten. I wish we had been a little closer in age."

To Terrie, their separateness stems from something more inherent than age. "I love my sister fiercely," but, she says, "We're very different people."

Both were raised in the same solid, stable environment in Mount Vernon, New York, where their mother and father provided them equally with all the creature comforts of home. Each had a room of her own and a yard with plenty of space to run around and play. "We had a pretty big backyard," recalls Lani. "We used to ride bikes back there and go sleighing."

The whole family participated in leisure-time activities, which included summers at the Peekskill Dude Ranch in Upstate New York, attending the Danbury State Fair in Connecticut during the fall, and regular excursions to Manhattan for museums and theater. "I remember meeting Mike Wallace a hundred years ago at the Guggenheim and my mother telling me who he was," laughs Terrie. "And we would go to the Negro Ensemble Company. That's when Robert Hooks and all those people came through. I saw them early on."

Education was always stressed, especially by their mother. "She was the only one of her siblings to graduate high school, and she took a lot of pride in that," says Lani. "Mommy made sure that we read books in the summer. We couldn't take our vacations unless we read a book, memorized the timetables, or something like that. And she was very involved in the PTA."

Undoubtedly, Terrie and Lani are cut from the same cloth, so to speak, but

their distinctive personalities were apparent early on. Terrie was more academically inclined and participated in activities reflective of that. "I wasn't always an honors student but I was accomplished. I was president of the key club, president of my seventh grade, always held class office, and that kind of stuff."

"I was a bit of a rebel," admits Lani. "I required more attention and needed somebody to stay on me a little more than Terrie did." And her interests were more varied. "I studied ballet for a number of years and I was involved in Girl Scouts and what not."

People were quick to compare the two—Terrie was the smart and outgoing sister, and Lani was the pretty one. "We always *hated* when people did that," explains Terrie, "because implicit in what they were saying was Terry was not as pretty as Yolanda and Yolanda was not as smart as Terrie."

But shunning outside comparisons never stopped them from making their own. As a teenager, Terrie thought that some of her sister's preoccupations were a little superficial. "She spent every *dime* on clothes and makeup. She was really the fashion queen—high fashion, high maintenance."

Lani thought that Terry was a little too straight-laced. "Terry just seemed to have tunnel vision when it came to doing well in school," something she chalks up to birth order. "Firstborns are more driven and they're more sober-minded."

But for Terrie academics didn't necessarily mean isolation. "I had friends, but Terrie seemed to have a lot of friends. She was always very sociable," says Lani. And Terrie's academic focus and sociable ways paid off years later when she established the Terrie Williams Agency, a very successful public relations firm that represents many high-profile celebrities. In fact, she herself has become a celebrity of sorts as an author and speaker, sharing the secrets of her success.

In contrast to Terrie's worldly pursuits, Lani followed a more introspective path, which sparked a spiritual awakening. "I certainly didn't plan to give my life to the Lord, but I had a transformation." As a young woman she was introduced to a "very Godly woman" who she says understood her totally. "She was about eighty-something years old and didn't have one tooth in her mouth, but she was able to tell me things that I hadn't told anybody. She saw my whole life." Lani is currently devoting her life to building a ministry with her husband, the pastor of the New Life Church of God in Christ in upstate New York.

Terrie and Lani may be opposite sides of the same coin, yet they value their relationship—differences and all. "I just feel very blessed to have her as a sister," says Lani. "She's helped me out a lot in my life. She's always been there for me." Like-

wise, she admires the way Terrie, like their parents, extends herself and gives back to those less fortunate. "Terrie is very loving and giving. I mean she's just very selfless in that regard. She really has a big heart like that."

Terrie treasures Lani's gift of discernment and her honesty. "One of the things that I'm forever grateful to Lani for is when she told me that she thought I was too mechanical, too robotlike," says Terrie, smiling. "It just stunned me. I wanted to ask, Where do you get off saying that to me? But because she was so candid and she was giving me feedback, I really appreciated it. To this day I think it's the thing that I'm probably singularly grateful to her for—having the insight, vision, and courage to speak it." And nobody she says makes her laugh the way Lani does. "She cracks me up. It's just the way she says things. Some of the things that she makes jokes about I would consider maybe just a little too irreverent to laugh about. But she will."

Still, between the two there are things that are unspoken and remain unsaid. Terrie hints that she would like to see Lani come more into her own and be a little more independent. And if Lani had her way, Terrie, too, would walk in the light of Christ. Certainly these things would bring them even closer, and isn't that the goal?

Says Lani, "I would really love for us to share God together, and I think once that happens then a lot of other natural things would follow." But Terrie, also a regular churchgoer, abides more by the if-it-ain't-broke philosophy.

"I don't think about it like that," she says. " I do feel that we have a strong bond. And I think that both of us, given our lives, are doing the best we can. I don't feel like I need to force something else. I think it's what it's supposed to be."

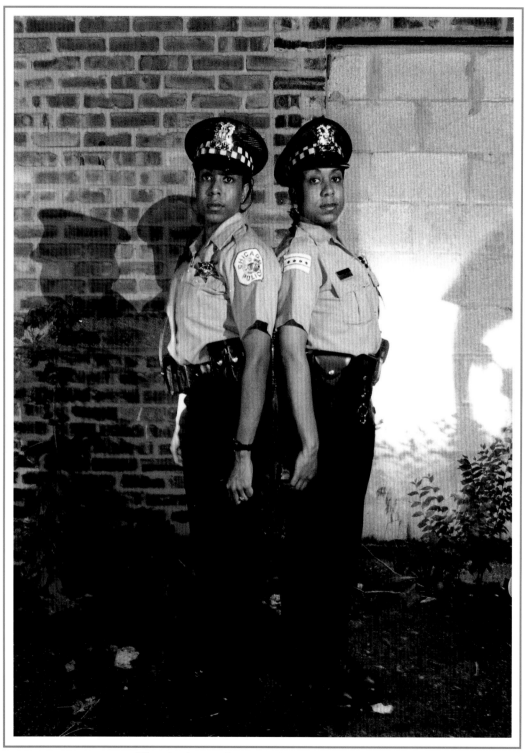

The Andrews Sisters: Stacy and Marcia

TWIN FORCE

BEFORE STACY ANDREWS could qualify for the Chicago Police Academy there was a little test she had to take. "I had to do a 1.5-mile run in like 16 minutes and 30 seconds," for her a daunting task that had her fretting for days. Her sister, Marcia, had successfully completed her run weeks before and was well into her academy studies. But Stacy still had a mile and a half to go before she could join her. "I was so stressed out about it, Marcia said, 'Well hell! Do you just want me to do the run?' " She admits it was a very tempting offer. After all, they are identical twins, so who would know? Ultimately, her better judgment won out. "I thought, I need to do this for myself." But it was nice to know that her sister was willing to go the distance for her.

Doing for the other is second nature for the Andrews Twins. When Stacy was in the process of buying a house through a city program and Marcia expressed that she wanted a house, too, "I just grabbed enough information for her and showed her how to do it," says Stacy. When Stacy had dental surgery and was in too much pain to get her prescriptions filled, it was Marcia who came to her aid on one of the coldest days of winter not even a month after having a baby. And interestingly enough, when Marcia, a more conservative dresser, began working in the street crimes unit and needed clothes for undercover work, she turned to Stacy. "I said, 'Give me some hooker clothes,' " she jokes. But according to Stacy, Marcia wasn't that specific at first. "She said, 'I need something out of your closet to go out on a mission,' " recalls Stacy, who was kind of flattered at first. Upon learning the details of that mission, however, "I thought, I'm insulted." Nevertheless, she came through.

Stacy and Marcia are identical twins in the truest sense of the term. Beyond looking alike, they also share the same doctors, dentist, beautician, bedroom furniture, cars (in different colors), and at various times in their adulthood the same living quarters—a dorm room, apartment, and house. It's not unusual to see them sporting the same hairdo or turning up someplace wearing the same outfits. It's a twin thing.

But there are distinctions, as they like to point out. Says Marcia, "Stacy wouldn't fight back when we were younger."

"My whole demeanor isn't like that," explains Stacy. "I'm more personable than Marcia is, not to say she's not friendly. I'm more *yak, yak, yak.* I talk a mile a minute and to everybody. Marcia is a little more feisty."

And contrary to how things may appear, both say things between them aren't always hunky-dory. "Last year we didn't speak for a month," says Stacy. "We'd be like a married couple," says Marcia about their disagreements. "People would get into it and take sides, then we'd get back together and they'd be out."

"And it used to be physical when we were in our twenties," says Stacy, resulting in scuffed walls, broken possessions, and hurt feelings. "I mean we had fights, but we finally learned that that's not the way to go."

Ironically, the way in which they interact with each other is sometimes misunderstood, or viewed as unreasonable by people closest to them. "That really does mess with our relationships a little bit because if I need something I don't necessarily go to my fiancé, I'll go to her first," says Marcia. "So we kind of ex out men— 'I don't need you to do that, I got my sister.' "

Says Stacy, "We have to explain to our significant others that it's a different type of relationship and a different kind of bond that they have to deal with—and they're like, 'That's a bunch of crap'—but it is. Everyone knows that Marcia's place [with me] is primary. My husband doesn't understand that I treat her with as great an amount of urgency as I treat him. Sometimes even a little bit before him."

Their mother in particular has always been cautious about the way they interact as twins. "Our mother always wanted us to have some kind of individuality," says Stacy, recalling how she would buy them the same outfits but in different colors and requested that they be put in separate classes in school. "I think we do to a point, but to another point we don't. Where Marcia starts I finish and where I start she finishes, and nothing can ever change that."

Still, their mother suspects that some of their mutual achievements are based in unhealthy competitiveness. "She figures everything Marcia and I do is out of envy

because when I do something, Marcia does it immediately after, or when Marcia does something, I follow suit."

"I don't look at it that way," says Marcia. "It's not, 'My sister has this so I'm going to do one better.' It's whatever I have I want my sister to have because we should be at the same level. Stacey didn't rush out and have a baby because I had a baby."

But she sure was there to help, and they laugh about what happened in the delivery room.

"Stacy was on my right side," says Marcia, "and she kept saying 'Push! Push!' and slapping my leg," giving the attending nurse cause for concern.

"She was saying she couldn't push anymore. I was hitting her and the nurse thought I was really mad at her."

Luckily their mother was on hand to alleviate the nurse's alarm. "She said, 'Ah, don't worry about that,' " remembers Marcia. " 'That's her twin. They're cool, they're all right.' "

The Garrett Sisters: (top) Lynda and Sandy; (bottom) Elizabeth and Sally

SISTERS IN MATRIMONY

WHEN ELIZABETH GARRETT took a job at the general store in her home-town of Scottsdale, Virginia, back in 1948, finding a husband was the last thing on her agenda. "I took that job straight out of high school to help support my family." But as she diligently stocked shelves and helped customers, she caught the attention of a young freight truck driver who made daily deliveries to the store. As she recalls, it wasn't love at first sight on her behalf. "I was always making myself busy with chores around the store, so I never paid him much mind when he would come in," says Elizabeth. "Then one day when he came in, the man who owned the store had stepped out so I had to sign the delivery slip. He said, 'I wondered what it was going to take to get you to talk to me.'" Once acquainted, Elizabeth quickly fell in love with Robert's warm and easy-going manner. They began dating and within a year they were married.

Two years later, her younger sister Sally also became a Garrett by marrying Robert's younger brother Earl. Like her older sister and brother-in-law, Sally didn't fall for her partner immediately. "We had met at my sister's wedding, but I was still in high school and going out with someone else at the time," remembers Sally. Then one day she attended a softball game that her husband-to-be was play-ing in. "We would get together to watch the town guys play ball, and Earl was on one of the teams." About halfway through the game she was struck, literally. "Earl was up at bat and he hit a ball that flew right into the stands and hit me on the leg," says Sally, laughing at the thought of it. "He rushed over to me to see if I was all right, which I was, just a little startled if anything. Later he walked me home and we've been together ever since." Sally admits, however, that even though she was marrying into a family that her family already knew and liked, her father was not keen on the

idea. "At first my father wasn't too cool with me getting married because I was only nineteen." He finally agreed but not without a warning to his daughter's young suitor. "He told Earl, 'I want you to be good to her and anytime you think you can't, bring her back.'" Fortunately for Earl and Sally, that was never an option. After they wed he moved north to New York City to stake out a better life for himself and his new bride, and she followed soon after.

For Sally and Elizabeth, two sisters marrying two brothers was not an oddity. "That kind of thing happened a lot back then in the South, because our communities were small and you got to know all the families that lived there," says Elizabeth. But both admit that in their case, their relationships have been especially rewarding. "Our families are so interrelated," says Sally, adding, "we're close, our children are close—they even look alike." And both women agree that they married well. "Robert was such a good provider for me and our children," says Elizabeth, who with her husband had ten children but lost one in infancy. "I didn't work regularly while the children were young—just some day work here and there—but he made sure we always had enough, and he'd save his money so that Christmas time was always special for us. Earl had that same quality. He and Sally have the best relationship I've ever seen. They are always doing for one another. And when Robert passed nine years ago, Earl stepped in and became a father figure to my children." For Sally, the thing that she has always found endearing about her husband and brother-in-law was their wit and naturalness. "They can be so funny, and they have a down-to-earth quality. What you see is what you get."

A generation later, history repeated itself, so to speak, when two of Sally's sons also married two sisters. Lynda Johnson Garrett was a young fashion journalist when she first met Earl Garrett Jr. Lynda was filling in as a foot model at a photo shoot as a favor to a friend, and Earl was the photographer. He was immediately smitten, but for her the session was not particulary memorable. In fact, when they met again a year later at a party given by the same mutual friend, he had to jog her memory about their first meeting. "He came up to me and said 'I know you, I took your picture,' and I said, 'That has got to be one of the best lines I've ever heard, but you have to come better than that.'" Through his humorous gift of gab he did and they spent the rest of the evening talking. The following day Lynda got another glimpse of Earl's wit when he asked her out for a date to a Betty Boop cartoon festival. "He told me that we had to go Dutch, something that a lot of women might have found insulting, but he was a struggling artist and didn't have much money, and I thought it would be fun." Many dates followed, but for Lynda, who was in a

relationship, albeit a rocky one, Earl was just a cool buddy. During the next ten years, however, their friendship blossomed into a full-blown love affair that was sealed in marriage on Earl's thirty-third birthday.

It was at their wedding that Earl's younger brother Anthony met and was immediately taken with Lynda's younger sister Sandy. And like the three Garrett unions before, it also took this Garrett-to-be a while to warm up to the prospect of what would ultimately become marriage. "Anthony would ask Lynda and Earl about me. I thought he was funny and cute, but I didn't think much more about him beyond that," Sandy recalls. A year later, after the four went on a double date, Sandy changed her tune and began seeing Anthony. Soon after, they, too, were married. Says Lynda, "I remember my father joking with Earl's father at the wedding, saying he was all out of daughters, but if Mr. Garrett wanted to marry off his younger son he had a granddaughter."

Like their mother- and aunt-in-law, the younger Garrett wives have enjoyed the closeness of their relationships. They, too, have shared the good times of reunions and get-togethers, and the sad times with the death of Lynda's and Sandy's father followed only a few years later by the tragic murder of their mother and sudden death of Earl, both within six months' time. "It's ironic that we and our husbands come from families of five children—three boys and two girls—where the oldest siblings are now deceased," observes Sandy. Unlike the older Garrett women, however, neither Lynda nor Sandy have children. And there's no denying that some of the same traits that attracted Elizabeth to Robert and Sally to Earl exist in the younger Garrett men. "They are smart men with a winning sense of humor," says Sandy. Lynda concurs, adding, "They're no-nonsense type of men, yet they're not afraid to laugh at themselves. They'll break a heavy moment with humor."

The Shabazz Sisters: Ilyasah and Malaak

BETTY'S GIRLS

Attallah, Qubilah, Ilyasah, Gamilah, Malikah, and Malaak Shabazz. The picture of the older three as young girls, seated with their mother, Dr. Betty Shabazz, left an indelible impression on us. The youngest two, twins born soon after their father, El-Hajj Malik El-Shabazz, the revered Malcolm X, was slain, are rarely seen. Since then, on occasion we've caught glimpses of them in the media, appearing elegant, composed, regally guarded. How has life been for them in the face of tragedy? What are the joys and struggles that they have experienced as sisters? The photo-ops and TV footage give no clue, but here third-born Ilyasah and Malaak, the youngest, converse on their unique bond.

WHAT WAS IT LIKE GROWING UP AS SIX SISTERS?

ILYASAH: Like all sisters, sometimes we have our ups and sometimes we have our downs. But we're like a big crew. We're like a lot of sisterfriends. The fortunate thing about growing up with a lot of sisters is that we had a lot of substantial friendships among ourselves.

MALAAK: My mother raised six individual daughters. When you see us separately, you see how different we are, but together you see the resemblance and the similarities by the way we interact. We all went to school together, we all went to camp together, we did a lot of things together. There were enough of us to have a birthday party without having to invite anyone else. Our mother was protective of us. Security was an issue and certain people had limited access to us, so we have a different kind of bond than most families.

ILYASAH: Growing up we were like each other's best friends. Our mother either divided us off in threes—the eldest and the youngest—or paired us off eldest, middles, and youngest. Or we had this system where my older sister would have Malaak as her baby, Qubilah would have Malikah as her baby, and I would have Gamilah as my baby.

MALAAK: I was very close to Attallah, being her baby.

WHAT ARE THE AGE DIFFERENCES?

ILYASAH: We're all two years apart with the exception of Gamilah and the twins, who are a year apart, and then the twins are the same age.

MALAAK: Six minutes apart, but hey, that was a big deal. Malikah got to hold the money on a school trip.

WHAT MEMORIES TYPIFY YOUR RELATIONSHIP?

ILYASAH: Something that really stands out is how we used to do each other's hair. On Sunday we would go to the mosque, all of us, no matter what we did the night before, and then go eat. After, my mother would do each of our hair, washing it, braiding it, or whatever it took. That was like our quiet, special time with our mother. And in turn, that's what we did with each other. Even today some of us wear braids, so it's like "Can you braid my hair for me?" One of our neighbors was telling someone that she always saw one of us doing another's hair and to her it looked like our expression of love. In retrospect I guess it was.

MALAAK: I used to come home from college and visit either 'Yasa or Gamilah so I could get my hair done. I didn't do my hair until I was fourteen because I was the youngest. I didn't have to. I remember walking around the house with my hair undone, going to the door and getting snatched by somebody. [*Laughs.*] They'd say, "Oh no! You ain't going out like that."

ILYASAH: Not you ain't. "You *are not* going outside like that."

MALAAK: Okay, okay. I'm tired.

ILYASAH: Our mother made sure we spoke well, I just have to say that. If you said any kind of word that you could not look up in the dictionary, you couldn't use that word. Another thing we used to do was watch *Soul Train.*

MALAAK: The *Soul Train* line? We did that. Then the six of us would go in the kitchen and do our "We Are Family" dance routine. We did all kinds of fun things.

ILYASAH: We all went to camp in Vermont, but the two oldest sisters went to Farm and Wilderness and my three younger sisters and I went to camp Betsey Cox, which was the best summer activity we could have ever had. Our mother chose to always keep us busy and active.

MALAAK: It was like a survivalist wilderness camp.

ILYASAH: The good thing about it was that it was multicultural, based on Native American and Quaker beliefs of equality and an appreciation of nature. The cabins were lit by lanterns, the fireplace heated the cabins, there was a lake instead of a pool.

MALAAK: Wilderness living.

ILYASAH: We got to learn how to live off nature, swim, play tennis, horseback ride, boat . . .

MALAAK: . . . mountain hike, square dance. It was an international camp; however, we were the first African Americans there. So we changed the square dance to a disco dance. Our mother sent up all these records. Remember when we had that disco dance?

ILYASAH: [*Laughing*] I do, but that wasn't the square dance routine, that was the social.

MALAAK: It was the social. We brought some flavor up to the camp.

SO WHAT WAS LIFE LIKE WHEN YOU LEFT HOME?

ILYASAH: It seems when everybody went to college, they confronted the reality of Black/White. Our Blackness. When we were in school and camp we were

all human beings, but when we went to college, our colleagues expected us to be these militant radicals coming to campus to start a revolution. Our mother shielded us from the realities of not only America but the world. And so we weren't aware of racism and all that negative stuff that depicts people of color.

YOU MEAN YOU ALL WERE AWARE OF IT, BUT HAD NEVER EXPERIENCED IT FIRSTHAND?

ILYASAH: See, we grew up proud of our heritage. Happy to be Black. We had a sense of African, African American, and Caribbean history. The people you read about, our heroes, we were fortunate enough to be around growing up. A lot of people are not aware of people from the African Diaspora who have contributed to world history. We grew up learning about it, so it was normal to us. From music to politics to business, I mean the whole Diaspora, we knew them all.

We also had Sheik Tawfiq. He was affiliated with King Saud and my father when my father first became a Sunni orthodox Muslim. He was one of a core group of African and Arab Muslims who were trying to teach the true meaning of Islam and not its interpretation. He would come to our house every Wednesday and tell us stories and things about African historians—different things just so that we'd have a good idea or perception of Africa and felt good about where we came from, number one, and knowing that we really did make a great contribution to world history.

SO HOW DID YOU DEAL WITH THE COLLEGE SITUATION?

ILYASAH: It wasn't something we could call our mother asking, "What is this stuff they're saying about Daddy? What is this stuff they're expecting us to do?" I think it would have been too much for our mother. So Attallah is the one we'd go to, to pat our backs and say it's alright. She really made us stand tall.

MALAAK: Because she was the oldest she had a very strong personal relationship with some of the people that were around at that time. She was born an old soul, I guess, and she was aware of a lot of the people around her. There were two images of my father: what we knew and what other people attempted to say. Attallah instilled in me, "Just don't listen." She rein-

forced, "They don't know what they're talking about. Don't even let it bother you. Next!"

Attallah's just number one. You know how on *Star Trek: The Next Generation* there's Captain Picard and Riker is Number One? Well, our mother was Captain Picard and when she was gone, Attallah was Riker, at the helm.

DESCRIBE YOUR OTHER SISTERS.

ILYASAH: Qubilah is the sensitive genius of the family.

MALAAK: Oh yeah, she's the genius. [*Laughs.*] Her I.Q. was off the scale.

ILYASAH: She went to the United Nations International School and was listed in *Who's Who in America.* That's how smart Quibilah is. And very funny. She used to tell us bedtime stories.

MALAAK: They were ghost stories. Scared the crap out of me. She was a great storyteller.

ILYASAH: I would go to her for help in school, and there was nothing she did not know. She's always been the genius of the family. She was fluent in Arabic and French by fifteen. She's brilliant. She graduated at fifteen and went to Princeton and then to the Sorbonne in Paris. Now if you ask me, personally, I think that I was the mother. [*Laughs.*] I had three little ones. From a young, young child I kept my eye on my mother, really studying her, and I became a mother figure at school and at home. I was always the fashion coordinator . . .

MALAAK: Oh, that's for sure.

ILYASAH: . . . the hairstylist . . .

MALAAK: Absolutely. That's 'Yasa. She's the fem in the family. Very feminine.

ILYASAH: How would you describe Gamilah?

MALAAK: Sensitive, a poet, writer, rapper, down. More of the down-by-law kind of girl. My fraternal twin, Malikah, is very creative, maternal, a know-it-all.

ILYASAH: Very self-sufficient. [*Both explode with laughter.*]

ILYASAH: When we were growing up, Malaak was very demure and shy. Once when we were out, she had to go to the bathroom and we pulled into a restaurant. I said "Go in," but she was very nervous. I told her "Go in that restaurant and act like Mommy. Whenever you're in doubt, think of Mommy." It seems like ever since, Malaak has been outspoken and assertive. She's like my mother.

MALAAK: We all have a piece of her in us.

ILYASAH: We're strong, independent voices. Opinionated.

MALAAK: Extremely. When we were set on something, and going to do it no matter what, even our relatives would say . . .

ILYASAH: "That's Betty's daughter."

MALAAK: "Those are Betty's girls."

AS YOU GREW UP, HOW DID YOU COMMEMORATE YOUR FATHER?

ILYASAH: We have a memorial day. But when we were younger we really didn't understand what it meant to my mother. That was the day we stayed at home. We prayed, we did things at home, and we would fight over who would take out the garbage because we just wanted to go outside. We were not understanding.

MALAAK: To this day on my father's memorial and his birthday I don't do anything. When we were in school, we didn't go on those days. We had Malcolm X Day from the beginning.

HOW WAS YOUR MOTHER'S TRAGEDY DIFFERENT FROM YOUR FATHER'S?

ILYASAH: First of all, when our father died, Malaak wasn't even born yet. Our mother was pregnant with the twins. Fortunately, our mother addressed the vacancy.

We didn't feel like we grew up in a single-parent household because we had pictures of our father all throughout the house. We discussed him very often.

MALAAK: It was like he was there with us. We spoke about him in the present tense.

ILYASAH: In the case of our mother, I think with all of us clearly being adults, it was extremely tragic. You can never be prepared for the loss of anyone, especially that of your mother, and our mother just really seemed to be invincible. So when it all happened it was a shock, a major, major blow for us. However, I think it made us all much stronger, and it made us understand her entire plight, her perseverance through life, and even her spirituality. She was our pillar of strength.

HOW DID YOU AS SISTERS HELP EACH OTHER THROUGH THIS AWFUL TIME?

MALAAK: We were just trying to deal. There were the legalities of my nephew [who allegedly started the fire that burned their mother], and the legal issues of [life support] assistance and the autopsy.

ILYASAH: And when she actually did go, we performed the j'naaza [the traditional Muslim burial preparation] for our mother.

MALAAK: That was the last moment that we as sisters had time with our mother. We put her in the coffin and sealed it.

ILYASAH: Even when we were wrapping her, instead of just tying the ends of the material, we made beautiful bows. At that point I think we were really comforting to each other. It was the last time we could be the six babies and our mother. And just as my father had been wrapped when our mother sent him off, we wrapped our mother the same way. That was a beautiful thing, because I think for us we saw a happy ending, that she would be with her husband.

Diane Limo and Bonita Potter-Brown

The Barrett Sisters: Rodessa, Delois, and Billie

eventually put her in touch with her mother, who lived only twenty minutes away from where the sisters grew up.

But meeting her, she says, "was not a good experience." Her mother's reaction yo-yoed from reluctance to loving acceptance and back again, leaving Diane feeling very hurt by it all. "For a while I felt like a basket case because of her." In those times Bonita was truly a blessed assurance. "She would say 'You can't let somebody who has had nothing to do with your life beat you down.'" Bonita would remind her of her many accomplishments and the loving experiences they shared growing up. "She gave me a lot of encouragement and strength. I learned that I cannot change my mother's behavior. I can only change the way I react to it, which is what I did."

Soon after, Bonita would also find her mother, who also lived closeby. Unlike Diane, Bonita had not been searching. "It was basically a fluke," she says, that began when she met a member of her nephew's church who shared her last name. At his insistence, she met his mother who had a strong suspicion that Bonita might be her sister's child. Initially, her mother, who was married with a son and daughter, vehemently denied even having another daughter, "but I guess her sister kept pushing the issue," says Bonita. And after a bit of pushing from Diane, Bonita herself acted on an opportunity to meet her half-brother. "I told him, 'I ain't trying to cause you any problems or anything, but I think I'm your sister.' He told his sister and they confronted our mother." Months later Bonita's mother finally agreed to meet her and eventually forged a relationship with her.

At first Bonita was ambivalent. "She can be very stubborn if someone hurts her feelings," explains Diane. "That's her defense. But I said, 'She owes you like thirty-five years and she wants to do it so let her.'"

"I was happy for her," she continues, "but it did make me more angry toward my mother. Bonita wasn't looking for her mother and it just kind of fell in her lap. I took the initiative to look for my mother and she was pushing me away."

"But I reminded Diane that we already had someone who loved us and took care of us and believed in us," says Bonita, who is now married with her own son and daughter. "I guess if we had been abused or mistreated, the rejection from our biological parents would have been devastating. But since we had a happy, normal childhood, to me finding them was not a big deal."

Now that she knows her biological family, Diane sometimes wonders what turns her life would have taken had she grown up with them. "I don't know where I'd be," she states frankly, acknowledging that there are distinct differences in values between them and her. "Now I see it as a blessing that my mom did not keep me." And the blessing undoubtedly extends to having each other as sisters.

school," says Bonita. "People would ask, 'Why are all of your last names different?' And of course when the case worker would come to our house in that state car."

"Yeah, with that big old symbol on there. That was a big source of embarrassment for us," Diane admits. "There were rumors in the neighborhood that our mother just had us for the money. But we knew better and we knew she loved us."

Bonita agrees. "We were better taken care of than some of the kids who were with their real parents."

"Exactly," says Diane. "We had a happy childhood."

Together with their other siblings, Bonita and Diane enjoyed the typical pleasures of childhood: school and church activities, sleep-away summer camp, family vacations to their mother's home down South, and the delight of always having someone to play with. They also had two doting older sisters who'd round them up for excursions to the park, circus, movies, and picnics.

They were always well dressed (their mother was a stickler for that), and when she wouldn't buckle to their pleas for the latest Pro-Keds or Converse sneakers, they got a paper route so that they could buy their own.

Christmas, especially, was a time when their mother really indulged them. "She would open a Christmas club savings account for each of us so we'd have money to buy whatever we wanted," recalls Diane.

"And she would *still* get us gifts," adds Bonita.

Sure, life was pleasant enough, but didn't they ever want to know who their real parents were?

"I never had the desire," says Bonita, who admits to sometimes feeling angry at the thought of her parents giving her up. "I wasn't going to give them a second chance to reject me."

"I did," says Diane, "but an incident happened that made me not want to do it. Our youngest brother was adopted. When they came to take him he was screaming and hollering because he wanted to stay. Our mother took it really, really hard." After witnessing something so emotional, she says, "even if I'd had the opportunity to go back to my birth mother I just wouldn't do it. Mommy put a lot of love and energy into raising us, and I was not going to hurt her like that."

Years later, not long after Armanda Robinson passed, they actually found their birth mothers, and it was emotional.

Diane, by then married with an infant son, wanted to know more about her family's medical history. Armed with the family records that she was given by a social worker when she turned eighteen, she set out to find them. Ironically enough, her research led her to a co-worker who turned out to be her maternal uncle. He

WHAT'S IN A NAME?

W E'RE DEFINITELY MUCH CLOSER NOW than when we were growing up," explains Bonita Potter-Brown of her relationship with sister Diane Limo. "There was no sibling rivalry, we were just into different things."

Bonita was the "academic bookworm" and family "scaredy cat" who was afraid of the dark. Diane was the social butterfly who hung out with a crew of take-no-stuff tough girls who let their presence be known.

"She was always fighting, and wore a size one," chuckles Bonita.

"I've just always been very protective of Bonita," explains Diane, who was ready to fight anyone who uttered a bad word about her sister.

As close as they are, Bonita and Diane are not blood sisters. Nor do they mince words about the circumstances that joined them.

"The people who brought us into the world," starts Diane, "for whatever reason could not—"

"Or did not—" clarifies Bonita.

"—want to care for us," Diane concludes. "So we were put into foster care—in the system—and we both ended up with Mommy."

The woman they call Mommy was Armanda Robinson, a sixty-something retired widow with two daughters of her own, two foster daughters, and three foster sons. She gained custody of Bonita when she was just five days old, and a two-week-old Diane came ten months after. Two younger foster brothers would later join them.

"It was very atypical to the normal foster care situation where children are switched from home to home," Diane continues. "She was the only mother we knew, so we were like sisters."

"The thing is we never knew we were foster kids until we got older and went to

FOR MORE THAN FORTY YEARS, the renowned Barrett Sisters have been making a joyful noise as one of the premier gospel groups in America. They are the disciples of the classic era in gospel music history that set the standard for much of what we hear today. Their performances—part concert, part revival—enable them to enjoy popularity throughout the world. In Europe, in particular, they are always surprised by how well they are received. "The people there just love us. They can't understand the words or the message from the songs, but they read the feeling that we give. What comes from the ear reaches the heart," says Delois Barrett Campbell, the eldest and central focus of the group.

As young girls, Delois, middle sister Billie, and a cousin made up the trio called the Barrett and Hudson Singers. Rodessa joined the fold after their cousin passed away. But it was Delois who first started singing professionally after she came to the attention of Roberta Martin, a pioneering pianist, composer, arranger, and singer. Her eponymous group served as a training ground for many of the vocalists who shaped the sound of gospel. "One day she came to our church and of course I was in the choir at that time. She heard me sing and then asked me if I would be a Roberta Martin Singer," recounts Delois. "I would sing with them during the summer months until I graduated. And after I graduated I became a regular Martin Singer." During this period, she would still sing with her sisters when she wasn't on the road.

"We were very happy that Delois was with the Roberta Martin Singers because

they were really one of our role models," remembers Billie. "When she would come home she would tell us all about New York, California, and Philadelphia. We would sit for hours and listen to her tell us who she saw. I remember one time she said she was in New York and went to the old Teresa Hotel and there she saw Mr. Joe Louis. She met Hattie McDaniels in California and these noted people that we would hear about on the radio at that time."

"One year we went to California and I met Ethel Waters," says Delois. "She happened to hear us on the radio so she called and invited us to her home for breakfast."

She was also friends with jazz and pop diva Dinah Washington, who also sang with Martin. "I knew her when her name was Ruth Jones. Her mother was a great gospel director, and she would come down to the church and sing."

Even after Washington switched to secular music the two remained friends. "She used to tell me many times, 'Delois, why don't you come over to this side and shake your hips and make yourself some money. Because you know in gospel you don't get rich.'"

But the Barrett Sisters weren't raised that way. In 1961 Ms. Martin got the sisters a record deal with Savoy, and they've made a good living singing for the Lord ever since.

For the Barrett Sisters, singing is more of an inheritance than a job. "Our aunt was a musician over the gospel course, so she really kept us enthused," says Billie. "She's the one that really helped us get together as the Barrett and Hudson Singers when we started off."

They were raised in a two-family house that their father bought with his sisters on the south side of Chicago. Their immediate family, twelve members strong, lived on the first floor, with aunts and cousins upstairs. "It was just a family building there," says Billie. "We had a lot of fun together. We played together, we sang together, we fought—we had our battles—but it was family. We cared about one another."

Since they were the youngest girls in the family and fairly close in age, their bond was especially strong and their father insisted that they keep it that way. And so today Delois and Billie own houses next door to each other, and Rodessa's house is just blocks away.

"He said to be a gospel singer and to be heard we had to be loving and outgoing," says Delois of their father, who was supportive of them throughout

his life. "He didn't want us fighting and instilled in us to always stick together. I was on the road longer and made the biggest piece of money, but he never let me buy three or four dresses and then buy Rodessa and Billie one. He said we had to share, and that's the lesson I've learned and it holds true today. Whatever we have we share."

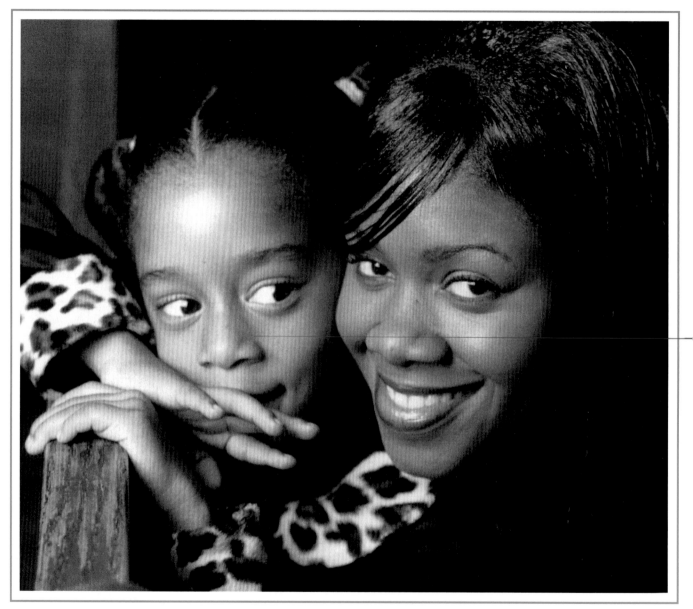

The Reid Sisters: Jacala and Calaya

CAL'S GIRLS

"MY NAME PRECIOUS," SHE SAYS in her Southern three-year-old drawl looking up at me from the living room floor. She is sitting Indian-style, playing with a Blues Clues sticker set I bought her for Christmas. "Calaya, my name Precious," she says again, staring with the almond eyes that we inherited from our grandmother. She searches my face for a reaction to her statement, hoping that I remember what her nickname means and who it came from. "Yes, baby, your name is Precious. You're Daddy's precious baby girl," I reply and smile, glancing away from the television. "Yes, it is," she agrees, and goes back to playing with the stickers, placing them in neat little patterns across the hardwood floor.

I was a sophomore in college when my father announced that his wife, Jamesetta, was pregnant with a baby girl. I was ecstatic. I already had several other siblings, but this was going to be my first *little* sister. Perhaps it is the fantasy of every young girl, to find out that they are going to be a big sister. I used to fantasize about changing diapers, playing mommy, having imaginary tea parties, playing dress-up, talking to her about the cute boys at school. However, that was my dream when I was about six. I was now nineteen and in my second year at New York University. To put it bluntly, I was way too engulfed in my schoolwork to have imaginary teas with anyone.

As I eagerly awaited her arrival, I wondered what role I could possibly play as a big sister. She would probably think I was old—outdated for preferring the Gap to Old Navy, Jodeci albums over Dru Hill. Of course I knew that the situation would be much deeper than that, but I feared being seen more as her square aunt than hip sibling.

On March 24, 1996, Jacala Julia Reid met the world (or, I should say, the world met her) and I do not believe it or our family has been the same since. I was

in school so it took a while before I could get to South Carolina to see her. However, when I finally laid eyes on her I was taken aback. I peeked into her crib to find a tiny yellow little thing with long chicken legs and a head full of coiled, jet black hair. She had my cherry-shaped nose. Then came the true test. I peeled back her baby blanket, removed her socks, and there they were, my feet staring right back at me, huge, huge big toe and all. Beside myself with joy, I thought, She's my baby sister all right.

As she grew into a toddler, the thing that amazed me about her was her connection to our father. She was always up underneath him—always crying for him to come to her side or trying to get to him. As his "namesake," and first baby girl, I must admit that I was not exactly thrilled about this. I was even less pleased about the special attention he gave her. I would often catch him staring at her or smiling, adoringly, as she ate her cereal. As a stay-at-home dad he was her first babysitter, which meant he combed her hair, bathed, and dressed her. I was happy to hear his daily reports as he gave them to me while I was in school, but I was actually growing jealous. Sensing this, he once said, "You didn't know I could do all of this? I did it for you, too." Sadly, I didn't. He spent much of my childhood away from home. While he was my "Daddy"—he was there to say the right joke, pull out a loose tooth, teach me to ride a bike—he was not there for me in the same way he was able to be there for Jacala. For me he was a young father—happy to be a father but still young enough to long for the excitement of partying with his friends and being distracted by the plethora of young women who invaded my grandmother's phone lines.

This is not to say that he was not a good father to me. On the contrary, up until the time he left for South Carolina when I was twelve, all I have are good memories of him. In my home my dad was sunshine. When he walked in the door from work each day the entire aura of the house changed. If you sat quietly you could hear my grandmother humming a joyous tune as she ironed, washed clothes, or watched TV. He usually headed first to the stereo to put on an album from his enormous record collection, then he was off to the kitchen to cook something that was guaranteed to be too spicy for anyone in the house to eat without having heartburn the next day.

We (kids) would sit in the kitchen pretending to watch TV, but were really watching him dance around the kitchen, singing "Endless Love," or some old hit by Barry White. To us he was a break from the other adults who always seemed to be complaining about or chastising us for something we had done or what they thought we might do in the future.

Even in my jealousy I could not deny that I was happy about Jacala and my father's relationship. My father, who had survived a battle with drugs and alcohol, had turned his life around, and Jacala in many ways was the fruit of his reinvention. He was able to provide for her emotionally and physically as he couldn't for me.

Jacala was in the house with our father when he died on January 16, 1999. He had spent his last hours on this earth with her alone. Jacala's own recollection of the occurrences that morning are that "my Daddy fall down in the kitchen" and that he asked her to massage his shoulder (he had a heart problem that made his shoulder hurt), then he asked her to kiss him. Still today, at three years old, she can clearly tell the story of what happened. We still don't know how long they were alone together before a friend came to the door and Jacala—then two—led them to our father out cold on the kitchen floor.

Since his death, my bond with Jacala has grown much deeper. Though we are separated by age, distance, and maternal lineage, we have gone from being just sisters to being "Cal's Girls." Together we represent the immortality and triumph of one man's life. We bring dignity to his death.

I will teach her about our father. Share with her his love of music, spicy food, and people. Her young, fiery spirit already reminds me of his passionate, warm disposition. I must say that it has been a privilege to be befriended by this eccentric little person. I receive unexplainable joy each time I watch her achieve some new feat, be it her first wordlike scribbles or recognizing her name on paper. And I look forward to being there for many future firsts.

by Calaya Reid

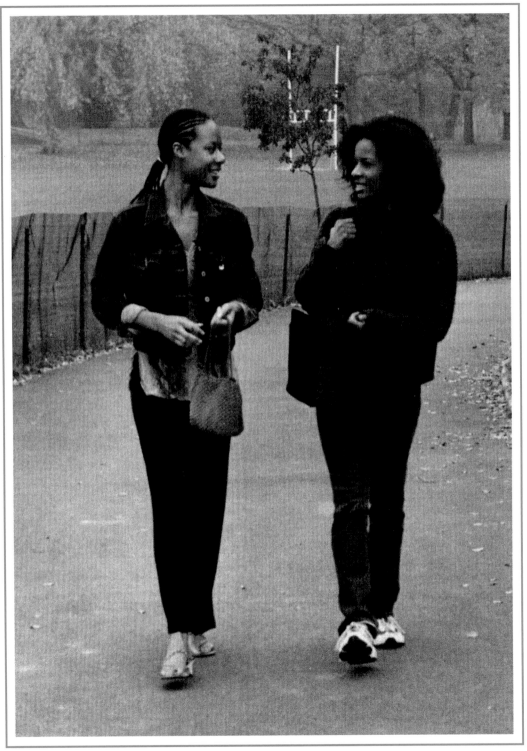

The Roach Sisters: Ayo and Dara

INDIVIDUAL TWINS

They are the daughters of famed jazz drummer Max Roach and esteemed historian and author Janus Adams. They grew up in a rich and stimulating environment of art, culture, and politics that continues to influence their lives today. They share a love for media: Dara is a broadcast associate with CBS News, and Ayo, who works for a film production company, hopes to become a film producer. And they just happen to be twins. But, they say, not in the conventional sense. Here they give their spin on being different while being alike.

ON TWIN-DOM

DARA: We aren't twins that were like raised together. You know, we weren't ever in the same class, we never dressed alike.

AYO: But we were always together.

DARA: We were always together, but we're not like those twins that are like freaks, that are inseparable—drive the same car and wear the same clothes at twenty-five. We don't look identical.

AYO: Like twins—

ARA: —like twins.

AYO: I'm much bigger than you are.

DARA: Yeah, you're a little bigger.

SURE WE ARGUE

AYO: I'm very protective and possessive over you. You, by far, are the closest person to me ever. We have three other siblings outside of each other who are much, much older, so we definitely grew up together, more so than with our other siblings. We still fight a hell of a lot—

DARA: But we get over it. We get over it very quickly. We'll fight—and this is what's very shocking to people who don't know us—and then an hour later we'll be at dinner together, and civil. We fight about everything.

AYO: Everything.

DARA: Just about. Now it's more like personality conflicts, in my opinion. Like you want me to do something, and if I don't do it your way then you know there's a conflict. I heard that phrase when I was ten or something, how does it go? We have to agree to disagree or something. I'm like "Okay, conflict over. We can agree to disagree." But with you it's like *No*. We can't ever agree to disagree, because in your mind there's some kind of issue that must be resolved. It's not going to work any other way. Whereas I'm like "Whatever," you know. I'm much more freer . . . Laid back on some things. We don't argue over clothes or anything tangible. It's more like communications. Communication problems, I'd say.

AYO: I think our arguing keeps manifesting itself and it's like a new problem every few years. Like another big issue.

EGO TRIPPIN'

DARA: You're like my alter ego. We're around each other so much. And it's difficult

when you have someone who's very, very close to you and who's always been there. When you're by yourself you're with somebody. I'm not saying you crowd me, but I'm saying it's just like being by myself. So all of the little things I might say to myself when I'm feeling insecure—that little voice in my head—I have right there, alive and real and in 3-D. That can be a problem because sometimes you don't feel like dealing with that. Other people have the option to kind of turn that alter ego off. We have a three-dimensional alter ego 24-7.

AYO: I never thought about it like that.

HOME IS WHERE THE BAND IS

DARA: Our dad is a bandleader. We had a nice big house, and it was conducive, in his mind, for all these musicians just dropping in and staying on the third floor. It's just that kind of tradition I think with musicians, especially the jazz musicians. You're dealing with a culture that is kind of grassroots more or less. Many of them were coming up in the forties and fifties—people stayed with each other while they were on the road. It's just part of the culture. We had a lot of interesting people around us, always.

AYO: Papa Joe Jones.

DARA: He was a drummer. He's like my dad's—

AYO: Mentor.

DARA: And much older. And then everyone in his band: Cecil Bridgewater, Odine Pope, and Joe Chambers from the quartet. Miles.

AYO: I don't think Miles Davis ever *stayed* at the house. We also grew up with a lot of incredibly huge personalities who definitely influenced our parents' lives and inspired what they did. Everything from writers to theater people to actors to musicians.

DARA: Like Maya Angelou and Sonia Sanchez. They came up a lot. And Sonia has twin boys so we grew up with them.

AYO: Amiri Baraka to the Cosbys. We did have those extraordinary moments with extraordinary people. And got to see and hear things. Memories that I'll have for the rest of my life, that influenced my perspective on everything, especially politically and racially.

DARA: Everything that was happening historically, culturally, and politically, we grew up in the center of. We were being told about politics, and the people and the history and the tradition. It's just like the air and water to us. I think growing up in Connecticut is very important to mention. I think that when you grow up in that environment you have to have a strong sense of self and what is going on in the world. We were lucky enough to be able to delve into that and to have the world come to us. There were very few other African American people in Connecticut. I find that so many kids who grow up like that or who went to all-white schools are really so unfortunate. They have a lot of inner conflicts.

AYO: In spite of all that, I think our mother had our childhood extremely balanced. Our father was away a lot. We did not travel with him and she did not always travel with him either. She was home quite a bit and provided us with a very normal childhood. Actually, most of the time it was normal, but there were difficult times. It wasn't always beautiful times growing up in the Roach house—Dad was a difficult person—and I think our mother really helped us make sense out of it.

THE WONDER YEARS

AYO: Growing up in a predominately white environment, I think to a certain extent there were some advantages. It was beautiful where we grew up, certainly. That was one thing. And we certainly had our friends in the neighborhood.

DARA: We played a lot. We hung out in the neighborhood. In the suburbs, you just go out every day after school. Ayo was really adventurous. She got into trou-

ble pool hopping. We had a big group of friends, and it was touch football or whatever, we were just out in the neighborhood playing.

AYO: And so many of our activities involved coming into the city. I danced a lot, we were both with a dance company when we were eight or nine. It was up in Harlem, so we spent a lot of time in the city working with that company. That was our social life.

DARA: For a minute, yes, doing theater productions, we traveled once a year and we went abroad to perform. But the commute from Connecticut was a lot after school.

EDUCATION BY GEORGE

AYO: Our mother did not want us to go to high school in Connecticut. She wanted us to go to a more culturally and racially diverse school. We ended up going to the George School, a Quaker school in Pennsylvania, which was very mixed.

DARA: High school was really nice because they let us do a lot of stuff. It was all different types of people that we were hanging out with so we were able to go on weekend passes to Philly and New York. It was like "What club are you going to go to?" We were *fifteen* and *sixteen* and we got into clubs.

AYO: The whole Quaker philosophy is very broad. They just allowed us to experiment and to learn and experience more. When I went to college I felt like I had seen so much more and learned so much more and got to experience so much more simply because of my high school years.

HONORARY WHITE PERSON

DARA: George School was extraordinarily political. We had an anti-apartheid day and the whole school was split up in the same ratio of Africans to whites as in South Africa. The whole day you had to role play. You had guidelines—places you could sit, places you couldn't sit, we had to use different doors to get

into the building. You were a Black South African and I was white. We came into the cafeteria and there was this enormous, lavish lunch set up. I thought, this is just school. It's just a game and I'm going to get my sister some food, because they had them in a corner with no lights—I don't even know if they had plates—just some bread and water. I started to walk over there to give you a sandwich and a teacher said "I'm sorry you can't." I said, "Come on, my sister's hungry. She plays sports and she needs something." It was an experience for me. He started to cart me off—I mean he was so serious. He put us both in this makeshift jail.

DOUBLE TIME

DARA: Just about everything we do socially includes both of us. We hang out so much together that the last guy you dated would invite both of us to go out. We have a lot of the same friends, the same circle. We go to parties, mostly industry parties.

AYO: Movies, dinner—my favorite thing is dinner with friends.

DARA: We do that a lot.

AYO: Going to dinner is a big thing we probably got from our family because we grew up having great big dinners and inviting lots of friends and family and talking, eating, and drinking. And we both spend a lot of time with family. It's like a priority. We spend as much time as we possibly can with our mother and our grandmother, and our father who is now seventy-five.

MIRROR, MIRROR

DARA: Unlike other sisters, we're so much alike, and so much of each other, that as alarming as it sounds, we couldn't live without each other. I get everything from her. It's hard to describe but there are these moments where we'll be sitting there on the bed watching TV and just end up staring at each other for hours—not really hours, but like thirty minutes—and not even realize

we're doing it. It's as if I sat at the mirror and looked at myself—looked at my eyes, my nose . . . We can do that with each other without even realizing thirty minutes have gone by. And then we just roll over and watch television. It's that kind of symbiotic relationship.

AYO: I never feel alone because I have you. And I feel very blessed for that. I've learned the importance of loyalty, respect, trust, caring, and friendship. Because of you, this person who is so close and dear to me, I'm more sensitive to those issues and feelings of other people.

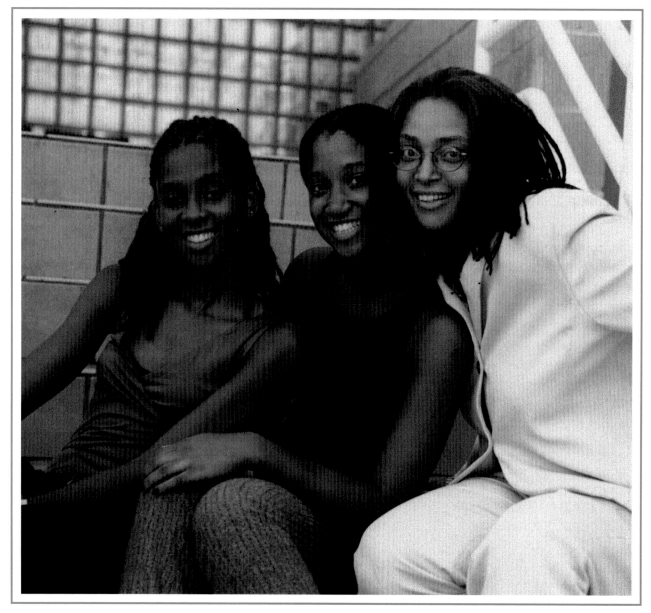

Shawnee Smith, Lori Clement and Lisa Smith-Lemmon

WE THREE

Lisa Smith-Lemmon, administrative assistant, Blumefield, New Jersey.

Shawnee Smith, freelance writer and editor, Jersey City, New Jersey.

Lori Clement, college student, Syracuse, New York.

FROM WHERE WE HAIL

Uniondale, Long Island, New York.

ROLE CALL

LISA: I'm head-sister-in-charge. I provided wisdom on self-respect, getting what you want in life, being happy with who you are, and boys.

SHAWNEE: I think our roles change so much sometimes. Mostly I consider myself the peacekeeper. So whether it's my sisters against our mother, them against each other, Lisa against her husband, Lisa against our father . . . you get the picture.

LORI: I don't know what my position is. I don't have one.

SHAWNEE: You're the head-brat-in-charge.

LORI: You see? Exactly. I'm the youngest one who gets picked on. Everything I do is analyzed. When I'm into something new, they all act like it's old because they've been through it already.

SHAWNEE: Lori is like the "community child." It's like she has three mothers. She's doted on. She's just the collective daughter.

US IN A WORD . . .

LISA: Close-knit.

SHAWNEE: Driven.

LORI: Strong.

DRAMA QUEENS: IF OUR LIVES WERE A MOVIE WITH A SOUND TRACK, IT WOULD BE . . .

LISA AND SHAWNEE: *Sparkle!*

LORI: Which song? "Giving Him Something He Can Feel?"

LISA: Yes, definitely.

SHAWNEE: I would be the brown-skin sister who runs away, and Lisa would be the drug-addicted sister. Her husband would say, "Crawl, bitch, crawl!" [*Laughs.*]

LISA: Yeah, right. He wishes.

THE FAMILY RESEMBLANCE

LISA: Nose?

LORI: No, I've got a big nose.

LISA: Okay, eyes?

SHAWNEE: No, I think Lori's eye are different. I don't know how we look alike. We all share some form of Keyla's [their mother] looks.

LISA: We all look like our mother.

APPLES AND ORANGES

SHAWNEE: I think y'all are pushy, straight go-getters—aggressive from the gate. I'm more cautious.

LISA: I'm the rabble-rouser, Lori needs to learn how to speak up sooner.

LORI: I think you all are nosier than me, especially Lisa.

LISA: And I plan on making a living at it.

SHAWNEE: Lisa has a big mouth.

KIDS' STUFF

LORI: I was the crybaby.

SHAWNEE: And Lisa and I used to fight like cats and dogs.

PASTIME PARADISE: OUR FAVORITE ACTIVITIES

SHAWNEE: Talking.

LISA: Getting together at holidays and discussing family.

LORI: Yeah, analyzing ourselves and others.

BACK AND FORTH

LISA: Our squabbles are usually worked out fairly quickly.

SHAWNEE: Lori and I have recurring squabbles about the stuff that she does at my house. She's lazy.

LORI: I'm not lazy, you're stupid.

THE ESCAPE ARTIST

SHAWNEE: Lori gets away with tons of stuff that we couldn't get away with when we were younger, like coming in at three in the morning, without calling.

LORI: C'mon, y'all think I get away with tons of stuff?

LISA: Yeah, and you do.

STICKY SITUATIONS: DIFFICULT EXPERIENCES WE'VE SHARED

LISA: Mommy saying she was going to move out of the country. Mommy saying she wants to have another baby.

SHAWNEE: How about just saying Mommy.

LISA: Let's try her many boyfriends that we had to deal with.

THE THING I LIKE ABOUT YOU

LISA: I wish I had Shawnee's financial wizardry. She's good with money. She's clear-headed and objective.

SHAWNEE: I wish that I was Lori, in the sense that she's been able to learn from the things that we went through. I see her as the "new and improved" one of us. She doesn't have to reinvent the wheel, she hits the ground running. With Lisa, I would definitely love to be as straight-to-the-point as she is. She's not scared of anything. She calls it as she sees it.

LORI: I think I emulate both of you. I like Lisa's outspokenness and her confidence. Her value of self-worth and self-respect. I like Shawnee's ability to put things together. She holds us together sometimes and she's always there for everybody. I also like her business sense and her connections.

LISA: With Shawnee having her own column at *Billboard* and working for *The Source,* we were able to go to all these concerts. What I admire about you two ladies is that you had a plan early on, whereas my plan didn't come until later. I wish I would

have had the advice to plot my life. I would have been twenty-four with my master's and starting my career, not thirty-one.

OUR M.O.

LISA: We strive for success and we're living our dreams. We're big on creativity: sewing, writing, and making our homes comfortable and beautiful.

SHAWNEE: I think we are feminists. We're warrior spirits, all three of us.

LISA: And sexual.

LORI: We evaluate, analyze, and reanalyze every man that's in our lives.

SHAWNEE: We're very emotional. Very spiritual—Good Lord how dare we forget that. That's number one.

FINAL THOUGHTS

LISA: It's nice having two other women to share life with. I like you all's company and I look forward to spending time with you.

LORI: I consider you guys my friends, my advisers, my people who are going to tell me when I'm about to do something stupid. The people who keep me on track.

SHAWNEE: I consider you two friends, but I look at you more as family. Family you can't do anything with. You couldn't get rid of them if you wanted to. [*Laughs.*]

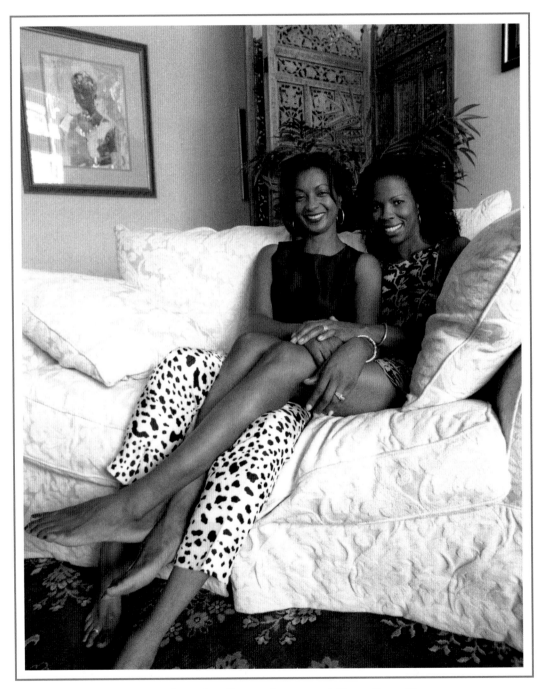

Sisterfriends: Karen Jones and Tyra Ferrell

SOUL MATES

TYRA FERRELL LOVES her three sisters Robbie, Alma, and Glenelle dearly, but "In growing up with siblings, sometimes you treat them like siblings— little sisters or big sisters, and people who can't relate." So when it's time to really let her hair down, she turns to sisterfriend Karen Jones for support. "I can go to Karen and tell her the most outrageous things that I'm feeling or thinking and she won't cut it down or say 'Are you crazy?'"

"She is the sister I've never had," Karen says of Tyra. "I can talk to her without having to explain a lot and she'll know exactly what I'm thinking and how I'm thinking. And sometimes she can actually finish a sentence for me."

Their sisterly relationship started some twenty-five years ago at Houston's High School for the Performing and Visual Arts, where Tyra studied acting and Karen music. "I remember her being very energetic, bubbly, and funny," says Karen.

"My first impression of Karen was that she made me laugh," says Tyra. "I would crack jokes or say something and she'd laugh. I enjoy people who appreciate my sense of humor."

Their humor, however, didn't always go over well in Ms. Gonzales's Spanish class, where they often got in trouble. "She was an A student. An *A-plus* student," says Tyra, "and I was a C student. She would pass and I would be in the doghouse a lot of times because she could party and get an A and I had to be totally focused."

After high school they each went their separate ways, Tyra to junior college and the University of Texas to study acting, and Karen to the University of Houston to study accounting. Eight years later, when Tyra was part of a Dick Clark project that brought her back home to Houston, the two reunited. "It was like no time had

ever passed," says Karen. "Right," says Tyra, "and we started giggling and laughing all over again." But now as mature adults, they hold a deeper regard for the connection.

Says Tyra, "She's just a Godsend as a friend."

Karen agrees. "I think we're like female soul mates. We connect so easily in many aspects of our lives."

"Sisterhood is about an understanding, and being one with somebody," says Tyra. So joined in fact that she says "sometimes it's like looking in a mirror." They use to marvel at the fact that they had the same birth sign, and number in numerology. And later, "We both had our personal breakthroughs with Jesus Christ around the same time, so we could share it. We get on the phone and have prayer sessions."

Says Karen, "On a spiritual level we are still growing, and that is something else that enhances our relationship."

Tyra is a noted film and television actor and Karen has her own real estate company. Even though their careers differ, their professional standards are the same. "We're both very interested in being the best we can be," says Karen. "We work very hard and competently." Moreover, she says, "We are both honest and direct with each other and we have the same value system."

But one time Tyra tried it with Karen and actually went "Hollywood" on her dear sisterfriend. "I was in the process of being this *actor*—you know, the business really whips you into shape. My ego was *so* big, which I thought at the time saved my life," Tyra laughs. "I said something to Karen, and she sent me this long letter, just an F-You letter in so many words, saying, 'You know you're from Houston and you're not better than anybody else because you left here.' When I say things that hurt her feelings, she just lets me have it." Then they take it to the next level. "The thing about it is when we hurt each other's feelings, we stop each other and say, 'That really hurt. Let's talk about what you just said to me.' It's about growth and we'll dissect it until she or I get it."

"We're very analytical—" says Karen.

"—Very analytical," Tyra repeats.

"—in our conversations," concludes Karen.

And there's a whole lot of conversing going on. "When we get together we talk women talk. Before it was girl talk, then it was men talk—it's still men talk," says Tyra, who jokingly calls Karen her therapist.

Karen calls Tyra a "wonderful sounding board. She's a great listener. In my stages of growth she has truly helped me and supported me and just given me posi-

tive words that I couldn't think of myself—that's where she really stepped up to the plate. Tyra's very wise and I truly appreciate her wisdom. She's also very sincere and I value her opinions."

And in an interesting twist, Karen teaches Tyra about sisterhood. "She's helping me deal with my sisters in the way that I deal with her. I'm learning how to enjoy them more."

In an "Ah-ha!" moment, Tyra shares a revelation. "It just occurred to me, Karen, for the first time, that you've never told me I was good or anything in a movie."

[Pregnant pause.]

"This is the point I'm making," Tyra continues. "The reason I hang with Karen is because she doesn't treat me like a celebrity."

"That never has affected me," says Karen. "No matter what role I see her in, I still only see her as my best friend—just the person I dialogue with and have fun with and share with. I'm very good at separating her work from who she is as a person."

But on one occasion they both were star struck, as Karen explains. "We were driving down the streets of L.A.—Tyra's driving. We're approaching a red light, and we both looked to the left at the very same time, and the car is full of *The Jacksons*. And there is Jackie Jackson in the backseat of this car. We both look over and we look at each other, and we *screamed.*"

"I mean at the top of our lungs, like teenagers," adds Tyra.

"And then Tyra steps on the gas," says Karen. "She should be slowing down so we can talk to him, and she steps on the gas."

"I was so nervous," recalls Tyra laughing. "She kept hitting me, saying, 'Why did you speed up?' I just said, 'I don't know.' I just didn't know what to do with Jackie Jackson. It was the *Jacksons,* you know."

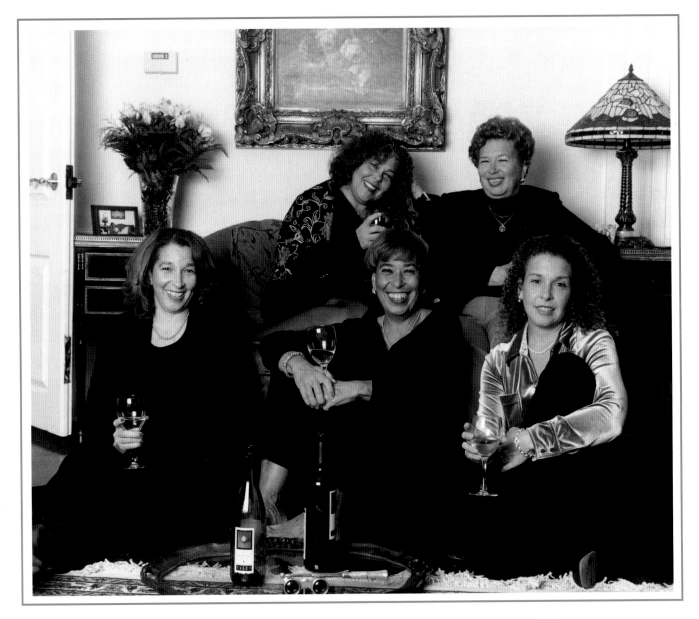

The Wilson Sisters: Dolores, Doreen, Denise, Dale, Donna, and Dawn

SEVEN'S COMPANY

These days, when having three kids seems like a big family, what must it have been like to grow up with seven sisters? Just ask the Wilson Girls of East Orange, New Jersey. They had the same parents and were raised in the same environment, yet each has her own unique personality and varying perceptions on growing up in a full house. Six of the "Seven D's" tell it like it was.

Dolores

Nicknamed "The Warden" by her younger sisters, Dolores always felt that it was her responsibility to take care of the rest of the family and that she had to be tough. Case in point: On a hot summer day, she decided to clean the house while their mother ran errands. To get the job done, she locked her sisters and brother out of the house while she cleaned.

"We were dying the entire day with no food or water," laughs Dale. "But when Mom came home the house was sparkling."

"As the oldest sister I felt this pressure to be a role model for the younger ones. Parents, either consciously or unconsciously, expect the eldest child to conduct themselves in accordance with the values they impose upon them, whether the child agrees with them or not. This can result in conflict with the younger siblings at particular times. I guess I was not as close with my sisters, because I was trying to carry out the values our parents instilled in me. I had to set the standard that they had to live up to. It was burdensome.

"As a young woman, I felt our mother was very docile and our father dominated her. Her life was raising children and I just felt a part of her was being stifled. My father and I were alike and we didn't get along. After an argument with him, I left home at seventeen and eventually moved to New York just to get away. I said I

would never get married (but I did) and I have no children by choice. When my sisters talk about some of the things that went on when they were growing up, I am totally oblivious to it. They've had experiences that I can't relate to because I wasn't in the house. They're closer and I'm removed."

Doreen

Strong, independent, and self sacrificing, Doreen, say her sisters, is the one who pulls everyone together.

"She's like Switzerland—she's neutral," says Dawn. "She's also very funny, quirky and creative—and always has a story."

"I'm strong in that I have my own identity and I am very proud that I can take care of myself and haven't had to rely on anyone else. But there have been times when I've wished I'd been everyone of my sisters.

"I felt like an only child at times, which is so weird when I reflect back on it. I mean invariably I would go in my closet to find that someone had something of mine. And our one phone line always reminded me that I wasn't the only one in the house. But there are times when I felt the focus was on me. I honestly don't remember a Christmas where I didn't get what I wanted. Our parents were not well-off at all, but I always had a feeling of privilege. And I remember my mom being very evident at my Brownie meetings and chaperoning my eighth-grade dance—things of that nature. I don't even know how she got a babysitter."

Denise

Denise was the feisty, straight-A student who worked her heart-murmur condition to her advantage (which she vehemently denies).

"She was very wild growing up—the partyier," remembers Donna. "And that heart murmur gave her a lot of leeway, too."

"I was extremely wild, but I got away with a lot because I was an *honor role student,* not because I had a heart murmur. I was the first one to wear hotpants to school. I led all the school walk-outs. In fact, one time the local newspaper came to our house to ask me when I was going to allow the students to come back to school.

"Even with all the children there were in our family, everyone knew the Wilson house was always open to everybody. My older sisters were always having parties at the house. They would come home and bring their friends and our mother would just say, 'Okay, it's a party,' and get out the soda. I would sit on the steps and peek at them. Or if there was nothing going on outside, we could just come home

The Hathaway Sisters: Lalah and Kenya

going on around me. I try to do that now in my life—have people over a lot and sort of mirror what was going on in our family.

"I was sort of treated like an only child, sort of my mother's last hope. When my sisters were growing up they played with the neighborhood children. I was driven to a private school in another town so all of my friends were actually outside of where we lived. In a way it isolated me more from my sisters, not going to the same schools and having the same teachers.

"I always felt a sense of competition. My mother used to always tell me to be different from my sisters. That was hard because that made six people I had to be different from. I always had a feeling of having to find my identity and my place— where I should go and what's right for me. The other drag was that as the youngest I always had seven mothers."

Like the proverbial elephant described by the blind men, each Wilson's perception is influenced by their point of view. But from the mothering oldest or the mothered youngest, sisterhood is something they all value and cherish. Says Dale, "It's really having somebody who understands you as a friend. You don't have to explain things, they know what you're going through. It's never having to be alone."

borhood park. During the summers we'd have carnivals where our parents would dress up as fortune tellers and all the neighborhood kids would come by. We had a station wagon and the back was painted like a commercial vehicle that read "Seven D's Van." Everybody knew that was us."

Donna

Donna was hands-down the sweetest, quietest sister of the bunch. "I'm very calm and I don't like fighting." But even she has her limits. One night at the dinner table, fed up with her siblings' teasing, "she jumped up and screamed 'I've had enough!' and left," remembers Denise. "We were all laughing and the next thing we knew she came flying back in the kitchen and slammed our brother's crutch on the table—just beating the table, dishes flying and everything. Needless to say, it was a long time before she was the brunt of our jokes."

"I was very quiet and I used to like to play by myself. Because I had a lot of sisters, I didn't have to make the transition of meeting people. Everybody knew I was a Wilson Girl and took me on, so going to school and making friends just came naturally.

"I have fond memories of trips to Martha's Vineyard, packing up the Seven D's Van and spending the summer up there. We pretty much had an account with the ice-cream guy. He would stop in our driveway, and if there were neighborhood kids who couldn't afford to get ice cream, our father would buy it for them. He loved kids and always wanted to give us whatever we wanted. In fact, he was more partial to girls than boys and gave our brother a hard time. But he also taught us a sense of responsibility, that we need to work and not be dependent on someone else. That really throws me to this day, because I'm a housewife, which I had a very difficult time adjusting to."

Dawn

Eight years younger than Donna, Dawn was the quintessential baby of the family—the one everybody doted on and spoiled. "Dawn had blond hair and blue eyes and everybody just wanted to be her mother," recalls Doreen. "We committed ourselves to giving her anything she possibly wanted—you know, shift the earth to the left a bit, Dawn would like it that way."

"Most of the time, when I was younger, there were only two or three sisters living in the house. The rest were married and had moved out. But we always had company over so it never felt lonely. I always felt comfortable with a lot of activity

to a bunch of people. Our father would run to White Castle or the rib place and bring back a bunch of food.

"The best thing about growing up with a lot of sisters is that you always have a close friend to talk to, laugh, and joke or go someplace with. You never have to count on the rest of the world because you have a tribe. In contrast, what's kind of a drag about having so many sisters is there's always a fight. There's always somebody not speaking to another. Right now we're pretty much all speaking. I wish people still had big families. I just think it's a wonderful, wonderful experience."

Dale

Smart, savvy, and sensitive are the words the sisters use to describe Dale.

"She's level-headed and continues to be very successful and thoughtful about doing things," says Doreen. "Although she wasn't the oldest, we would defer to her, and still do, because if anybody could think rationally about a situation, it was her."

"We lived in a big house, and there was always seven or eight of us around, depending on who was living there. And then there were always a lot of people around—friends, and cousins, always. Throughout most of my young life I shared a room with one of my sisters. Part of growing up was that you'd eventually become old enough to deserve your own room. That was like a badge of honor.

"With eight girls there were always lines for everything—a line to get your hair done, a line for the *one* bathroom we had. Everybody had their chores and had to chip in. Denise, however, was able to skate by without doing some of the hard labor.

"Meals were always taken as a family. Dinner was always at five o'clock—it had to be on the table. Somehow our mom always managed to get everything done. Dad was the patriarch of the family and everybody had to serve him.

"In the summer our dad used to do things that we know now were serving two purposes. He'd sit in the yard with this huge vegetable scale and everybody would go around the property gathering pebbles and rocks, and you'd bring them to him and he would pay you a nickel a pound. Well, we were his landscapers. That was his way of getting the yard free of rocks, but he'd do it in an ingenious way to keep us busy and productive.

"There were always games and things that were going on where my parents made our play fun and interesting. For example, my dad had built two swing sets, a merry-go-round and seesaw, sliding board, and sand box that was like the neigh-

MUSICALLY INCLINED

WE DIDN'T REALLY DO MUCH TOGETHER when we were little," says Kenya Hathaway of the early relationship she shared with older sister Lalah. Though there are only two years between them, "there was a maturity difference," she says.

Lalah was the one who was four going on twenty-four. "She was so cute with her little orange Afro, glasses, and little white socks," Kenya recalls endearingly. "She took piano lessons and knew how to dial people on the phone. She used to read us the TV guide and tell us what was coming on. That was her job."

Kenya, on the other hand, fully embraced being the baby of the family. "I can remember being held and not having to walk until I was like two years old," she laughs. "I was still playing with toys and Lalah was reading and doing other things. We were just in two different spaces in the same house."

Differences in personalities often led to straight-up differences with things, like clothes, Walkmans, or the front seat of the family car at stake. Sometimes there were standoffs, "One week here, two weeks there, depending on what got destroyed," says Kenya. Other times it got physical, but, says Lalah, "We would have to finish the boxing before our mother got home or else there'd be trouble."

"The whole concept of sisterhood is just really a complex relationship that you cannot always put into words," Lalah continues. "It's having somebody who is your best friend and confidante, who can also be your worst adversary. We argued and fought a lot as kids, and then at some point Kenya went from being my younger sister to my contemporary."

As adult contemporaries, their distinctions are now more complementary than divisive. "It's like we are different sides of the same coin," is how Lalah describes it.

"We are intense but in different ways," offers Kenya. "Lalah is intensely serious and I'm intensely . . ."

"Whimsical," says Lalah, finishing her sister's sentence. "I know there are people who used to say that they thought Kenya was much more fun and approachable, to which I was just shocked and dismayed because I feel like I'm fun and approachable."

"You are, once people get to know you," says Kenya.

"Right," agrees Lalah. "Get to know me."

"She is actually very funny," laughs Kenya. "A very funny girl."

"Kenya is very organized," says Lalah. "She can look at something from *A* to *Z* and follow it through instead of skipping from *A* to *Z* to *Q*, which is what I generally do. She's very positive and has a lot of energy—just one of those people who can light up a room with the energy coming off of her. I feel like I left my energy in the womb."

"I wish I had the ability to communicate like Lalah does," says Kenya. "Those skills are up there. She knows how to talk to people and not stick her foot in her mouth, and complain *nicely;* and just basically gets things done. If we go into a store that Lalah has been in, the salespeople all know her by name and want to help her again. I love that skill!"

"I'll teach that to you later," kids Lalah.

One of the main things the sisters share is a passion for music, which is something they come by honestly. Their father was famed singer-songwriter Donnie Hathaway and their mother, Eulaulah, is a classically trained singer.

With three solo albums to her credit, Lalah is primarily a jazz vocalist who has recorded with musicians like the late saxophonist Grover Washington Jr., pianist Joe Sample, and composer Burt Bacharach, and performed with the likes of Stevie Wonder and Chaka Khan. Kenya, who plays flute and guitar, is finding her voice in alternative R&B and sings with a band. Ironically, despite their musical lineage and the fact that they hold degrees from the prestigious Berkley College of Music in Boston, both find it challenging to capitalize on their artistry in today's homogenized music industry, and it's a topic of conservation that comes up a lot between them.

Lalah's take: "We're not doing the typical sort of 'black girl' songs that are out right now. I don't begrudge anybody who is, but there are also a lot of us who play instruments, write songs, and are completely clothed."

Kenya agrees. "I'm glad that more of us are making records, but there are

some really good people out there trying to do something new" who are seldom heard.

Yet, given the circumstances, the two remain dedicated to their craft. "We can't throw in the towel, because we have something that we're supposed to continue," says Lalah. "Our father was there so that we could be here, and we are here so that he can be here."

Once at a college talent show, Lalah and Kenya performed what turned out to be a type of impromptu tribute to their father and their sisterhood. "They wanted us to sing 'You've Got a Friend,' " recalls Lalah. "It was probably the first time we had ever sang anything together in public and I think we were both nervous. We were just standing on stage holding each other's hands and singing it. That moment sort of typifies our relationship."

The Ross Sisters: Carrie, Gloria, Rosie, Ruby, Mary Ann, and Dorothy

SISTER'S DAY

ONE SUNDAY A MONTH, SISTERS Carrie, Gloria, Rosie, Ruby, Mary Ann, and Dorothy gather at one of their homes in the Washington, D.C., area to get down to the business of sisterhood. Welcome to Sister's Day, Ross Family—style, a feast of fellowship and food smothered in a gravy of spirited conversation.

"First we join hands and pray," says Gloria, the second eldest in the group. "Then we read the minutes from the previous meeting, pay our dues of five dollars a month, and share the food that each of us has prepared. We close with a prayer."

The sisters plan family activities, reminisce about the old days, and catch up on what each other's kids are up to. Holiday meetings are real special. At Christmas, "we dress up," says Gloria, and, chimes in Carrie, "we exchange gifts." And Father's Day is a big to-do. Then, "we invite the entire Ross Family and friends for a big picnic in the park."

For seven years now, the six sisters from Paris, Virginia, have assembled this way. "After we lost three sisters and four brothers, we decided to do this to stay close," says Carrie, the eldest of the group.

"Our deceased siblings are still very much a part of our lives," adds Gloria. "They are mentioned or talked about at every gathering."

"My sisters are all very dear, caring, and sharing," says Rosie. "I like looking at pictures with them and talking about our family—past and present."

What is the true meaning of Sister's Day? Gloria sums it up. "Each one of us has a different but strong personality. We can agree and disagree and still love each other and remain best friends. Spoken or unspoken, we know that we are always there for each other."

Happy Sister's Day!

Tina Redwood

SKIN AND BLISTERS

GROWING UP IN A SECOND-GENERATION British-Caribbean family was for the most part like a staple diet of curried goat and chips: a seemingly novel experience for those with romantic notions of immigration, but a culinary and cultural disaster for proud Jamaicans and Englishmen everywhere.

We were a family of seven: two parents, brother Jason, sisters Clare, Val, Ella, and me. Contrary to the myth perpetuated by my childhood friends, TV's Huxtalbe clan we were not. If the vast economic difference between the Redwoods and them wasn't enough to set us apart (Dad was one of London's finest, a taxi driver, and Mum a homemaker), then our lack of sibling unity, especially among we sisters, was. Our dad's insistence that we adopt the English sense of irreverence—"Kids, nobody funnier dan de Englishman"—meant the acerbic nature of British culture seeped into our family and gave rise to an intimacy that bore more resemblance to that of a spaghetti-western standoff as opposed to the warm-and-fuzzy escapades of "Sondra, Denise, Vanessa, and Rudy."

Our parents tried to force closeness by restricting our time with neighborhood and school friends, but it never worked and we'd fight. We probably would have respected one another more if we'd been allowed to socialize more. But being crammed into what often felt like a rabbit warren, with no sense of individuality being encouraged, made us all feel desperate.

From way back I remember Dad (Dada to me) referring to us as his "Five Stars." If anything, we acted more like an open hand—I was the "bird." And the older we got, the more I reveled in my role. I was obnoxious because I was smart, mischievous out of boredom, and loud just to be heard—a Bart Simpson template.

I think my sisters appreciated me bringing the court jester factor to my family. My unpredictable outbursts could always be counted on to take the edge off of our various recurring family tensions, which often were silenced with my parents' mere mention of "tanning yuh behin'" with the infamous "belt."

My decision to move to the States was for the most part fueled by a conscious desire to flip the finger at a country that had for years taunted me and mine with "there ain't no black in the Union Jack, so why don't you lot fuck off back." No Black colleges, no Black CEOs, and the Blacks who were "representing" were so enamored of their own position of novelty they made sure Britannia kept ruling the waves and the rest of us stayed seasick.

I needed to heal. I knew nothing about New York and even less about America, but what little I did know is that I wanted to be around Black people with enough bravado and race pride to tell you I know you and I love you and to go screw yourself in the same breath. I *wanted* to heal. To my eyes, Americans were people who lived their lives in full-blown color, as opposed to Britain's constant pewter, and even then I made it my mission to experience that, at least for a little while.

The instinctive feeling I had while boarding the plane at Gatwick Airport was that I'd never see the U.K. as "home" again. It was a moment I'd been working up to since I was eight, when we'd pore over episodes of *Starsky and Hutch* on the family's thirteen-inch Sony black and white, with a coat hanger for an antenna and absolutely no vertical hold.

So it wasn't surprising to my sisters when I announced my decision to leave. At first everyone brushed it off as another harebrained scheme; after all, I'd been the one to devour books about blond kids at boarding school, that I begged my parents to send me to so I could live out my "midnight feast" fantasies. I even got a place at a college outside of London; ensuring contact with my home base was an act of financial necessity. So ten months later, with a ticket in my hands, it seemed natural I'd correct my parents' initial mistake of coming to the Motherland by checking out her beastly and gaudier relative.

Mum and Dad aside, my brother and sisters never cultivated the art of letter writing and over three thousand nautical miles of murky green water was not about to get them to start. Instead, we relied on sarcastic notes stuck to the refrigerator—or our backs—and a real show of affection was a card with the ripe bum of a baboon in heat. When we were kids and as we grew older, we never were the type of sisters who'd hang out together.

We never shared those "common ground" interests. Not movies, books, art,

warm and fuzzy rivalry, nothing. I guess when poverty forces you to survive on one another's carbon dioxide, the claustrophobia was palpable, and the realization that we were not conjoined felt like a life sentence.

But after a six-year stint I've realized that despite my quest for living well—vengeance and a healthy distance for the things that grated on me and stunted my growth—those are in fact the ties that I cling to the most. It's a strange feeling of disconnect. I don't experience it every day or for any serious length of time, but I've certainly come to appreciate the Cockney rhyming slang for sisters—skin and blisters.

Of all my relationships, the most recognizable shift has occurred between my sister Val and myself. Among the four of us we were always the closest. My "little sister," though only fourteen months younger, the person that people frequently thought was my twin. We're now a far cry from the Jamaican expression "batty and bench" (bench and seat), which implies inseparability—now the most simple experience like sharing an elevator feels like being force-fed. I'm embarrassed and frequently guilt-ridden because I know, without having to dig too deeply, that no time soon will I put in the required effort to fix things between us.

After undergoing knee surgery following a sports injury, she still suffers from periodic bouts of arthritis. As testament to our closeness when Val's knee hurts, as far as I am away from her, mine does too. I often find myself making lame attempts at bridge building, reliving the days when we'd talk far into the night, and Mum would bang on the papier-mâché wall with a threatening, "Nuh mek me ha' fi com in de tonight an go a prison fi unno."

Now she's married with two kids and a part-time job, and our present lives have little in common; I'm forever treading the tenuous waters of our connection. It's the relationship that saddens and ties me to my family the most. Through its changes I get to see how far I've come, and at the same time how little progress I've made.

Ella, our family's sweet pea, plays out the baby sister role to the max. The break in the chain with my brother, Jason, didn't, for me, upset the female chain of command. If I am the plug, then she is the socket as far as happening London is concerned. So far, she's the only one who's visited me here—and it was one of those two short weeks spent on our own that our relationship evolved from big sis—kid to two women. She gives the best massages and has a fashion sense way beyond her years. I need her to feel like I'm needed. As someone's big sister, I get to play a specific role.

Like certain members of most oversize West Indian families, Clare is the one who can be counted on for bringing the latest get-rich-quick scheme home and laying on the snake oil shtick. Our age difference seems nonexistent now. Always a diva, she for years occupied the glamorous position of being a Southeast London-version of Halle Berry. Because I realized early on that she'd smoke me for the remainder of eternity in the looks department, I stuck with the accolades of academia and with unnecessary parental carrots and sticks. Her evolution is like a succession of distinct and unrelated characters to me. She's now a card-carrying member of the Nation of Islam, what I call her "holy" phase. I'm very vocal with my criticism—not so much with the Nation, but with her staying power. But we've seemed to have reached a happy don't ask–don't tell theological medium, which for the most part hasn't significantly intruded on our relationship. Her ability to make me laugh remains intact.

Because Clare's conversion happened while I've been Stateside, it initially made me a little more reserved when we first saw each other. I think Clare enjoyed watching me squirm when I'd offer up explanations after she introduced herself as Clare X. So now I avenge myself with practical jokes—like calling the store where she works and asking if she sells pork belly or to speak with her husband, that nice white man Mr. Jones. It's in those moments I realize that underneath the veil, she's still my very cherished twisted sister and I can still tap it.

On more recent trips home, I've seen with painful clarity how much my sisters, Clare in particular, are trying to make sense out of their lives in London, to have something that counts. And when it hits me, I relive all the feelings of resentment and frustrations that fueled my decision to leave the Motherland in the first place.

Even now I have no regrets about living away from Britain, but sometimes I wonder whether the family trade-off was worth it, as none of my sisters have even a remote desire to move Stateside. My "no return policy" may change when I have children, as I'd like them to have a relationship with their aunts and uncle; if only or especially for the fact that I think it would help my child to understand me a little more and fill in some of the puzzle that is their mother.

Ultimately I suspect that what keeps us tied (or chained) to each other is the collective sense of stability the others create. When we're together we're clear about two things: our slight abstinence from the world, and a mixture of shyness, snobbishness, and Jamaican steeliness that accounts for the way we relate to each other. We're tied because of our ability to laugh, with and at each other. I think they're proud of me, although not too surprised at my apparent Navy

SEAL survival skills, as they always considered me a bit of a shark. I want them to visit me, all of us together—with me in Harlem. I want to show the life I've chosen that makes me who I've evolved into, that for me living in New York is as we all suspected, larger than life—at least in comparison with the one we were promised by Britannia.

by Tina Redwood

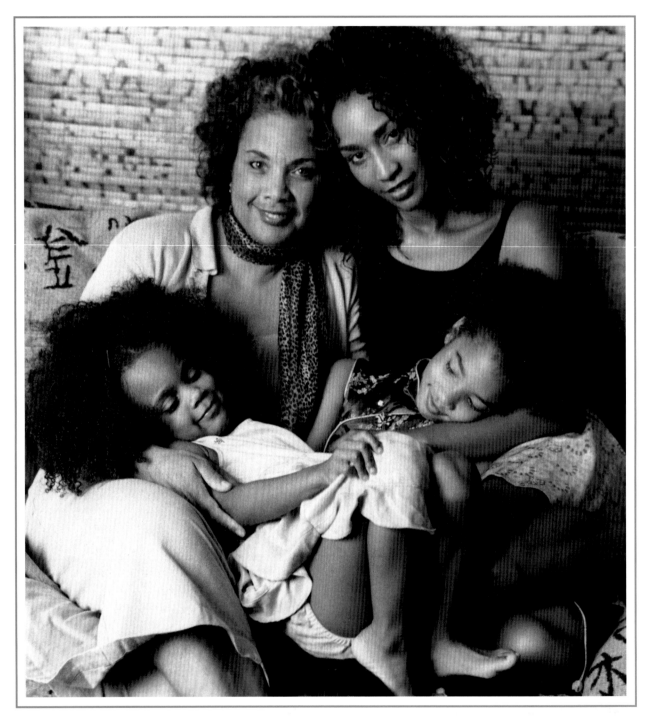

(clockwise from left) Edwina and Sonya Wells,
Alexandria Edwards and Sala Risby (Sonya's sister)

ALEX AND ME

ALEX IS MY *LITTLE* SISTER in every sense of the term. I was twenty-two when she was born. In fact, I'd had a dream that my mother was pregnant, and so I asked her, jokingly, if she was. She denied it and just laughed it off, but three months later she admitted being with child. She had been hesitant to tell me at first because she didn't know how I would react. She was forty-four, divorced, and living alone. I had just moved to New York from our home in Connecticut, and my younger brother was away in college. But I was cool with it. I didn't get upset or mad; I was just concerned because of her age. At the time, I wasn't too particular about whether the baby was a boy or a girl, as long as the child and my mother were healthy.

When my aunt called me from the hospital and told me that Mom had had a baby girl, I was happy but somewhat in shock. My reaction was, Okay, there's a new one in the family. I saw her about two weeks later, and she was absolutely beautiful.

I hadn't given much thought to what my role would be as a big sister. Back then, I was busy living the life of a struggling New York artist—holding down different jobs to keep a roof over my head while at various times working in dance, textile design, and later acting, directing, and set design. But as Alex has gotten older, I've begun to play a more integral part in her life, and she in mine.

On the surface, we couldn't be more different. We don't look alike: she's very fair, like my mom, and has brown hair; I'm brown with dark hair. At nine, she is big into fashion, music, and, believe it or not, boys. At her age I was a little more studious, and clothes and boys didn't consume me. She's also a lot more strong-willed than I was, and she's developing already, unlike me.

Our mother is definitely not raising Alex the way she raised my brother and

me. Unlike Alex, we grew up in a two-parent home. Times were simpler, and I don't think Mom worried about us as much. But now that she's single and raising a young child in this day and age, I've noticed that her parenting method has become a little stricter.

Of course this can lead to clashes, and I'm often called upon to intervene. Usually it's over clothes—Alex may want to wear something to school that my mother thinks is a bit racy for a child her age. I'll have to either verify to our mother that the garment in question is okay or explain to Alex why it wouldn't be a good idea to wear it. Other times I'll need to help Alex understand that cleaning her room is not a mean and unreasonable punishment our mother is doling out but a responsibility she has to fulfill before she can go out to play.

Alex looks up to me, so I try to talk to her in a way I would want to be talked to. I leave the scolding to my mother. And because I don't live nearby, I make the effort to keep the lines of communication open. I want her to know that she can always talk to me, especially now, as I see her going through changes.

Hair is a big issue for her at the moment. She wants long hair cascading down her back and becomes frustrated because her hair grows much slower than mine. Or she's upset because she wants a perm and my mother won't let her get one. So I told her, "You are beautiful. You don't need a perm or extensions down your back to be beautiful." I tell her all the time because I remember our mother being very open with me about looks and appearance and stressing how feeling beautiful on the inside radiates to the outside.

But I also remember how awkward the preteen years could be, and I try to comfort her and keep her esteem up through it all. When her two front teeth came in, much bigger than the rest of her teeth, kids at school started teasing her and calling her Bugs Bunny. I tried to make light of the situation by showing her a picture of me at her age, with buckteeth—and glasses, too! That cracked her up. It also helped her to realize that this stage won't go on forever, and won't even matter in a few years.

Alex and I have a great relationship. We have a lot of fun together. I introduced her and my daughter Sala to horseback riding. We inherited from our mother a love of arts and crafts projects, and Alex has become quite a painter and illustrator. Shopping is a given. She also likes to write, so I got her a diary. I always had one, and when I had a problem, writing it down helped. I don't indulge her, but I'll give her a little spending money or something she may need. When she visits me in New York, I take her and Sala out to do kid stuff. They're great playmates. In

fact, their relationship is similar to my relationship with our mom's younger sister Kim. Though we are aunt and niece, there were only four years between us, so we got along like sisters.

The biggest lesson I've learned from my relationship with Alex is how much the things I say and do influence her. There was one such occasion, when she was younger, when she took notice of the fact that I wore thong underwear. Once when we were out, she seemed uncomfortable and kept tugging at her pants. Later I realized that she had put her underwear on backward and wedged them up so that they would look like a thong. She couldn't understand why I'd wear those things. At first I thought it was so funny that she would mimic that of all things, but it was also a wakeup call for me. I sometimes feel that because she looks up to me, I have to really be mature in front of her. I've done some silly stuff in my day that I wouldn't want her to do. But I also know I can't protect her from everything. She will make mistakes, and hopefully learn from them. But in the meantime, I'll continue to be patient, loving, and caring. Sometimes when I talk to her, I know she's only half listening, but she's a kid. Right now she just wants to play and have fun.

as told by Sonya Wells

The Watkins Sisters: bell hooks and Valeria

I'LL BE LOVING YOU ALWAYS

GROWING UP IN A HOUSEHOLD WITH FIVE SISTERS who were all uniquely different, I learned the true meaning of sisterhood. Coming from a family of sisters who oftentimes competed, quarreled, and "fell out with one another," Mama was determined that her girls would be raised knowing how to be friends, knowing how to give each other respect and care, knowing how to forgive and forget, knowing how to love each other always. This home-training was feminist action at its best without Mama even knowing or using the word.

In patriarchal culture it ain't easy for females to love each other rightly, to cherish and value one another. We are constantly encouraged by sexist thinking to see each other as the enemy—to put each other down. Some of the most bitter rivalries in women's history have been between blood sisters. Mama knew from experience the value of teaching us how to actualize our sister love.

Mostly, females are socialized to love the girls who are like them and to shun those who are different. My sister, Valeria, and I were always different from each other. Born a year ahead, I was bonded with my older brother. He and I were often seen by outsiders as twins. I followed him around adoringly and worked overtime to let the world know I was his equal, his partner, his buddy, his friend. And along came Valeria, a little sister, a new little friend longing to be included in the circle of love.

Like I adored my brother and followed in his wake, Valeria adored me. From the start we were studies in contrast. Willful, hardheaded, speaking my mind, a rebel, I was always in the danger zone. Valeria was obedient, a peacemaker, quiet

and steady. Each day I was out of control, she was learning how to maintain control at all costs. She remembers herself as a "lost child"—the one who tried to be seen and not heard, because visibility meant punishment and repression. I was eager to be seen and heard at all costs. She remembers how much I was punished for talking back, and the ways witnessing my pain made her choose silence.

By our teen years we were no longer close. Differences of interest and inclination separated us. Valeria chose adventure, the outdoors, sports (tennis was her passion). I chose contemplation, reading, and solitude. She grew weary of being compared to me, of having to follow in my wake. I set the standard and she was always having to measure up. And the last thing she wanted was to be "like her sister." Her silence was alien to my spirit. We grew apart.

In our college years we found each other again. Feminism was our shared passion. We were both struggling to find a way to be uniquely ourselves, to move beyond identities to claim the selves we invented and chose. Even so, when Valeria chose to be a "bad girl," breaking the rules, breaking with the conservatism of our upbringing, I, her radical older sister, was blamed. Mama felt I charted the path that would lead my sister astray. But Valeria knew she was finding her own way and that we were fortunate, blessed even, that our paths intersected. If I have sometimes guided us along the way, she has been the force pushing me onward, giving me the strength and affirmation needed so I keep on keeping on.

We support each other, give each other radical acceptance, the love that lets us be who we are—we affirm, appreciate, and cherish our bonds. We watch each other's back. And when we disagree (which we do) we work through the difficulties; we communicate, process, and start over. Together we have come to appreciate the power of sisterhood rooted in solidarity. We are able to be for one another—sister, friend, and comrade. Trusting that nothing will ever separate us we have become the sisters Mama wanted us to be—sisters who are loyal, who can be there for each other, loving each other always.

by bell hooks

ACKNOWLEDGMENTS

I AM BLESSED AND VERY GRATEFUL.

To my beloved family Carol, Kessie, and Caed, godson Alejandro Black, and mom Lucille I. Price. To my godmother Evelyn Gorham, who always insisted that I had a couple of good books in me! To my sisterfriends: Donna Johnson, Debbie Fierro, Rachel Mac, Carol Rielly, Kelli Givens and Kathy Mosolino, Mable Miller, Nicole Bengiveno, Pat Simon and Hermene Hartman, N'Digo Magazine. To my Brother Friends: John H. White, Eli Reed, John Wilson, Rodney Bates, Delbert Guy, George Vesay, and Aaron Reynolds, my accountant.

To Jennifer Lyons, my agent, for developing the idea of Sisterfriends and for being persistent about me shooting this project, and keeping my spirits high. If you ever think of doing a book, I hope that you are blessed to have an exceptional editor like I have had in Tracy Sherrod. How could a sister lose? Special thanks to Chester Higgins Jr. for spiritual support during the project and taking my portrait for the cover (poor man)! A special thanks to Penelope Haynes at Pocket Books for selecting a wonderfully talented designer, and for her astute advice throughout the book-publishing process.

Now, you are looking at the book and the photos are looking good. And you all are patting the photographer on the back, ok, but that's not all of it! Behind every photographer there are several sets of eyes to see what you shoot or did not shoot. Talk about blessings, this group of folks were wonderful and very patient with me. My photo editors: Bob Black of the *Chicago Sun-Times*, my mentor since I was 19 years old, thinking I was all that with a camera, gave up many of his vacation days to come to Brooklyn to edit work on the project. To my brother, Bud Williams, who spent a few evenings out of his busy workweek at the *New York Daily News* to edit a few frames. To Beth Fynn, who edited on her free days, away from the grind of photo editing from the *New York Times*. Thanks to Fred Conrad, telling the wonders of one light, Jim Estrin, for reminding me to keep it simple, and Jim Wilson, for telling me to use a larger format. And a special thanks to TAR for helping me "polish" all the photographs with grace, finesse, and a fine sense of humor.

Now running around the country and chasing down sisters can make a sister crazy, so special thanks to Kathy I. Moses, and Dr. Henry McCurtis, who reminded me that this was only a book! A special thanks to the people who knew my photo budget was tight and gave me a place to lay my head: Mrs. Phyllis Riley in Atlanta, Jeanette Lewis in Chicago, and Kellie Wilson in Los Angeles. Thanks to Elan Car and Limousine Service for donating transportation while I traveled around the Midwest. Technical support is the backbone to a photographic project of this magnitude and the following brother totally had my back: Brandon Rielmer, of Fuji Film, the primary film used to shoot this project. To Isaac and Oleh, and brothers at TREC, Professional Lighting, of New York City, for helping me light the sisters up like they were en route to Hollywood! The last will come first! Very special thanks to Laurent, Lucy, and Larra of Lexington Labs in New York City.

This is in memory of all who will attend my book celebration in spirit: My grandmother Florence Smith Dabney, my grandfather James K. Dabney, Nate Richardson, John Tweedle, Romona (Mew) Twillie, NY Detective David Allen, and The Honorable Harold Washington.

—*Michelle V. Agins*

Sincere thanks and appreciation to my parents, Shirley and Edward Chance, for all of their loving support and recommendations throughout this endeavor; my sister, Elise Chance-Mussen, for her bright ideas and assistance from day one; Jimmy James Greene, for all of his encouragement, insight, and precious time spent in helping me stay focused while whittling a mountain down to a molehill; Craig Rose and Alonzo Wright, for coordinating my many interviews—by hook or by crook; super-transcribers Lysette Moore and Caryll McGill, for whose insight and wisdom I am forever grateful; Michael Jackson, for his topnotch legal assistance; my wonderful aunt, Anice Wilson, and sisterfriends Sharon Pendana, Lynda Johnson, and Ayana Davis, who were invaluable resources in helping me find several of my subjects; brotherfriends Lloyd Boston and Sam Fine, for passing on the lessons; eternal optimist Stephen Rountree, for helping me to keep things in perspective; Terrie Williams and Patrik Henry Bass, for their sincere help and guidance; my music industry sisterfriends, Jai Saint Laurent-Smith, Karen Mason, Cheryl Fox-Spencer, and Terri Haskins, for helping me to attain our sisters in song; all of my family and good friends who kept the positive vibes flowing; and all of the sisters who lent their heart-felt stories and time to this effort. Finally, I would like to dedicate this book to the memory of my dear sisterfriend Jennifer Austin Drayton, whose wonderful character and selfless deeds truly embodied what sisterhood is all about.

—*Julia Chance*